WHAT IS WRONG WITH US?

Essays in Cultural Pathology

Edited by
Eric Coombes &
Theodore Dalrymple

imprint-academic.com

Published in the UK by
Imprint Academic, PO Box 200, Exeter EX5 5YX, UK

Distributed in the USA by
Ingram Book Company,
One Ingram Blvd., La Vergne, TN 37086, USA

ISBN 9781845409005

A CIP catalogue record for this book is available from the
British Library and US Library of Congress

Contents

Preface

The present volume has its origins in a proposal first made several years ago, when a number of people were kind enough to suggest that an essay of mine deserved to be more widely known. It quickly became clear that widespread dissatisfaction with the level of public discussion—most obviously but far from uniquely, discussion of the visual arts (or what are labelled as such)—would motivate support for an attempt to get a little more intelligent criticism into the realm of public accessibility.

This collection of critical material is the outcome of that support, which has taken several forms, particularly, of course, that of offering to contribute or of responding to requests to do so. The collection is no more than a sample of *intelligent* observations from various viewpoints on cultural topics, by the possessors of independent and well-informed minds. Many important topics, entire areas of cultural life such as music, are inevitably missing, not because their importance is unrecognized, but simply because of the necessary limitations of a modest project. Nevertheless, we hope that what is said about specific areas or aspects of our culture will be found relevant, by analogy, with others.

Although the contributors are united in their disquiet about the condition of our culture, they have not been asked to support any specific view of our discontents, and are all writing about things that particularly concern them. This collection, therefore, is presented not as amounting to an overarching account, diagnosis or theory of our situation, but in the hope that the individual contributions will be of some interest, and at least provide food for thought. Nevertheless, in the introduction, I venture one or two more general observations about what may underlie the more specific manifestations of cultural malaise. But any readers whose intellectual curiosity or disquiet would lead them further in that direction are advised to read Roger Scruton's enormously impressive *Modern Culture*.

The editors are very grateful to the contributors. All have been as helpful as one could wish. I particularly wish to acknowledge Ian Robinson for unprompted encouragement at an early stage, and David Lee, who first suggested the idea of compiling a collection of essays.

Theodore Dalrymple has not only contributed two essays, but has also, as co-editor, been unfailingly assiduous, and consistent in exercising his well-known astuteness. Both editors would like to record their appreciation of the efforts of David Lee, to whom we all indebted for continuing to produce, in the face of enormous difficulties, *The Jackdaw* — the only regular publication which consistently adopts a genuinely critical stance towards the imbecilities of the contemporary-art world.

Eric Coombes

Modern Croydon has a population four or five times greater than that of Renaissance Florence, yet I doubt that in half a millennium's time tourists will be flocking to it to marvel at its cultural achievements: its art, for example, or its architecture.

Mankind's advances in material well-being have never led automatically to an artistic flowering, but perhaps our own age is unequalled in its gulf between such advances and cultural shallowness. In Britain, at least, it seems as if there is an almost official ideology of crudity and vulgarity, often state-funded; and an aspiration to something higher is an embarrassment or, worse still, a sign of unpardonably elitist sentiment.

The essays in this book express the authors' profound unease at our present cultural situation. They each do so through the examination of a single aspect of that situation and obviously no book can hope to be comprehensive. Neither do they offer a solution — indeed, they exclude top-down solutions. Rather they offer an appeal to us to bethink ourselves.

One of the difficulties they have is that, while in previous ages the moral or aesthetic judgement of the cultural elite might have been decried as poor, shallow or bad, in our age it is the very notion of judgement itself that is under attack. It is frequently denied that a higher and lower, a profound and superficial, a good and bad, actually exist, on the grounds that there is no unassailable metaphysical basis for distinguishing between them. This is a dishonest and self-serving philosophy, always used in the service of shallowness, that the authors of the essays in this book are concerned to refute.

I am grateful to all the authors, and to my fellow-editor, Eric Coombes, upon whom the bulk of the editorial work has fallen — and also for his most lucid introduction.

Theodore Dalrymple

Acknowledgement

The editors are most grateful to Mary Ann Coombes for her unstinting editorial assistance, and for undertaking the compilation of the index.

Note to readers

Some of these essays discuss works of visual art or features of the urban environment. In most cases, reproductions or relevant photographs can easily be found on the internet.

Notes on Contributors

Michael Bussell is a structural engineer, now retired. He worries that undue reliance on electronic technology will displace reasoned thought, as common sense becomes increasingly uncommon. He worked on the re-use and restoration of many older industrial structures, including King's Cross and St Pancras Stations in London. Lecturing and writing on his structural interests include the 1997 book *Appraisal of Existing Iron and Steel Structures*.

Eric Coombes studied Fine Art at the University of Reading. His post-graduate work led to a Ph.D. thesis consisting of a philosophical discussion of visual representation. He was at Camberwell School of Art for many years, where he taught art history and aesthetics. Since retirement, he has tried to paint and write, and has contributed substantial pieces to *The Jackdaw*.

Theodore Dalrymple is a retired prison doctor and psychiatrist who for many years wrote a column in the *Spectator*. He has written for the *City Journal* of New York for more than 20 years. His latest book, a collection of essays published in the *New Criterion*, is *Good and Evil in the Garden of Art* (Encounter).

Michael John DiSanto is Associate Professor of English at Algoma University in Canada. He is the author of *Under Conrad's Eyes: The Novel as Criticism*, the editor of *The Complete Poems of George Whalley*, and with Brian Crick, the co-editor of *Selected Literary Criticism of Matthew Arnold* and *D.H. Lawrence: Selected Criticism*.

Mark Dooley is an Irish philosopher, journalist and broadcaster. He has held lectureships at the National University of Ireland, Maynooth, and at University College Dublin, where he was also the John Henry Newman Scholar in Theology. Since 2006, he has been a columnist and critic with the *Irish Daily Mail*. His books include works on Kierkegaard, Derrida and three volumes on Roger Scruton. In 2011, he published *Why Be a Catholic?*, a widely acclaimed defence of his

Catholic faith. His latest work, *Moral Matters: A Philosophy of Homecoming*, was published in 2015.

Laura Gascoigne is a reviewer and commentator on the visual arts. A former editor of *Artists & Illustrators*, she is art critic of *The Tablet* and contributes regularly to *Apollo*, *RA Magazine*, *The Oldie* and *Country Life*. Her bimonthly column in *The Jackdaw* is frequently focused on the contemporary art world's abuse of the English language.

Brian Lee has been writing since he was a junior hack. He saved up and went to UCL, and then became a lecturer in colleges of technology, which, through various routes, led to his being a lecturer in English Literature at Newcastle Polytechnic, now Northumbria University. He has written various articles, textbooks, a study of Eliot's criticism, satirical verse, children's verse. He was co-editor of *The Haltwhistle Quarterly*. He still tries to write.

David Lee was educated as an art historian. He was the editor of *Art Review* and now runs *The Jackdaw*, a polemical art paper, which he founded in 2000. He has contributed to national newspapers and magazines, made popular television series for ITV and BBC2, and has been a judge for many art competitions, national and local.

Edward Lucie-Smith is generally regarded as one of the most prolific and most widely published writers on art. A number of his art books, among them *Movements in Art since 1945*, *Visual Arts of the 20th Century*, *A Dictionary of Art Terms and Art Today*, are used as standard texts throughout the world.

Duke Maskell graduated in English from UCL in 1962. He taught in Canada and Sierra Leone; and took early retirement from Newcastle Polytechnic in 1989. He co-edited *The Haltwhistle Quarterly*, edited *The Gadfly* and (online) *Words in Edgeways*. He wrote *Politics Needs Literature* and co-wrote *The New Idea of a University*. He is a director of the Brynmill Press.

Ian Robinson read English at Cambridge under F.R. Leavis, then lectured at Swansea University for many years. Co-founder of The Brynmill Press and editor of *The Human World* (1970). Publications include *Chaucer's Prosody*, *The Survival of English*, *Cranmer's Sentences*, *Untied Kingdom* and (with Duke Maskell) *The New Idea of a University*.

Selby Whittingham was introduced by his mother to Shakespeare and mediaeval history, to French culture at the Sorbonne, educated in the

classics, and employed at the National Portrait Gallery, the Courtauld Institute and Manchester City Art Gallery. He founded the Turner Society, and then The Independent Turner Society to campaign for a proper Turner Gallery, Donor Watch and the Watteau Society.

Eric Coombes

Introduction
The Disutility of Utilitarianism

When we speak of 'culture' we are often thinking of the arts or of intellectual pursuits, of *'high* culture'. But in its widest application it includes the common culture of social life itself—spontaneously adopted practices, tacit understandings and assumptions, shared points of reference and so on. We could think of high culture as the self-conscious part of the whole culture.[1] Its condition is not without significance for the health of the common culture that it should enhance, on which it reflects, and to which it should offer models of excellence. A high culture is corrupted and deranged when its self-consciousness gives way to self-delusion—a possible summary of some of our essays.

The unthinking assumptions and acceptances of the wider culture are likely to be revealed least guardedly below the level of cultivated self-consciousness, not just in what is said, but in what is done, tolerated or in practice unpreventable. Let us consider just one example, taken not from the lives of the materially deprived, but—more significantly—from the upper-middle-class life of Cambridge.

The following appeared in one of the 'quality' national newspapers a few months ago.

> A friend with a daughter doing A-levels told me a couple of weeks ago that she had just been on patrol with a flashlight in the garden at a teenage party. ... 'I was trying to stop the Line Up,' she said.
> 'What's the Line Up?'
> Readers of a delicate sensibility may want to look away now.
> ... the Line Up is where several girls get on their knees to 'service' a line of standing boys. You could call it a mass adoption of the Monica Lewinsky position. This, I should point out, is happening, quite commonly, among privately educated teenagers, not kids from families that have given them no boundaries or self-respect.

1 See Roger Scruton, *A Political Philosophy* (London: Continuum, 2006), p. 112.

'Who would have believed that this is where feminism would get us?' said Nicky with real anguish.[2]

'Quite commonly'! It is becoming increasingly difficult to know what, if anything, will spontaneously provoke confident disapproval—except, of course, what defies some arbitrary prohibition of political correctness. I assume, nevertheless, that most readers will find this disgusting and disturbing, although the astonishment of some might be moderated by a measure of weariness. But what exactly is the objection to a group of girls generously exercising their 'team-work skills' in a fashionable party game of collectivized fellatio, or to a group of boys enjoying the (freely bestowed?) gift of their attentions? To the feminist, does the objection lie in the apparent asymmetry of gratification in favour of the boys? Surely not that, *primarily*. Is there some bargain of reciprocation, explicit or tacit, in the form of equivalent services to the girls, preceding operations in the Line Up, or following its consummations? If not, what is in it for the girls? Status? The opportunity to practise their oral techniques?

It is not hard to think of some minor practical disadvantages of this procedure, the most obvious, perhaps, being the risk of herpes. But it is surely safe to say that such considerations would not figure prominently in the reactions of what, I suppose, would still be the majority of responsible adults. To most of us, even today, it is *self-evident* that this behaviour is disgusting, morally degrading and—dare one use the word?—*impermissible*.

But is this judgement justified? What immediate *harm* comes from this sexual activity (there is no risk of unwanted pregnancy)? What unwanted *consequences* does it have for the only people (as might be claimed) whom it affects? The answer can only be 'none' or, at least, 'none that begins to explain the level of disquiet that such reports may induce'.

It is not implausible to suppose that a simple-minded utilitarianism which scorns 'irrational' moral intuitions has been subliminally absorbed by these young members of the 'respectable' classes. Even if we agreed with those who objected to the *tone* of F.R. Leavis's notorious Richmond Lecture, first published in 1962, in which he denounced C.P. Snow's Rede Lecture of 1959, *The Two Cultures*, we couldn't doubt his prescience in seeing Snow as a 'portent' of the coming utilitarian blight, the triumph of a 'technologico-Benthamite'

[2] Allison Pearson, *Daily Telegraph*, 01/09/15. An earlier article had reported girls aged fourteen being expected to provide oral sex at a mixed-sex 'highly regarded [sic] boarding school': *Daily Telegraph*, 23/01/13.

ideology.[3] And though undiplomatic, his scorn for Snow's intellectual pretensions was entirely justified.

Utilitarianism's principle of promoting 'the greatest happiness of the greatest number' is notoriously difficult to elucidate without construing 'happiness' as the sum of *pleasures* minus the sum of pains. As an account of morality this will be viciously circular if the pleasures summed include those which already presuppose moral sentiment. But the observation of right and wrong, *in itself*, is a *direct* source of pleasure or pain. We rejoice in the victory of the good and bemoan the triumph of evil, irrespective of direct consequences for ourselves.

The social functionality of morality may well help to account for its nature and survival. But this does not sanction utilitarianism's *reduction* of morality to its own functionality, which, if widely accepted, must weaken our intuitions about what is right or wrong in itself, undermining the authority of morality itself and thereby its functional efficacy. Has this not, in fact, happened? We might think of this as the *disutility of utilitarianism*.

For utilitarianism, culture is a kind of service or supplier to individuals who enter its premises, if at all, as one enters a shop. (For our governments, this metaphor is almost a literal truth, in that 'investment' in 'culture' — including education — is justified solely by its alleged contributions to GDP, the arts being a kind of nationwide department store.) The shoppers seek what they already think they want — not enlightenment about what would be right, good or healthy to want: judgement about *that* is precisely what utilitarianism precludes. The individual self of the shopper, possessed of sovereign preferences, is a given, formed outside the culture — somewhere or nowhere.

The evaluation of ends has no place in the conceptual space of utilitarianism, where means chase means in an infinite regression of futility, endlessly retreating from judgements of value. It allies itself with the now dominating superstition that elevates science above all other forms of thought and inquiry, and seeks *scientific* answers even to those questions which are necessarily beyond its scope, such as how we should behave. This *scientism* does not, of course, capture the minds of the most intelligent scientists. But where it prevails, and science provides the only accepted models of thought and intellectual discourse, it does immense harm, as Michael DiSanto argues in his essay.

3 Readily available, e.g. C.P. Snow, *The Two Cultures*, Introduction by Stefan Collini (Cambridge: Cambridge University Press, 1998); F.R. Leavis, *Two Cultures? The Significance of C.P. Snow*, Introduction by Stefan Collini (Cambridge: Cambridge University Press, 2013).

Utilitarianism, scientism and non-judgementalism[4] are slightly variant diseases of a single 'technologico-Benthamite' blight.

The disutility of utilitarianism is felt everywhere. Many things which have great instrumental value cannot be *understood* merely as such. Friends, for example, may well be useful to us: but to 'befriend' someone in order selfishly to exploit friendship is to become not a friend, but a 'friend'.[5] To assess something for its immediate instrumental benefits may well be to remove it from the cultural context which provides the conditions of its meaning and value (as with norms of sexual restraint). It may even be removed from the context which, in an important sense, is the condition of its existing at all. Whether or not they have functions beyond themselves, works of art provide important examples of this observation.

No work of art is *simply* identifiable with a physical object. A play, as distinct from its performance, or a poem, as distinct from the marks on a piece of paper, exists only by virtue of a kind of unremarked tacit agreement, that the shared recognition of its existence, in a sense, *constitutes* its existence. A work of art is constituted not (just) materially but *culturally*; and its continued existence presupposes cultural continuity. It can no more survive without that continuity than a sound can be transmitted through a vacuum.

This is most obvious in the case of literature, since the *basic* material with which works of literature are constructed is already a cultural construction. To state the tritely obvious, a necessary condition for literature and its works to survive is the survival of the language in which they have their being. By providing (or failing to provide) models of how the language can be employed at its highest level of power and sophistication, literature — and the discussion of literature — sustains (or fails to sustain) the health of the language itself. And the consequences of *this* extend beyond the sphere of 'high culture', to the common culture, where the integrity (or disintegrity) of language has potentially serious implications for the conduct of affairs.

Here we can see a benefit beyond themselves which the arts might bestow. But if that is so, as with friends, it is a *function* rather than a *purpose*. If, for example, we treat that function as the main reason for young people to read and study literature (which is just the kind of thing which our philistine political masters and even educationists

4 The bane of non-judgementalism is a significant theme in Angus Kennedy, *Being Cultured: In Defence of Discrimination* (Exeter: Imprint Academic, 2014).

5 I borrow this particularly clear example from Roger Scruton, *Culture Counts* (New York: Encounter, 2007), pp. 46–7.

seem to favour) we are deforming our understanding of literature by trying to reduce it to its own functionality, and will lose the social function along with the literature: *the disutility of utilitarianism.*

The enjoyment of literature *for its own sake* engenders a love of the language in which it is written, and a desire by the educated to use it well, which brings its own utilitarian benefit unbidden. But as several contributors point out, we can no longer rely on the capacity of 'educated' people to write merely competent prose. This has incalculably serious consequences for the conduct of public, professional and commercial affairs, since thought and communication are smothered and confused by illiteracy and incoherence.[6]

A culture is constituted by its own continuity (not changelessness). Language provides the central and most revealing example of cultural continuity, partly because all cultural continuity ultimately depends upon it. It is therefore unsurprising that the corruption and misuse of language emerges as a major theme in the essays collected here. It is at its most explicit in the contributions of Ian Robinson, Laura Gascoigne, Brian Lee and Michael DiSanto; it is at least touched upon in them all, and is centrally important, sometimes in less immediately obvious ways, in the contributions of Duke Maskell, David Lee and myself.

Ian Robinson is concerned, above all, with the self-understanding that constitutes the identity of a nation. For us, this self-understanding is realized in and through the English language. The state of the language reflects and is constitutive of the state of the nation, and each failure or refusal, ignorant or calculated, by politicians and the powerful in general, to treat our language with respect damages it a little further, thereby damaging national self-understanding and threatening our identity a little more.

This abuse of *language* by the powerful is also an abuse of *power*, conscious or unconscious. Our lords and masters now find their spiritual home in the intellectually corrupt world of management-speak, which finds a better use for words than the expression of thought or the articulation of honest argument. Words are more useful

6 I cannot resist offering this spectacular example from a document submitted to a Planning Inspector on behalf of her developer client by a 'planning consultant', a person with professional qualifications and an honours degree. 'While the effects described in the first two reasons eschew an amount of subjectivity the appellant notes they fall short on detail, and do not describe the nature of effect that would be caused or why that effect is harmful.' Not long ago, it was *inconceivable* that anyone with any kind of degree could have produced this grotesquely pretentious illiteracy.

to arbitrary power when evacuated of meaning in the service of obfuscation and pretence.

Is this *merely* the triumph of cynicism, or partly the outcome of an ill-understood process by which stupidity is perversely rewarded with (worldly) success? Managerialism, with its mind-deadening argot of illiterate verbosity, has certainly spread itself widely, even overrunning many of the very institutions where it should have provoked the most determined repulsion—the universities. Michael DiSanto's essay discusses the denaturing of academic life by this conquest, and its cata-strophic consequences for the quality of intellectual life that can be cultivated under its subjugation.

Laura Gascoigne gives us some more detailed observations of management-speak replacing the educated usage of English in the mouths of our politicians to conceal truth both from others and them-selves. Her main concern, however, is a parallel phenomenon: the intellectual narcosis of the endless flow of nonsense which fills the art world and suffocates intelligent discourse, an argot in which nothing can be genuinely said or *thought*.

This toxic gas is pumped out by the propaganda machine of 'State Art' and its suppliant acolytes in the media. It is effective, not by persuasion, but by so deadening the minds of those who breathe and emit it, that they become incapable of thinking at all. State Art and its monopoly of public patronage is the subject of David Lee's essay. As he points out, there are a great many accomplished painters, sculptors and printmakers, indeed the great majority, who are simply ignored by the panjandrums of the State-Art establishment and thereby deprived of publicity. Their work *can* be seen, in some of the small commercial galleries and, in London, most notably at the Mall Gallery, which is the exhibition space for a number of important exhibiting societies. Never-theless, because of the stranglehold of what the late Brian Sewell called the Serota tendency, they get virtually no coverage in the national press (notably not in the 'culture' sections of the weekend newspapers), and consequently no critical discussion. Not that *State* Art gets *critical* discussion: where the visual (or 'visual') arts are concerned, we have nonsense about nonsense, but nothing at all about what is worthy of discussion. There is no forum, open to the educated in general, in which the most serious work being done in the visual arts has its place in a wider culture of discussion and judgement. This is a very unhealthy state of affairs: a far cry from Paris in the late 19th century, or London in the 18th century, when Joshua Reynolds and Samuel Johnson were close friends.

The absence of a healthy culture of criticism in the arts is a major theme of my own essay, in which I suggest that it is 'inseparable from

the absence of a healthy culture of moral, social and political criticism, and from the degraded state of education'. If not always coming or quite amounting to judgement, criticism is its prelude or supporting discourse, and for that reason may be instinctively avoided or obfuscated. The movement towards judgement may be most threatening when it approaches the exposed position of *aesthetic* judgement: for this is a place from which utilitarianism's retreat from questions of value can find no further place to go, where the ultimate necessity of judgement inescapably imposes itself. Mere intellectual idleness or incompetence aside, the disengagement from genuine criticism in the arts may be the clearest manifestation of a wider irresponsibility, born of cultural anxiety, displayed, as it were, in its least disguisable form.

Judgement, in the relevant sense, is not a matter of assent to a proposition, but of *perception*, where this is understood as including in its scope the realms of imagination and memory. 'Professor' Tracey Emin's bed has no perceptible qualities relevantly to distinguish it from any other unmade bed in an adequately squalid state of uncleanliness and disarray. Whether or not we find interesting all the information about the events and circumstances leading to its 'creation' — that is, to the instructions to put it on display — none of it could amount to criticism unless it informed our perceptions. What we can *see* is that it occupies a large amount of space at Tate Britain, thereby denied to a considerable number of important works in the permanent collection consigned to invisibility by the whims of curatorial fashion. Where is the *criticism* that would enable us to *experience* the 'work' appropriately — *criticism* as distinct from the biographical information whose presumed importance lies only in the presumed importance of Tracey herself, *as* herself? Criticism has not failed: it has not even been attempted.

Tracey Emin is important not as an 'artist', but as a kind of celebrity. Celebrity culture, on which subject my co-editor, Theodore Dalrymple, writes in this volume, is part of the imposture of *pretence*, by which the trivial and vacuous is held up as an object of admiration. In the case of State Art, it is the pretence of radicalism, associated with the 'avant-garde' of Modernism, especially under its more simple-minded interpretations. Modernism is a complex phenomenon, constantly oversimplified, but we can say that it was at least partly rooted in a felt need to repudiate, escape from, or put at a critical distance, aspects of the culture in which the Modernists found themselves. In his clear-sighted account, Edward Lucie-Smith describes how the rhetoric of the 'avant-garde' has now degenerated into a mere marketing strategy, and, far from criticizing or offering an alternative to the worst consumerist excesses of the 'upper' reaches of our grotesquely materialist

society, the 'avant-garde' is as much part of it as is the fashion industry, from which, indeed, it is barely distinguishable: 'avant-garde lite'.

Duke Maskell's essay discusses recent government attempts to mitigate our problems by the utilization of things called 'British Values'. This almost pitiably — or comically — crass notion emanates from within the very class whose increasingly reckless irresponsibility, over a period of decades, has done most to promote the cultural maladies it now claims the authority to remedy. 'British Values' are to be invoked in a kind of *branding exercise*, when imposing — like trading standards — the current arbitrary dogmatisms of a deracinated and dictatorial governing class: *we* shall decide what 'British Values' are and (more importantly) *how to interpret them*; *you* will accept them. In practice, of course, their supposed application entrenches the hysterical obsessions of political correctness.

The principles by which we live reveal and assert themselves not as inert abstractions but in the forms of life which nurture them. *That* is what we mean by a culture. It is futile — even dangerous — to suppose that our social and cultural maladies can be cured by the insolence of imposing from above, *by edict*, the confused and over-specialized obsessions of a governing class, which itself is barely rooted in the culture of the nation it presumes to govern. Such measures betray the uneducated disproportionality that isolates specific issues and disregards the cultural context in which they are embedded, where those measures may have unintended consequences — unforeseen or foreseen but discounted. This blizzard of presumptuousness comes from the temporary occupants of office — not from distinguished, serious or even basically educated thinkers — from people whose hands have alighted on the levers of power by the workings of chance and of low political calculation.

As Ian Robinson shows in his essay, there is every reason to suppose that those occupying the heights of power in recent decades have often been, despite their privileged schooling (Fettes, Eton, etc.) and Oxbridge degrees, essentially uneducated. But we should also bear in mind the apparent need felt by many politicians to defer, or appear to defer, to the demotic, and ask ourselves how far the *practice* of pretence internalizes the pretended attitudes and erases the very distinction between pretence and reality.[7] This need, of course, is

[7] Before the war, Wittgenstein was once asked whether he thought that Hitler was 'sincere'. 'Is a ballet dancer sincere?', he replied. In Ludwig Wittgenstein, *Personal Recollections*, ed. Rush Rhees (Oxford: Blackwell, 1981), p. 153.

hugely amplified by the ubiquity and nature of the media monopo-
lizing public discourse, where frivolity has become compulsory, so that
a 'celebrity', such as Russell Brand, can be invited on to discussion
programmes, to be received respectfully for the incoherent and
intemperate expression of fatuous opinions.

Theodore Dalrymple reminds us of the ubiquity and significance of
'celebrity culture' in today's world, where a condition of being a
celebrity, in its now sublimated essence, is the lack of anything worthy
of celebration. And, as Dalrymple argues, this is its explanation: it
reassures devotees and makes aspiration unintelligible, by displaying
wealth and acclaim as possessed by people undistinguished from
themselves in any significant way — especially not in achievement,
ability, intelligence or refinement — except for that wealth and acclaim.
Wealth and acclaim are *deserved* by virtue of possessing wealth and
acclaim.

Such is the potency of this adventitious glamour that the most
exclusive parts of society, as traditionally perceived, are not necessarily
closed to the celebrity, as we saw in the sickening case of Jimmy Savile,
knighted by the Queen and even by the Pope. The phenomenon of
Princess Diana could be understood as a kind of reciprocating move-
ment in the opposite direction from Savile's, rewarded by the acclaim
of 'she's really just like us!' The domain of high culture is far from
immune to this pathology, particularly, but not only, in the 'visual' arts.
This will be obvious to the reader of Edward Lucie-Smith's essay. The
point has now been reached, as with Christopher Wool (mentioned in
Laura Gascoigne's essay), where the market 'value' of a painting lies
entirely in its possession constituting evidence of the purchaser's ability
to pay for it.[8]

I've suggested that the simple-minded utilitarianism of our contempo-
rary world is dysfunctional, because it endlessly postpones necessary
judgements of value. Sustained attempts to avoid judgement become
sustained pretence. Uneasiness about the concept of ultimate value
does not entail its dispensability, and reluctance to exercise it may be
central to the debasement of our culture. Since religion provides the
leading example of values held as ultimate, it is often supposed that the
decline in religious practice is a major factor in our social/cultural
problems.

That view may seem as plausible to the irreligious as to the reli-
gious. The sacred is valued *unconditionally*: it transcends the *particular*

[8] See my piece in *The Jackdaw*, No. 119, Jan/Feb 2015, responding to the
editorial in No. 118.

interests, needs or obsessions of individuals and is, necessarily, beyond
price. Mark Dooley argues that awe of the sacred is therefore the ulti-
mate binding force of a society, and makes possible the preparedness
for sacrifice on which the survival of societies ultimately depends.

The unremitting insistence on the primacy of the individual in
contemporary Western societies (especially in Britain?), has almost
rendered the spirit of sacrifice incomprehensible. Nevertheless, most
people actually experience a form of the sacred in the force of
unconditional commitments, most obviously, perhaps, in love of their
children, especially when they are completely dependent on their
parents.

Even if the *word* might baffle the unbeliever, it is not so much the
sacred itself which meets with indifference as the churches which
promise to enshrine it, and their rituals, doctrines and disciplines. The
contemporary proliferation of quasi-religious obsessions might lead the
optimistic Christian to suppose the roots of religious sentiment not to
be dead, and to hope for a renewal of the Church. For Mark Dooley,
this is a matter of cultural survival. He occupies the viewpoint of a
committed Catholic, but there is nothing narrowly sectarian in his
writing, and it should be of interest and concern to Christians of all
denominations, to non-Christians and even to atheists.

Since our forms of life and meaning have evolved in a context of
Christian teaching and ritual, Mark Dooley's essay might lead the
unbeliever as much as the believer to ponder not so much the disputed
truth *of* Christianity, as the truth *in* Christianity. As a *vehicle* of truth
Christianity is not just a set of factual propositions demanding assent,
but a repository of moral teachings, stories and images — doctrines, so
far as *they* can be understood allegorically — and ritual practices, which,
rehearsed in a posture of humility, subdue the importunity of the ego,
with its resistance to truths we should prefer to ignore.

Changes in the liturgies of the churches are often thought to have
hastened the decline of religious practice. Many are repelled by the
banality of the 'modernized' liturgies, and their inhospitality to intima-
tions of the numinous. The affinity between the sacred and the aesthetic
means that the aesthetic dimension of the liturgy is neither arbitrary
nor unnecessary and certainly not adventitious. It is through the beauty
of the liturgy and its context of painting, sculpture, music and archi-
tecture that the sense of the sacred is sustained. There is a deep
connection between the traditions of the arts, the ritual practices of
religion, and the cohesion of a society.

Even if the sacred *has* instrumental value, it is *sacred* by virtue of
being valued unconditionally. In this it is joined by or united with the
beautiful. It is unsurprising that the contemporary world, so

unaccommodating of religious sentiment (except when it induces fear, or calculation of political advantage), should be uncomfortable with the idea of ultimate values, including the sacred, the beautiful and the numinous: for they have no place in the prevailing utilitarian ideology.

Though Turner rarely deals with explicitly religious subjects, no painting embodies intimations of the numinous more powerfully than his. Does Turner, therefore, actually make demands on us that embarrass the contemporary mentality, by subliminally evoking the sense of something beyond the comprehension of utilitarianism— something implying that great art should not just be *used*, but has a value in itself which puts us in the position of trustees, with obligations not just to ourselves, but to the past and the future?

This Burkean understanding of cultural trusteeship informs Selby Whittingham's account of the treatment of J.M.W. Turner's great bequest to the nation. Even without the specific details of how Turner's wishes and the terms of his will have been disregarded, is it not extraordinary that the great national collection of work by a painter of Turner's unsurpassed greatness ends up displayed—to the extent that it *is* displayed—in the outrageously inadequate Clore Gallery at Tate Britain, where the paintings cannot even be well lit? Compare this with France's treatment of Picasso, who is, to put it no more forcefully, not more important than Turner.

Whittingham is concerned about a tendency for curators to regard the collections in their care as vehicles for self-promotion and, through temporary exhibitions, fund-raising assets. It has certainly become common for exhibitions, often quite openly, to be less an occasion for displaying works otherwise inaccessible than an elaborate illustration of a curator's not necessarily profound thoughts. Can we not see a parallel development in drama and particularly in opera, when performances of a work subject it to the egoism of a director, imposing 'interpretations' which have no regard for the integrity of the work itself?

These examples raise questions about the duties of professions concerned with the arts, including, or especially, in the context of education. The paramount duty, surely, is to *sustain our culture*. This is impossible without care and respect for what we have inherited, as it is in itself, and not as the vehicle of the curator's, director's or, indeed, educationist's self-importance.

Nowhere is the duty of trusteeship felt more strongly than in the context of the urban environment. Architecture stands as a visual symbol of what we have inherited, and embodies in its enduring public forms the continuity of the culture which has formed us. It is, perhaps, the

most intuitively compelling manifestation of culture as constituted by its own continuity: compelling to many for whom the intuition asserts itself in subliminal feelings rather than fully articulated or even conscious thoughts. Such feelings are possessed by those appalled by the urban vandalism that we have seen for many decades, when graceful buildings and benignly familiar environments are destroyed to make way for overbearing temples of Mammon, or are subject to the visual assault of rapacious invaders. The obligation to conserve our architectural heritage, and to extend it only with great circumspection and respect, is understood as the duty of a sacred trust, and the rapacity of the predatory developer as sacrilege.

The casualness and brutality with which developers are allowed to wreck for ever this inheritance is something which distresses Theodore Dalrymple. The very eloquence of his essay might provoke the outrage of 'experts'. What are his qualifications to express an opinion about architecture?[9] What impertinence to set his opinion above that of graduates of the AA or the Bartlett School of Architecture! But there is no subject on which the views of experts, in the sense of people who can boast certification, have less overriding moral authority, and there is nothing which affects us so much over which we have less control. We have no choice but to live and work in the environments formed by what architects and developers have been allowed, often corruptly,[10] to impose on us in pursuit of wealth and self-aggrandizement. This is not, of course, to say that there are no architects or architectural theorists worth attending to, only that in this field the intelligent and visually sensitive layman has a particularly legitimate authority.

Michael Bussell, writing as a highly experienced structural engineer, casts an interesting light on these matters, making his observations from a viewpoint not very familiar to the wider public. His essay discusses the history and recent development of structural engineering, and relates this to more general changes in the regimes of professional life, which he does not consider entirely beneficial. He explains how extraordinary developments in materials and technology have now made it possible, through the services of structural engineers, to erect structures in almost any configuration that the whims of architects can contrive, with results that may dismay those most affected — the general

9 I experienced this myself, when my wife and I had the temerity to make some observations about architecture in our local newspaper. We were telephoned by a local architect demanding to know what our qualifications were to have any opinion on the subject. This was followed by a letter to the newspaper, which did not so much as mention any of our actual points, and contained nothing but vulgar abuse.

10 I have in mind here moral and intellectual as well as pecuniary corruption.

public. This, he suggests, raises questions of professional ethics for structural engineering.

Buildings form the environment of our day-to-day lives, where they do not usually receive our *focal* attention, so that our perception of architecture is largely subliminal, but not, for that reason, less important. We are *immersed* in that environment, just as we are immersed in the language of day-to-day life, and the context of everything constituting a culture. Culture is not a shop that we enter or leave at will, but a city extending to the horizon of our lives and thoughts, determining their limits and containing their possibilities. When the character of that city is degraded though neglect, vandalism, stupidity and ignorant obsessionalism, it becomes disorientating, alien to those for whom it is, or should be, their home. The experience of trying to make one's way through this once-familiar cultural environment is evoked by Brian Lee in his short piece: he does not attempt systematic description or analysis, but offers a sample of how its weirdness appears to an astute observer, whose perceptions are uncorrupted by the temptations of comforting pretence.

The Cultural Environment:
Social and Built

Theodore Dalrymple

Built to Destroy
The Nihilism of Modern Architecture

We speak these days about revolution, and we are making it with pride. — Le Corbusier, *Destin de Paris*, 1941[1]

A few months ago I had a conversation in a pub (that indispensable forum for art criticism) that continues to haunt me. My interlocutor was a man aged about 40, a design engineer. I had just returned from a visit to Cheltenham where I had been much exercised by the contributions of the 20th century, especially the second half of it, to that town. I described Imperial Square to him, a large green space as much a park as a square, on the far side of which from where I stood was a graceful Regency terrace. Looming over it, so prepotently that the eye could not ignore it or screen it out, was a hideous grey-brown tower block of offices, from which were now festooned all kinds of satellite dishes and aerials, a building that destroyed once and for all the harmony of the townscape. If any building could be described as criminal, the product of an unholy alliance between aesthetic nihilism as an ideology and financial corruption, this could.

'Who is to say it is ugly?' said my interlocutor, the design engineer. 'It is only a matter of taste. Personally, I like contrast.'

Contrast is not, of course, by itself a judgement of aesthetic quality. A pile of decomposing offal next to a Piero della Francesca would be a contrast, but it would be of no value whatsoever — or rather, it would have strongly negative value.

Having recently re-read Adam Fergusson's *The Sack of Bath*,[2] I tried to use the City Council's attempted destruction of that city as another example to persuade my interlocutor that something was rotten in the state of architecture and with the taste that informed it. But I had no more success with Bath than I had had with Cheltenham.

[1] Le Corbusier [Charles-Eduoard Jeanneret-Gris], *Destin de Paris* (Paris: Fernand Sorlot, 1941), p. 9.

[2] First published 1973. Reprinted with new preface, London: Persephone Books, 2011.

'So what if a few thousand 18th-century houses are demolished. I don't care. There are thousands more 18th-century houses.'

He spoke as if the preservation of one such house would do, as a kind of historical curiosity like a stuffed great auk, or in the spirit of those who list for preservation buildings such as the concrete brutalist signal box at New Street Station in Birmingham, admittedly a monstrous assault on the eye but unique of its kind, to be preserved merely for its historical significance. With this idea I have some limited sympathy: it is no doubt salutary to preserve *some* memorials to human stupidity and viciousness; but that is not the reason for having wished to preserve Bath.

I confess that I did not know what to say. I felt as if I were speaking to an alien, someone so different from me that communication between us was almost impossible. I recalled the speech of Lord Curzon in 1900, when he was Viceroy of India, to the Bengal Society, describing the importance of preserving India's architectural heritage:

> India is covered with the visible records of vanished dynasties, of forgotten monarchs, of persecuted and sometimes dishonoured creeds. ... Many of them are in out-of-the-way places, and are liable to the combined ravages of a tropical climate, an exuberant flora, and very often a local and ignorant population, who see only in an ancient building the means of inexpensively raising a modern one for their own convenience. ... If there be anyone who says to me that there is no duty devolving upon a Christian Government to preserve the monuments of a pagan art, or the sanctuaries of an alien faith, I cannot pause to argue with such a man. Art and beauty, and the reverence that is owing to all that has evoked human genius or has inspired human faith, are independent of creeds ... There is no principle of artistic discrimination between the mausoleum of the despot and the sepulchre of the saint. What is beautiful, what is historic, what tears the mask off the face of the past,[3] and helps us to read its riddles, and to look it in the eyes: these, and not the dogmas of a combative theology, are the principal criteria to which we must look.[4]

'A local and ignorant population, who see only in an ancient building the means of inexpensively raising a modern one for their own convenience': is that population indeed what we have now raised up at home? Another Briton of the time, living in India at the same time as Lord Curzon, the man who discovered the mosquito transmission of malaria and won the Nobel Prize for having done so, Sir Ronald Ross, was also something of a poet, and wrote:

3 As in a way, alas, does the New Street Station signal box.
4 Reprinted in *Lord Curzon in India*, ed. T. Raleigh (London: Macmillan, 1906), Vol. 2, pp. 273–4.

Here from my lonely watch-tower of the East
An ancient race outworn I see —
With dread, my own dear distant country, lest
The same fate fall on thee.[5]

But we are not viceroys, and we have to pause to argue with such men as Lord Curzon declined to speak to. Unfortunately, it is not easy to know what to say to a man who can contemplate with equanimity, and even welcome, the destruction of Bath. It is like trying to argue with someone who does not see what is wrong with cruelty to animals.

That my interlocutor was a design engineer made our conversation all the more alarming, for such engineers are of enormous importance in the way we build now, perhaps even more important than architects: for where the fulfilment of function is more important than any other desideratum, the engineer is king. (It is an irony that function and efficiency are like happiness, in as much as that they are seldom reached when directly aimed at.) One might see professional self-interest in his liking for stylistic contrast — actually, 'clash' would be a better word for it — in so far as large modern buildings imperatively require the services of design engineers and guarantee them employment. But I do not think this is the explanation, or at any rate the whole explanation. Liking for clash, or indifference to harmony, is widespread.

Not long ago also, I was walking in a provincial town with an intelligent young man who was writing his doctoral thesis in philosophy. We happened to pass through a square, mainly 18th-century but with a neoclassical bank building dating, I should imagine, from the 1920s. The square was originally pleasant and unpretentious, harmoniously put together; but on one side had been erected, in the late 1960s or early 1970s to judge by its style, a modernist building with bright fire-engine red glass panels. I commented on this architectural and aesthetic excrescence, which now dominated the square entirely, to my philosopher friend, who clearly was not as exercised by it as I.

'But most of the square is still the same', he said. 'Why not just take pleasure in the buildings that remain and are the same as they have always been?'

Why not indeed? What he said was factually correct: the modern building occupied only about an eighth of the square. But it caught nearly a hundred per cent of anyone's visual attention, not by merit but by sheer obtrusion. What could I reply that might explain that a townscape is not, or ought not to be, merely a gathering together in physical proximity of individual elements, and that this had consequences for

5 *India*, in Ronald Ross, *Memoirs* (London: John Murray, 1923), pp. 43–4.

the practice of architecture? I thought of an analogy from a field now much dearer to most people's heart.

'Suppose', I said, 'you are at a table in a good restaurant. Your food is delicious. Suddenly a person at the next table vomits all over the place. Would it be reasonable for me to say to you that you should disregard it, that after all your food on your plate was just the same as it was before, just as delicious?'

He received the point but still I could tell that the obvious outrage the modern building represented (it could only have been deliberate) did not move him much, even though he by no means liked it. And I realized then that the modernists had succeeded in their aim, which was not merely to build but to reform man's soul, of which taste is an important manifestation. My philosopher friend had grown up with the very kind of clash to which I drew his attention all about him, so that he accepted it as normal, as inevitable, as the way the world was, as if there were no alternative. Urban architectural harmony was no longer desired by such as he, because it did not exist in his experience and therefore was not even a possibility; disharmony was accepted by him with a kind of fatalistic equanimity. Against the inevitable, the gods themselves fight in vain; and so any architectural outrage what-ever is accepted with joy by architects and structural engineers and with resignation by everyone else.

The reformist or even revolutionary zeal of the architects and structural engineers, combined with defensive resignation on the part of the population, is not confined to these shores. Egregious examples of hideous architectural juxtaposition are to be found in Holland, for example. Arriving at Utrecht Station, anyone not resigned to the visual vandalism of modernist architecture will be appalled that the buildings surrounding it have been built within a few hundred yards of some of the most civilized and graceful architecture ever devised. One cannot help thinking that the buildings are intended as some kind of revenge of barbarians upon the civilized whom the former cannot equal.

This impression is strongly reinforced by a visit to the Binnenhof in The Hague. This large assemblage of buildings, where the Dutch parlia-ment still sits, was constructed over a period of four centuries, with each succeeding building in harmony with what already existed. There is unity here in diversity; it fell to the latter part of the 20th century to smash it up completely. It is true that during the revolutionary turmoil of 1848 some politicians wanted to demolish the Binnenhof because of what it symbolized, namely the past; but the citizens of The Hague were wise enough in those days to protest against this projected

vandalism.[6] The architects of the late 20th century learned their lesson: they could not destroy the Binnenhof directly, by outright demolition, but could do so by construction—and this they did.

They constructed two huge skyscrapers to house ministries not far away, so that, looking in one direction, they loom over the Binnenhof as Brobdingnagians over Gulliver. The eye, looking in that direction, cannot ignore them or attend to the Binnenhof alone; and once having seen them (as is inevitable), even turning one's back on them is not sufficient to eliminate them from one's consciousness. One knows that they are there and that is enough—one cannot un-eat of the fruit of the tree of visual destruction; they wait to pounce on one's retinas if one so much as turns the head slightly. They dominate and ruin, as it is difficult not to believe that they were intended to do.

Even as skyscrapers they are completely undistinguished, of less interest than those in Dubai, some of which, at least, have an elegance, albeit an elegance of a charmless and inhuman kind. They are just huge, designed merely to preponderate and make all around seem puny, insignificant and even ridiculous by comparison—in effect to humiliate it. At least the skyscrapers of Dubai were built on a nearly blank slate[7] and are therefore not a crime against an architectural heritage, or only to a limited extent. The buildings that loom over the Binnenhof do not radiate power so much as power-madness, they have size without grandeur: they are a raw architectural illustration of *la loi du plus fort*, whose reason, according to La Fontaine's ironical assertion, is always the best. It is only appropriate that these buildings should be ministries, dwarfing not only individuals but previous efforts of the state to direct the affairs of the people under its jurisdiction. But I suspect—and certainly hope—that the architects, in producing the effect they did, were aware of, and themselves humiliated by, their inability to produce anything that will still be admired in 700 years' time.[8] Physical size and the aesthetic destruction of what already exists are the only ways in which they can make their mark—which, as we shall see, is of enormous importance to them.

A Dutch architect of my acquaintance, who is much in favour of the modernist transformation of his country's townscape, argues that the construction of such buildings offends people because they do not *understand* the language of the architecture behind them, which is a

6 Vandalism is a permanent temptation of Mankind, and is in fact highly enjoyable, as anybody who has seen a riot will attest.

7 Never having been very large, a few old Arab buildings remain, which are of course eminently suited to the climate as well as having a simple elegance of design.

8 The Binnenhof was constructed between the 13th and the 17th century.

foreign tongue to them.[9] If people are appalled by the ugliness of what is built, by its visual destruction of much-loved townscapes that have endured for centuries until a single building destroys them once and for all, they stood convicted in his mind of *ignorance*. Eventually they will come to understand, and then they will see that the architects were right all along and thank them for their visionary work. In fact what happens is resigned acceptance because of impotence. One does not struggle against the unavoidable. The New England transcendentalist, Margaret Fuller, wrote 'I accept the universe'. On being told this, Thomas Carlyle said, 'Gad, she'd better!' So it is with modernist (and post-modernist) architecture.[10]

The technique of making ordinary people feel guilty that they do not understand architecture, and therefore have no right to pass judgement on it, has been employed for a long time. And it has worked. Le Corbusier used often to divide the world into those who see and those who do not see, often with italicization for emphasis, that is to say those who accepted uncritically what he said and those who did not accept uncritically what he said, the enlightened and the unenlightened, the advanced and the retrograde, the intelligent and the stupid. And he fully understood Napoleon's dictum that the only effective rhetorical device is repetition; he was nothing if not repetitive. He never condescended to use a logical argument to make his case, in part because no such arguments could have been found; his books are strings of badgering *ex cathedra* dicta, each one of which is extremely doubtful, and most of which, in so far as they relate to facts, are false. In *Quand les cathédrales étaient blanches* (*When the Cathedrals Were White*), for

[9] It was famously said of Wagner's music that it 'is better than it sounds'. Whatever one may think of Wagner, this remark brings to the fore a serious problem of aesthetics, namely the role of knowledge and intellectual understanding in aesthetic judgement. A brilliant man may be a philistine, a man of exquisite taste need not be a scholar. But the history of all arts is sown with instances of artists whose work was incomprehensible to the public at the time they produced it, but which became within a short time standard or classical, understood and cherished by all, or at least all who were interested in the art to which it was an addition. (It is far more often the case in history that the work of great artists is appreciated immediately it is produced, but this fact is most often overlooked by those with a modernist or avant-gardiste axe to grind.) The fact that there has been such incomprehension in the past is used to promote a kind of aesthetic nihilism, all on the basis of an obviously invalid syllogism: great art has been misunderstood by contemporaries in the past, this new work of art is misunderstood, therefore it is great.

[10] Bell Gale Chevigny (ed.), *The Woman and the Myth: Margaret Fuller's Life and Writings* (Boston: Northeastern University Press, 1994), p. 352.

example, he states baldly that men are ants, a belief that he held that is, or ought to be, perfectly obvious from his urban designs. (That he was also a Fascist sympathizer is likewise perfectly obvious from them.) The main, and indeed the only interesting and important, question about his career is how a man such as he could have come to exert so strong and lasting an influence, so that to this day it is impossible to criticize him in French architectural schools and not be excommunicated.[11]

I encountered the intellectual and moral terror which modernist architects (in particular Le Corbusier) have managed to exert on intelligent and sensitive people at two recent exhibitions of Le Corbusier's work, one in London and the other in Paris. The first was held at the Barbican, the second in the Centre Pompidou: both appropriate enough locations, the first being a 'classical' example of British brutalist architecture,[12] the second a building with a good claim to be among the ugliest in the world, built in a city with a good claim to be the most beautiful in the world.

In the London exhibition was shown a film made in the 1920s of Le Corbusier in front of a map of Paris with a large black crayon in hand. Le Corbusier uses the crayon to demolish a large part of the city in his imagination, all with an emphatic flourish worthy of Bomber Harris contemplating the map of a German city—Bomber Harris who at least had the excuse that there was a war on.[13]

The exhibition was not well-attended (which is how I like exhibitions), at least while I was there. I watched the film of Le Corbusier destroying Paris in his mind's eye in the company of two cultivated ladies, slightly older than I, whom I did not know.

I engaged them in conversation about what we had just seen. I made it clear that I thought that Le Corbusier was a monster, and not only that but *obviously* so, indeed so obviously so that it was scarcely a judgement separable from the immediate perception or apprehension of what he did. Who else but a monster could even conceive of wiping out a large part of Paris in order to replace it with what was, in effect,

11 *Quand les cathédrales* (Paris: Plon, 1937). In his book *Le Corbusier: une froide vision du monde* (*Le Corbusier: A Cold View of the World*) (Paris: Michalon, 2015), the French architectural critic, Marc Perelman, relates how he was excluded from French architectural schools as a teacher after he published a book in 1986 that was critical of the architect. The totalitarian spirit lives on.

12 What kind of people, one might ask, would accept to wear as a badge of honour a cognate of the word 'brutal'?

13 At least Bomber Harris wanted to destroy only German cities: Le Corbusier was more internationalist in his approach to demolition. He had Algiers, Antwerp, Buenos Aires, Moscow, Rio de Janeiro and Stockholm, among others, in his line of sight.

an enormous council housing estate, as demonstrated by the model of his famous — infamous — *Plan Voisin*?

The two ladies were startled by my views (I cannot altogether rule out the possibility that they were startled merely by the fact that I, a stranger, addressed them at all, but I do not think so). They looked as if I had uttered a blasphemy in a holy shrine in a theocracy: lightly frightened.

I asked them where they lived, for I recognized them as upper-middle class. They lived in Richmond.

> And are there any buildings in the proximity which are in the style of Le Corbusier?

They said that there were.

> And do they improve the townscape?

Now that they came to think of it, they did not, rather the contrary.[14] My next question was an obvious one: in what way or sense, then, was Le Corbusier a great architect? They could not think of one, except that everyone said that he was, and such unanimity of opinion cannot be wrong. It was the argument from authority.

I was reminded of an article in an Irish newspaper I had read about the refurbishment of Eileen Gray's villa in the South of France, charmingly called E1027. Eileen Gray was a modernist Irish designer and architect who lived practically all her adult life in France and was an associate of Le Corbusier. E1027 had been almost forgotten when the critic from the Irish newspaper visited it. His report indicated that he found it small, poky, inconvenient and charmless. Nevertheless, his article was premised on the supposition that it was a great work. It is surely odd for a work about which the critic could find nothing to say that was complimentary (other than that the view from the windows

[14] It is not only from the aesthetic point of view that Le Corbusier was severely deficient. The supposedly iconic Villa Savoye, which looks like a small laboratory in the middle of a field, was never habitable for long because it kept leaking and was poorly drained (rather important if a roof is flat) and the cost of its maintenance was prohibitive. It can survive only as a *Monument national*. The continued idiocies of modernist architects are clearly laid out in a very amusing, indeed hilarious, book about the new Bibliothèque Nationale in Paris, *L'Effondrement de la très grande bibliothèque nationale de France: ses causes, ses conséquences* by Jean-Marc Mondosio (Paris: Editions de l'Encyclopédie des nuisances, 1999). The architects did not realize that the ground on the banks of the Seine might be damp (not good for books) or that sunlight through glass has a tendency to damage the likely contents of a library. Moreover, it was designed as if specifically to frustrate the work of scholars.

was marvellous, the beauty of the view being attributable to nature rather than to the architect) not to be dispraised.[15]

Leaving aside the effect of national pride that so 'important' a figure should have been Irish, the answer must surely be that the critic had been thoroughly indoctrinated by an historicist or Whig interpretation of art and architectural history. According to this interpretation, what comes after must, almost by definition, be better than what came before, that it progresses or ascends to some ideal. Eileen Gray (and Le Corbusier) were *ahead of their time*, a weaselly expression that precludes aesthetic judgement: 'ahead of their time' meaning that they influenced many who followed them in time, which is a matter of mere historical fact and not in the slightest a commendation, which must rely on judgements of value rather than of fact. Houston Stewart Chamberlain was no doubt ahead of his time in the sense that his ravings influenced Hitler and the Nazis (he died in 1927), but we do not therefore accord him any great respect. Being ahead of your time is no virtue if the time that you are ahead of is one of aesthetic degradation.

In one field of human endeavour, namely science and technology, the Whig interpretation is plausible, though even there not entirely sufficient. Science undoubtedly progresses, technology also (though technologies, or at least skills, may be lost as well as discovered). No one would wish to be operated on using the same techniques as those of a hundred, or even fifty, years ago; the telephony of my childhood seems pitifully unsophisticated and inefficient by comparison with that of today; the computer on which I write this is more powerful than that which sent men to the moon, and is by no means the most powerful available in any computer store; and so on. It is obvious from his writings that a figure like Le Corbusier was dazzled by the progress of science and technology, and by a process equivalent to transferred epithet, thought that such progress had occurred or could occur in aesthetics also. This, of course, is completely false; Trechikov is not a better painter than Velasquez because he was born three centuries after Velasquez. The transference of the concept of progress to architecture, similar to that seen in science and technology, is plausible (though false) only because technology can and does affect architecture. But more advanced technology is not the same as better architecture, even where more advanced technology leads to improvement in some function or other, for example in heating efficiency. Beauty is an indispensable quality of good architecture, however, indeed a

[15] 'The Price of Desire', *Irish Times*, 25/02/12.

necessary condition of it; and the Whig interpretation of history is peculiarly inapplicable to aesthetics.[16]

Irrespective of whether the Irish newspaper's critic was right to find nothing to praise in E1027 (a name of a house worthy of *Brave New World*), it is clear that his mind was clouded by the progressivist fallacy. In view of the way in which he described it, only this could have prevented his condemnation of it; but he was afraid to condemn something that was *ahead of its time*, for that would have marked him out as a reactionary. He had been terrorized in the same way as the ladies from Richmond.

At the Paris exhibition in the Centre Pompidou to mark the fiftieth anniversary of Le Corbusier's death, which made not the slightest reference to the architect's social and political views, there was film of him made during the construction of Chandigarh, the new planned capital of the Punjab in India. It showed the enormous public spaces, paved in raw concrete, between the main public buildings such as the Assembly, the High Court and the Secretariat (all of them, of course, in raw concrete, a material that does not age but only stains and deteriorates, and which Le Corbusier once described as 'friendly', raising the question as to whether he suffered from a mental disorder such as autism). There was no shade provided in any of these concrete expanses, an important absence in a city in which for six months of the year the temperature rises to 90 degrees Fahrenheit and in some months to 110 degrees. (In addition, concrete reflects heat well.) It is as if Le Corbusier had wanted to punish those who attempted to walk across these spaces, so much cleaner, more tidier, less cluttered, if utterly deserted.[17]

'What incompetence!', I exclaimed as I watched, and a French couple standing near me who were also looking at the film turned round with the same startled look as that on the faces of the ladies from Richmond.

'What do you mean?', asked the lady.

I explained about the climate, and the lady asked me whether I had been there. As it happens, I had; but even if I had not, I know from general knowledge that India is a hot country and that in hot countries

[16] Any art critic who uses the word 'progressive' in his criticism is being evasive and trying to mislead (or intimidate) his readers. You might as well praise a sparkplug for its flavour or a carrot for its intelligence.

[17] The same criticism might be made of Brasilia, the planned capital of Brazil. The urbanist and architect responsible for the design of this city, Lucio Costa and Oscar Niemeyer, were both admirers and followers of Le Corbusier. They made sure that any pedestrians in the city would be punished for their temerity in walking.

shade is much appreciated by human beings. It is surely not a very difficult thought and I claim no originality for it; but it was something that did not occur either to Le Corbusier (or if it did, he dismissed it as unimportant because of his contempt for actual human beings) or to the French couple looking at the film. That so obvious a consideration could be overlooked or ignored is astonishing but symptomatic of an arrogant inhumanity among architects by no means confined to Le Corbusier, as a walk on the South Bank in London will attest.

A little pamphlet published by Le Corbusier in 1941, titled *Destin de Paris* (*Destiny of Paris*), is instructive because it was *in advance of its time*.[18] In view of the contents, the title alone is instructive: for it implies that what Le Corbusier is about to describe in his pamphlet is not a plan dictated by human thoughts and wishes, but by something independent of them and much more powerful and ineluctable than they. There is a kind of architectural demiurge at work that it would be both futile and reprehensible to resist. He is like the mugger who would tell his intended victim that his destiny was to be mugged, without mentioning who was going to do the mugging.

The plan and the architecture in his booklet are, according to Le Corbusier, made necessary and ineluctable by the machine age. Man no longer walks or rides horses; he flies about and drives motor cars. He has speeded up by a factor of up to fifty, if not more; old towns and cities impede his journeys. For *intramuros* Paris, Le Corbusier suggests the preservation of about an eighth of it ('with appropriate cleansing', he says, a sinister expression coming from him, as we shall see), to be used solely by the upper administration of the country, and the rest demolished to make way for, among other things, super highways on stilts, five of which, interconnected, would provide access to the very centre of the capital from every corner of the country.[19] For Le Corbusier, speed of travel was very important, what this travel arrived

18 Le Corbusier, *Destin de Paris* (Paris: Fernand Sorlot, 1941). Le Corbusier was at the time a convinced Pétainiste and believer in his *Révolution nationale*. It would be unfair to accuse Le Corbusier of mere opportunism, however: he was a firm fascist from early on, well before the debacle. The publisher of *Destin*, Fernand Sorlot, ran a publishing company that seemed to flourish under the Occupation, publishing works on the Jewish peril, etc. After the Liberation he was forbidden to publish and all his assets were confiscated.

19 The Dutch social-democratic politician, Joop den Uyl, when still a member of the Amsterdam council—he later became Prime Minister—wanted to drive a motorway through the city for easier access to the central station, which would have necessitated the destruction of a considerable tract of 17th-Century Amsterdam: http://www.theguardian.com/cities/2015/may/05/amsterdam-bicycle-capital-world-transport-cycling-kindermoord (last accessed 15/05/2016).

at much less so, and therefore much could and should be sacrificed to speed. Though he claimed always to be thinking of the future, in fact his imagination was confined very strictly by the technology of his day.[20]

Everything will be built upwards, said Le Corbusier, towards the sky, allowing much greater density of population, while freeing land around the tower blocks of flats for gardens and sports fields, in which the population will achieve strength through the joy of 'frolic and sport'. Le Corbusier is also a bit of a hypochondriac on everyone else's behalf: every tower block of flats will have a spa and sanatorium. And every area will have its function (residential, commercial, industrial, etc.).

The object of Le Corbusier's particular hatred is the street. It is messy, illogical, unorganized and retrograde. He looks at it much as a proud and obsessional housewife looks on dust, that is to say as something that should be ruthlessly swept away. Commerce in his opinion should be confined to the right place, namely the commercial quarter. It should not obstruct the speed of traffic. He says the new *radiant city* (a favourite trope of his) will have:

> Organized provision on the basis of consumer co-operatives with shareholding management (traders finding in it secure livelihood under the aegis of an organization infinitely more steady than that provided until now by free trade).[21]

The street, in his description of it, consists of 'hubbub, disputes, pollution and harmful gas'. Elsewhere he calls it smelly.

'The traditional city', according to Le Corbusier, 'in fact represents *nothing* but a huge pile of stones, a desert of tarmacadam, bricks, stone, tiles and slates.'[22] This being the case, it is hardly surprising that he wants to sweep away the detritus of centuries everywhere he finds it.

Worse still is the population of Paris (and presumably of every other large city). He says:

> Paris [the Paris of his plans] will be composed of one, two or three million inhabitants. (The quality of these inhabitants demands examination. Paris must get rid of lifeless crowds, of those who really have

[20] *Destin*, p. 54. The pamphlet ends with the claim that the city of his design will be less susceptible to aerial attack. It is clear that he does not envisage 'progress' in the technique of aerial bombardment. For the author's limited modernist imagination, the latest is always the last.

[21] Ibid., p. 40. He proposes the same corporatist reform of private property in land and buildings.

[22] Ibid., pp. 37–8, emphasis added.

nothing to do in Paris and whose place is on the land or in industries to be removed elsewhere.)[23]

It is clear from this, I think, that Le Corbusier was more than just an architect and thought of architecture as the means to reform man's soul, his whole way of life.[24] Stalin said that writers were engineers of souls;[25] Le Corbusier thought the same, *a fortiori*, of architecture. That a man who wrote such arrogant, deeply nasty and unintelligent drivel from the beginning of his career to its end, and whose opinions were far from unconnected with his actual architectural designs and practice, should be almost universally revered by the architectural profession worldwide does that profession infinite dishonour.

Le Corbusier spoke to the world in the imperative mood. In a sense, architecture is an imperative art, for inhabitants cannot avoid it as they can refuse to read a bad poem or look at a bad picture. But that is all the more reason for a certain modesty on the part of architects, a modesty that Le Corbusier claimed for himself, though it was the modesty of Swift's *Modest Proposal*: 'Very modestly,' he writes, 'we have for years believed it our duty to make clear to Paris, by our plans, our conclusions.'[26] Paris had in all modesty to be destroyed to be saved in all modesty.

'If', says Le Corbusier, 'the reform I evoke is not taken as the basis of architecture and urbanism, we will make neither a human city nor a human dwelling.'[27] You have the choice, then, ladies and gentlemen: do as I say or be inhuman.

Again, Le Corbusier says (this time correctly) that cities cannot be static entities, and that Paris, to take only an obvious example, has layer on layer of different architecture, is an urban palimpsest. But it does not in the least follow that, if change is only to be expected, any change must be accepted. It escapes Le Corbusier's notice entirely that he (and other modernists) have created a style that is incompatible with anything other than itself, such that even if it were good in itself it would

23 Ibid., p. 32.
24 'Soul' is not perhaps the right word to use where Le Corbusier is concerned. He describes Man as an ant in *Quand les cathédrales*, in *Destin* he refers to Man as living in a termite nest (p. 49), as if it were intrinsic to his nature to do so. If man is an insect, what is wrong with his living in an appropriate nest? Le Corbusier was nothing if not stupid. Among many other evasions, he fails to mention *how* the lifeless crowds of Paris who have nothing really to do there — lifeless by what criterion? — are to be removed. Given the context of the time, this is extremely sinister.
25 Speech at home of Maxim Gorky', 26/10/32.
26 *Destin*, p. 42.
27 Ibid.

not harmonize with the already existent. And this is not surprising, because such harmony is not a problem for Le Corbusier (and others). It is not that he extols contrast as an aesthetic desideratum, as did my interlocutor whom I described at the beginning of this essay, except to compare the 'rationality' of his plans with the higgledy-piggledy nature of towns and cities as they have grown down the ages. He simply does not consider the question at all because for him it is not a question. That is why the perfectly obvious thought that a forest of 600 feet-tall towers will completely dominate, overwhelm and dwarf 12th- to 19th-century buildings does not occur to him; but if it had, it would not have disturbed him in the slightest. That is because, like so many ideological intellectuals, rationalist rather than rational, his theories were more real to him than any concrete results (no pun intended) to which they might have given rise.[28]

In all of this, again, he was *ahead of his time,* for this disregard of what already exists and the need to harmonize new construction with it is still disregarded by architects, if not quite always, more often than not. Architects continue to indulge in what might be called 'architectural individualism': that is to say, they often consider the building on which they are engaged to the exclusion of everything else, except where they actively intend the destruction of harmony.

For example, a French niece of mine, an engineer, is excited by the prospect of the second great modernist tower to be built in Paris, the go-ahead for which has just been given after years of refusal of permission, and on the construction of which she will be employed.[29] Irrespective of whether the proposed glass ziggurat of 600 feet will in

[28] In *Destin*, Le Corbusier refers to the supposed Cartesianism of the French people to popularize or make acceptable his plan for their capital city. As is well known, Descartes sought an indubitable single foundation upon which the whole of human knowledge could be established. Le Corbusier proceeded likewise with a few supposedly indisputable and unarguable premises, for example, that from a dwelling, a cell, everything else in his plan followed. He was very fond of organicist metaphors which, however, he also took literally.

[29] The reasons for this reversal after years of opposition are unclear. Several councillors who had previously opposed the project unexpectedly changed their mind. One suspects skulduggery. Be this as it may, the justification for building upwards in *intramuros* Paris, given for example by the most famous French architect of the day, Jean Nouvel (who always dresses and shaves his head like a contemporary thug), is the overcrowding of the city. This is certainly a problem, one that in my opinion ought to be lived with; but in any case the new skyscraper will not relieve the problem, since it is intended for offices and a hotel, which can only exacerbate the problem of the shortage of residential accommodation.

fact affect the aesthetics of Paris adversely, as has the *Tour Montparnasse*, I discovered that for my niece, who has at least the excuse of youth and inexperience, this was simply something that she had not considered. The technical excitement of the project was all that was important to her. For her it was the *Future*, and that was enough.

One of Le Corbusier's postulates was that, as he was coming into adulthood, architecture was dead. This was simply not true; what he meant was that the architects of the time did not claim for themselves the preponderant or grandiose role for themselves that Le Corbusier envisaged. Even up to the 1930s in Paris there were architects who built blocks of flats that, while not masterpieces in the sense that the Sainte Chapelle was a masterpiece, were recognizably of a different style and of their time, yet not destructive of everything around them. A walk around Paris should be enough to convince anyone of the self-serving nature of Le Corbusier's assertion. For personal reasons unnecessary to go into, I am myself renting a flat in Paris at the moment in a block that was constructed at the very time Le Corbusier was speaking of as architecturally dead. This block of flats is not an architectural masterpiece that anyone would travel far to see or even stop long to look at, but it is individual in that it is mildly different from the other blocks around it and it has the virtue of what might be called *good manners*.[30] It is by no means small (my flat is on the eighth floor), divided into two halves connected by a grand but not grandiose hallway, but manages despite its size to retain its human scale and convey a sense of intimacy appropriate to its function, which is to house people comfortably. In short it is *civilized*. It is a fair bet that the architect had no vast theories to propound about how people should or would live in the future or about how the city should be structured as a whole, confining himself to the task in hand; and he evidently considered (or rather took for granted) that what he built should harmonize with the neighbouring buildings, should in other words be neighbourly. This, of course, is true of all the other buildings nearby, resulting in an agreeable and aesthetically pleasing urban environment in which the pleasures of urban existence

30 *Good and Bad Manners in Architecture* was the title of a book first published in 1924 by Trystan Edwards (London: Philip Allan), a title which would have been completely meaningless at best, and positively otiose at worst, to Le Corbusier, and almost certainly—and more importantly—to most subsequently practising architects, at least to those of any ambition or pretensions to distinction. In the book, Edwards urged architects to respect the architectural environment in which they built—assuming, of course, that it had something worth respecting, which was not always the case. Thanks to destructive modernism, the areas in which there is nothing left to respect have increased exponentially in size.

may be enjoyed without difficulty imposed or created by either architecture or grandiose urban planning. The architect had none of Le Corbusier's fatuous objections to the street on the grounds of its unplanned disorder, on the contrary taking it for granted as a precondition of a social life and a proper urban existence. Within at the most two hundred yards I can buy my bread and all other comestibles, sit in cafés (of which there is a choice, as there is of restaurants) or a small park, find the newspaper, buy books, go to the cinema or a theatre, and so forth.[31] Thanks to the excellent *Métro* I can live entirely without a car, the possession of which, indeed, would be a profound nuisance to me. It is true that I am in a privileged position in so far as I am able to live and produce without having to go very far: but when I do have to go far, I am still able to take advantage of the vast increase in speed of transport that Le Corbusier made one of his premises for the almost total destruction of the city. Being so profoundly unintelligent, he did not realize that speed is a good servant but a bad master.

Of course, the construction of such an environment gave a somewhat limited role to the architect. It imposed a certain modesty upon him. This is symbolized by the way in which architects were commemorated in, or rather on, their buildings. On each of them is a little plaque set in the wall, usually on the first floor above street-level, with the date of construction and the architect's name or that of his firm. Hardly anyone stops to look at these plaques, but I do so briefly in order to render some slight homage to these admirable, honourable, unegotistical men (unegotistical architecturally I mean, of their private lives I know nothing) who, with skill and taste, created an environment fit for humanity and to whom a thought such as that Man was an ant would not have occurred and who, if it had occurred to them, would have had the decency to keep it to themselves: and certainly would never have built as if it were true.

There have, of course, always been 'star' architects who have built important public buildings or even remodelled whole cities or areas of cities. The name of Haussmann comes naturally to mind in this connection. He was the Le Corbusier of his time, though with an absolutely crucial difference. Under his direction, an enormous swathe of old Paris was torn down and replaced by the streets and boulevards we know today. There was opposition to him at the time, and no doubt much that was ancient and valuable was destroyed that could have been preserved by a less visionary (or is it *more* visionary?) architect and planner. What is undeniable, however, is that what Haussmann

31 Within a very short time I became known to the local *commerçants*, who Le Corbusier thought would be much happier in collectivities.

replaced it with was itself of great value, not least aesthetically. Haussmann did not build a hideous Novosibirsk-sur-Seine as Le Corbusier undoubtedly would have done if he had had his chance.

At any rate, the loss of modesty among architects, of an awareness that their work should be mannerly, happened to combine with another most unfortunate tendency, a belief that artistic endeavour should be above all original and, if possible, transgressive in some way or another, irrespective of what way. The self-admiring, self-praising and self-congratulatory Italian architect, Renzo Piano, has more than once described himself as a 'bad boy' of architecture, as if this were an accolade and as if architecture were a suitable medium for the expression of adolescent rebellion. That there was nothing in the world like it at the time when he co-designed the Pompidou Centre is no praise of it at all, unless it has aesthetic value *sub specie aeternitatis*, which it certainly has not, quite the reverse in fact. I have never heard anyone praise it as beautiful, only as innovative, interesting, ground-breaking, startling and a variety of other things—none of which, how-ever, in the least detracts from its offensiveness to the eye. 'Yes, it is ugly but …' Its meaningless spaghetti of pipes exhibited on the exterior of the building, painted in the vulgar colours of the cheapest prostitute, is difficult to protect from swift decline into shabbiness, a shabbiness that has none of the charm of the genteel variety.[32]

Of course, someone like Piano could not have succeeded unless there had been a collapse of aesthetic standards among the patrons of architecture, public and private, and also among critics. Piano's latest contribution to the world is the Whitney Museum of American Art, built at a cost of $442 million. It is not quite as garish as the Pompidou Centre, but it otherwise meets that building's exceptionally high standards of ugliness. It is true that its surroundings are for the most part unlovely, but that is no excuse for architectural ugliness any more than it is an excuse for committing fraud that many others do or have done likewise.

Again the building is unique, but that is no praise of it. The museum, which from its appearance could be anything from an abattoir to a waste disposal facility, is clad in a material which will soon (in fact already does) lend itself to shabbiness. It is full of extraneous features such as a protruding platform from high up that is convenient for suicides, and so forth. It has no unity of overall design, it is (as the saying about human life goes) just one damn thing after another.

[32] My French brother-in-law once remarked to me that it was undergoing renovation. 'More like an enema', I replied.

Above all, it screams that it is the product *ex nihilo* of its architect: it is the quintessence of modern architects' egotism.

What do architectural critics have to say of it? I take as my example the critic of the *Guardian*, Oliver Wainwright, because the readership of that organ may safely be taken to be above averagely concerned with such matters as the aesthetics of architecture. Here is what he said:

> Crashing into New York's Meatpacking district, like some great Arctic icebreaker washed up from the Hudson and run aground on the High Line, the new Whitney Museum makes an unlikely container for a beacon of modern art. It is an awkward hulk, lurching this way and that with a clumsy gait, somehow managing to channel the nearby vernacular of warehouse sheds, refrigeration stores and district heating plants into one gigantic industrial lump.[33]

You might think that this was unqualified adverse criticism: in which case I can only remark that this shows a lack of understanding of the cowardly, pusillanimous soul of modern man, at least of the modern art critic. He continues:

> From the outside it might be shockingly ugly to most eyes, but it trumpets its awkwardness in a strangely compelling way. It is all elbows, but gradually, thin slivers of sense can be read in the great industrial bricolage. To the east, it sprouts a big steel gantry, once again recalling the terraced decks of an oil rig, or the fire escapes of nearby brownstones—another detail sampled from the low-key, rough-and-ready context ...[34]

Thin slivers of sense can be read, indeed: the implication being that the judgement of buildings requires the kind of skill needed to read cuneiform script. Behind the pusillanimity of Wainwright's words lies a terror, the same terror as that experienced by the ladies from Richmond. It is this terrorization of common judgement that was and remains a necessary condition of the complete triumph of the arrogantly destructive architect.

[33] *Guardian*, 23/04/15.
[34] Ibid.

Michael Bussell

The Changing Profession
of the Structural Engineer

Introduction

For almost half a century I worked as a structural engineer. During that period, sadly, my chosen profession has not escaped the blights of commercialism and fashionable novelty that have infected so many aspects of daily life, conduct and thought in recent decades. Recent changes in our culture have impinged on the profession of engineering, so that, while it still demands technical skill and experience, it has become a more openly commercial activity. Most engineering consultancies today operate as limited liability companies or practices, whereas they used to be partnerships practising with potentially unlimited liability. Advertising and bidding for work on the basis of competitive fees are now normal, when not so long ago they were forbidden. And technical changes have transformed the structural engineer's daily working life—I need only mention the computer.

Set in the broader context of general moral and cultural decline (particularly in the West), these changes may seem unimportant, affecting an area of life which is little known to the general public. But despite this relative obscurity, they may be significant as typifying the character of all-pervasive cultural transformations. I shall describe their consequences as I see them, having first outlined what structural engineering involves, and tracing its evolution and that of its institutions.

What is Structural Engineering?

The design of all but the simplest building, bridge or other structure will today involve a structural engineer. While we have stronger materials and superior methods of construction than ever, their effective and economical use still requires knowledge, skill and expertise, in a task that was for many years simply and well defined by

the Institution of Structural Engineers on the Contents page of its journal *The Structural Engineer*:

> Structural engineering is the science and art of designing and making, with economy and elegance, buildings, bridges and other structures so that they can safely resist the forces to which they may be subjected.

(It may be significant that this definition no longer appears in that journal.)

It is indeed both a science and an art. It demands economy and (wherever possible) elegance. Safety is paramount—the safety of all who engage with the structure as occupants, users, passers-by, construction workers, or whatever.

The Evolution of the Structural Engineer

From earliest times, buildings obviously needed a builder, often with no other talent involved. In due course arose the engineer ('one who contrives, designs, or invents'—*Shorter Oxford Dictionary*: significantly, the word shares a root with 'ingenious'). Engineers were needed to scheme and construct larger structures, particularly in the military field. Before the advent of iron in the late 18th century, basic building materials were stone, brick (either sun-dried or fired) and timber. Builders (including stonemasons and carpenters), and talented architects such as Wren at St Paul's Cathedral in London, drew on experience and precedent to ensure that masonry and timber members of adequate dimensions and strength were used. The role and contribution of the architect had not yet differentiated itself from that of what we now call the structural engineer. In these circumstances architectural invention could be deeply informed by an internalized or intuitive understanding of structural requirements and possibilities.

This changed when cast iron, stronger than timber, became available for buildings and bridges from the late 18th century, followed later by wrought iron. Cast iron was a key product of the Industrial Revolution, which also saw the development of multi-storey textile mills packed with machines and of multi-storey warehouses storing valuable materials, together with the construction of new canals, turnpike roads and bridges (and later railways) to improve transport. Producing safe structural ironwork, economically, required a more numerate understanding of material properties and of loads to be carried, met initially by the technical knowledge of ironfounders and civil engineers. Some of these had begun as millwrights: all were practical men. (The qualifier 'civil' distinguished those who were not military engineers.) The Institution of Civil Engineers (ICE) was founded in 1818, some years ahead of the Royal Institute of British Architects (RIBA) in 1834.

Structural steel and reinforced concrete superseded iron towards the end of the 19th century, further increasing the need for engineers with specialist structural skills. The ICE — as a largely gentlemanly establishment — did not initially welcome engineers who worked 'in trade' for specialist concrete contractors, so interestingly it was the RIBA that encouraged formation of the professional Concrete Institute, in 1908. In 1922 this was renamed the Institution of Structural Engineers (ISE), covering all structural materials and recognizing this distinct profession.

Recent Changes in the Structural Engineering Profession

Professional structural engineering has changed significantly in the last half-century. A profession is still seen by many as 'a vocation or calling, esp[ecially] one that involves some branch of advanced learning or science'.[1] Yet with changes in the regulation and conduct of structural engineering a practitioner is arguably now 'professional' more in the sense of 'engaged in a specified activity as one's main paid occupation'.[2]

Professions have traditionally operated within established ethical rules. The reward motive that drove 'commerce' and 'trade' was subservient, so that fees for professional building design services were set by a self-regulating consultancy association, being calculated as a percentage of construction cost, or based on a prescribed hourly rate for advisory work. Structural engineering consultancies were obliged to practise as partnerships, with potentially unlimited liability for the consequences of their actions, like other professionals, and fee competition was not permitted. That is how matters stood when I started work in the mid-1960s. The idea of advertising was anathema — literally unprofessional — as was the active seeking of work (known derogatorily as 'touting'), or of offering to work for a lower fee than the established level. Infringements of these rules brought disciplinary action.

More recently, the questionable view that providing professional services could be equated with selling cars or tea-bags led to an official judgement that this approach restricted competition, and so was not in the public interest. Nowadays, structural engineers — like architects, solicitors and other professionals — can operate with *limited* liability as partnerships, or indeed companies. Fee competition is often now a key consideration; indeed, clients commonly invite what are in effect

1 *The Concise Oxford Dictionary*, 8th edition, 1990. First definition given.
2 Ibid. Third definition, giving the unappealing example of 'a professional boxer'.

tenders from individual consultants or from design teams, with the fees quoted being a significant factor in the selection process. While this can be seen as good for the client (soon, perhaps, like passengers on trains and buses to be known as 'customers'?), and engineers remain duty bound to provide a competent service, I fear that some professional ethos has been lost too.

Changes in Professional Engineering Institutions

The traditional role of a professional institution has been to establish and maintain ethical standards of conduct, and to act as a learned society in promoting and sharing knowledge in its field of endeavour, all for the public benefit. As such, it can be seen as mirroring the state of its represented profession.

Nowadays the ICE and ISE still rightly maintain qualification requirements for civil and structural engineers respectively, and over-see standards of conduct, but have also become more openly involved in wider public affairs. Perhaps inevitably and perhaps understand-ably, contemporary issues such as climate change, sustainability,[3] reducing the female–male imbalance in membership numbers and 'diversity' are often addressed. But some changes have occurred that to me are manifestly unwelcome. The most visibly significant are the abandonment of engineering papers to be presented for discussion, and the 'revamping' of institutional journals.

The regular publication in journals of engineering papers ahead of presentation and discussion at open meetings, with the discussion sub-sequently being published (often *verbatim*), was always seen—or until recently, it now seems—as an essential part of the institution's role as a learned society. The papers were often lengthy, and so were the discussions that ensued: often quite vigorous and critical, allowing alternative ideas and opinions to be aired. Knowledge and experience were thus shared, debated and disseminated, a procedure which aspired, at its best, to F.R. Leavis's conception of 'collaborative

3 I regard 'sustainability' as a 'Humpty-Dumpty' word—a word used, invariably with the bullying connotation of being indisputably either 'a good thing' (as here) or, disparagingly, a 'bad thing' (as for example 'reactionary'). '"When I use a word," Humpty Dumpty said, in rather a scornful tone, "it means just what I choose it to mean—neither more nor less." "The question is," said Alice, "whether you can make words mean so many different things." "The question", said Humpty Dumpty, 'is which is to be master—that's all."' Lewis Carroll, *Through the Looking-Glass and what Alice Found There* (London: Macmillan, 1871, reprint ed. 1921), p. 125.

creativity' in literary discussion, where response and counter-response typically take the form 'yes, but …'.

This valuable practice has now, it seems, been abandoned by both the ICE and the ISE, as far as I am aware without members being consulted. (I certainly wasn't!)

True, some papers still appear in ICE journals, although typically much shorter and no longer presented for discussion. Instead, written comment is invited under the rather 'matey' tag of 'What do you think?', and printed in subsequent issues with authors' replies; but this of course lacks the cut-and-thrust of oral debate—and unsurprisingly draws little response. A member's subscription used to include a bulky monthly issue of ICE *Proceedings* covering all aspects of civil engineering. This has been replaced by a slim quarterly issue containing short papers, often with colourful illustrations occupying more space than text. The booming quasi-industrial expansion in worldwide academic engineering research and associated publication is presumably largely responsible for the remarkable splitting of ICE *Proceedings* into no fewer than 17 monthly or quarterly journals covering particular facets of civil engineering—but available to members only at additional cost. So it is now considerably more expensive (and hence deterring) to keep up-to-date in one's own field of work, let alone in developments in the wider civil engineering field.

The ISE's journal, *The Structural Engineer*, too, has recently undergone what the BBC would doubtless call a 'make-over'. The Editorial page has been re-titled 'Upfront' in very large bold type; other similarly large topic headings and restated article titles waste full pages; and papers are replaced by 'Feature' articles (implicitly not inviting comment), where again illustrations often outweigh text.

Further evidence of how institutional attitudes have changed came in a recent ISE email to members headed 'Find new customers for just £10 per month', promoting a subscription listings service to 'any structural engineering practice looking to increase its local customer [sic—not client] base'.

Changes in Education and Working Practice

When I started work in the 1960s, the educational requirements for professional structural engineers were changing. They now segregated academic learning of theory from the acquiring of practical experience, which still seems odd to me in relation to engineering. Previously, the budding engineer started paid work and learned practical skills such as drawing, building construction and site working, while simultaneously being granted 'day release' or attending night school to study engineering theory at college. In due course the engineer gained corporate

membership of the ICE and/or ISE. But now an engineering degree became a basic requirement for corporate membership, initially of three years to Bachelor level, nowadays of four years (full-time) or longer (part-time) to Master's level, followed by practical work experience.

Today's graduate engineer can type, calculate and draw on a computer – but commonly has lacked the opportunity of drawing by hand, sketching of initial ideas and seeing construction on site. These experiences aid the thoughtful development of imaginative talents and the critical evaluation of structural schemes – essential skills in the 'art' of structural engineering. Regrettably, office work anyway now seems to be too often centred on attendance at innumerable meetings and the generation of umpteen reports and emails, with calculations and drawings largely produced with the aid of a computer. The slide rule, tee-square and pencil have been replaced by the keyboard and the mouse. And, whereas office-based engineers would formerly visit site regularly to ensure that the contractor was making a competent job of construction (giving young engineers the opportunity to tag along and learn site practice), nowadays building contract procedure makes no provision for this, as the contractor bears responsibility for implementing his own 'quality assurance'. So the opportunities to gain real practical experience at an early age – and perhaps later – are diminished.

The Client, the Architect and the Structural Engineer

The role of the structural engineer depends in part on the type of structure being developed. For buildings, the architect responds to the client's brief with a basic design, to which the structural engineer then puts a structure. The degree of design 'integration' between the architect and the engineer varies. At one extreme, the engineer just superimposes a routine 'framing plan' of beams and columns on floor plans for the architect to approve, and this is then built. More fruitfully, there could be collaboration from which, ideally, emerges a practical, economical, elegant design (or, less ideally, a 'whimsical' structure – to be discussed below).

The consulting structural engineer is customarily employed and paid directly by the client. So the design is 'for' the client, although designers must – certainly should – consider the needs of occupants, users and surely the public at large too, who will certainly see it (and may have to pay for it).

But in reality the engineer will desire an amicable relationship with the architect, both for collaborative satisfaction, and also in the hope of future work, because architects often guide clients by naming a

preferred engineer for a project or when competitively bidding for work. In practice, therefore, the structural engineer is often in the unenviable position of serving two masters.

For bridges and some other structures, the structural engineer has the key role. An architect may advise on aesthetic aspects (and design ancillary structures), but the responsibility for the basic form of the structure belongs with the engineer.

A third category of structure, in addition to buildings and bridges, is the large public sculpture, in which an artist needs structural input to turn a concept into the built reality. These are appearing more commonly nowadays, and are often commissioned to serve as 'iconic' landmarks, or may become so. (Some buildings and bridges can become iconic too—think of the Sydney Opera House and Tower Bridge.)

Whimsical Structures

While many useful structures are still designed which quietly fulfil their roles, today's digital tools also enable the visualization, design, accurate manufacture and erection of structures of almost any shape and form, to the extent that almost anything that can be sketched can be built. Construction on site will be aided by high-precision electronic surveying instruments, so that even what appears to be a higgledy-piggledy jumble of steelwork can be erected with everything in its intended position. Buildings, bridges and 'public art' can be erected which challenge, defy and even affront our intuitions of structural 'rightness' as visually presented. This includes structures whose design defies 'physical logic' — that loads, for example, are best carried to earth vertically, because that is how gravity acts.

Various terms come to mind to describe such structures (including 'perverse', 'silly', 'egotistical', 'extravagant', and others less polite), but I will here use the milder term 'whimsical'. A primary motivation for many such structures is surely the wish to attract attention—which they often duly receive, being lauded in the media (where novelty often trumps merit), and frequently dubbed 'iconic'—a term which (like many used in 'critical assessment') has lost its original meaning, and now often means 'Oh, do look at me!'. (In contrast, some structures, built without the intent to be iconic, nevertheless come to define a particular location—I have already cited Sydney Opera House and London's Tower Bridge.)

Why design a slender tall building that steps out on one side half-way up? The Beetham Tower in Manchester, at some 550 feet (169 m) high, is the tallest residential building in Europe, with a hotel occupying its first 22 floors, then a bar, and above that a further 23 floors of

apartments. The really notable (and to me disconcerting) feature is that at mid-height one long side of the building *steps out*, so that end-on it looks like an inverted capital L with the cross-stroke being half the height of the upright. The structural engineer was clearly exercised to ensure that the foundations were designed to accommodate this unbalanced 'top-heavy' profile, adopted, it seems, to accommodate upper floor apartments that needed more width than the hotel bedrooms. Why the step-out was on one side only would need the architect to explain; stepping out equally on both sides would at least offer loading symmetry, and visually be less disconcerting. To me, it just looks wrong.

Or why design a building to be supported on columns that are randomly inclined out of the vertical, or that are cranked at mid-height? The former can be seen in the Palestra Building in Blackfriars Road, London, while both angled columns (in Melbourne and Toronto buildings) and a cranked column in a building in California are illustrated in a recent 'Feature' article in *The Structural Engineer*.[4] Its author (an Associate Professor of Architecture, though with engineering qualifications) appears to argue that such columns are to be applauded as endorsing his paper's theme, that structure can reinforce 'design concepts and qualities'. I'm unclear what that means: surely structure is there principally to hold things up safely. To me, such columns defy common sense, by ignoring the widely-known fact that gravity invariably acts vertically downwards—it does not wander off in other directions, or crank out and then back again. They also cost more, and impinge more on useable floor space, than traditional and simple vertical columns. And, again, they just look wrong! One wonders how the structural engineers for these projects felt about being asked to design them.

Similarly, why design a hanging bridge deck with its supporting cables not aligned vertically above the loads they have to carry, again disregarding how gravity acts? Yet, in recent years, numerous bridges have appeared in which the cables, and the arch or towers that support them, have been consciously angled out of the vertical.

An early exponent of this approach is Santiago Calatrava, a Spanish architect-engineer who, perhaps significantly, had instant appeal for architectural students that I was tutoring in the mid-1980s, well before he came to the attention of most structural engineers. Such bridges may be eye-catching, even 'iconic', but their structural design is more

4 Andrew W. Charleson, 'Structure as reinforcement of design concepts and qualities', *The Structural Engineer*, 91, 12 (December 2013), pp. 16–22.

complex, and construction is both more difficult and more expensive than for an orthodox bridge.

An example nearer home is the Millennium Footbridge across the Thames in London, its design a collaboration between an artist, an architect and structural engineers (in that order, it would seem). The bridge has three spans, the middle span being the longest. Instead of suspension cables hanging vertically and being supported on towers located above the deck, as in a conventional suspension bridge such as Brunel's Clifton Bridge in Bristol, on this bridge they are tilted to lean sharply outwards. Indeed, at midspan, they hang lower than the deck itself, in order apparently not to obstruct pedestrians' views of the river. (Have you ever felt your view outwards was obstructed by the cables when walking or driving across a suspension bridge? No, I thought not.) The bridge opened in 2000, and was at once popular. However, when large numbers of folk walked across it, unanticipated and disconcerting sideways swaying occurred. This was investigated and was solved at some cost by the fitting of 'dampers' to limit this motion, on the same principle as car shock-absorbers, and the bridge returned to uneventful use. Being whimsical can sometimes make a structure's life difficult.

Commemorative schemes and grand public projects offer further opportunities for whimsical and 'iconic' structures. The ArcelorMittal Orbit, a tower, was erected on the East London site of the Olympics in 2012, conceived by an artist and realized with the help of structural engineers. Reportedly, most of its cost of around £20M was funded by Lakshmi Mittal, head of the largest steel-making company in the world, although some £3M was voted by the Greater London Assembly (i.e. came from London taxpayers). The tower comprises a central steel 'trunk' housing lifts, stairs and a high viewing platform, surrounded by what has been described as a three-dimensional knot of looped steel elements (none of which appears to serve structurally). At 374 feet (114 m) high, the tower is the tallest sculpture in the UK, somewhat taller than the Statue of Liberty and six times taller than the Angel of the North. As a structural engineer, I personally find the Eiffel Tower in Paris more pleasing. Built to mark the centenary of the French Revolution, its concave tapering elevation was chosen by its eponymous and very capable engineering designer as a functionally very efficient profile to resist wind forces. And certainly it now says 'Paris'!

Whimsicality and the Need for
Effective Structural Criticism

Why conceive and build such structures? The question is not rhetorical and needs to be answered, because it seems to me that more structures

that challenge logic, gravity and what looks 'right' are being conceived and built nowadays than in the past.

Perhaps the most understandable motive is to create what will serve as a landmark or 'icon'. The Angel of the North, for example, is undoubtedly a popular landmark. It offers a tempting target for the wind to overturn, by exerting pressure on its huge outstretched 'wings', and thereby certainly tested the talents of the responsible structural engineer.

Or there may be the sincere desire to create a design that is truly innovative, outstanding and remarkable. Innovation is healthy, but only when it works—the Millennium Footbridge comes to mind. The designer might be seeking to give the client not only more than was expected, but more than could have been expected. That may be a worthy aim, but I have difficulty in thinking of an example that did not in the event cost a great deal more than the client originally expected, and did not go through a protracted and painful gestation. A successful and satisfactory structure is more often achieved by following the acronymic advice KISS (keep it simple, stupid).

Less worthy is the desire to produce a 'look at me' design, to attract the attention and, it is hoped, the praise of architectural critics, competition judges and awards panels. This may be criticized as merely egotistical, novelty-seeking or both, but such plaudits carry weight, enhance reputations and bring future commissions. Too often, desire for the unconventional and the novel outweighs consideration of structural sense.

Although awards for structural achievements are given annually by engineering institutions and others, there is little or no reasoned discussion, public or so far as I'm aware professional, of their merits, and novelty often seems to have trumped structural logic. There is surely a strong case for reintroducing such rigorous discussion as I have described above under the auspices of the professional institutions and in the professional journals. Structures would be assessed in terms of functionality, economy and elegance. Even better would be joint discussions with architects, in the hope of diminishing the effects of that separation of roles inevitably following from the highly specialized nature of the engineer's knowledge and expertise.

Conclusion —
and a Dilemma for the Structural Engineer

I have tried to show how, like it or not, the meaning of professionalism for the structural engineer has changed in recent times to become more openly commercial. The engineering institutions have changed, and so too has working practice, with digital technology now making possible

the realization of structures that formerly would have been utterly impossible.

A particular and to me unwelcome consequence of this is that the engineer may feel under pressure to agree with—rather than to challenge—an architect or artist with determined ideas about structural form, even if to the engineer these appear (at best) to mask an imperfect grasp of sound structural principles.

The structural engineer has moral obligations which, even in the fulfilment of a contract, are not exhausted by the terms of that contract or by the need to satisfy a paymaster, just as a lawyer, for example, has an obligation (whether or not he honours it) to uphold the rule of law, even as he acts in the interests of a client. This wider social responsibility is an essential part of what has traditionally been understood by professionalism.

Nowhere is this more obvious than in the context of large-scale building projects, where the overwhelming majority of those most affected by the outcome are not the paymasters and have no say whatsoever in what is done. Where these projects involve whimsical, megalomaniac or merely silly proposals, they may well be loathed and resented by most of those whom they affect. Since the possibility of realizing almost any architectural whim is entirely dependent on his services, the structural engineer is therefore placed, at least potentially, in a position which challenges the moral obligations of professionalism. Do such obligations retain their force?

Brian Lee

The World in a Form of Words
Art in the Community

i

Here, as Elsewhere

Hexham is not the smallest town on the 'Hadrian's Wall Line' between Newcastle and Carlisle: on fast trains it is sometimes the only stop, apart from the 'Metrocentre', a gigantic shopping 'facility', one of those intolerable places we tolerate … but still a little way from the centre of things, a nice town—with a grade-II listed station, 1830s ex-North-Eastern Railway, built when locomotives were works of art, beautifully kept with flowered platforms (just *bizzie-lizzies*, etc. though) and where our local ticket-office manager, 'gurning' at you like Les Dawson, can always get you a cheaper fare than the elderly can find on the feared internet, where so many people seem to more or less live now—in it and of it, too.

We are in a well-tended waiting room with clean toilets, comfortable seats, newly-painted, six people waiting silent, two reading *Metro* —you know *Metro*, you can't get away from it, the free daily paper with deliberately horribly-punning headlines; part of our daily culture, thick with adverts interspersed with news stories (*that's* News?) 'written' in the most limited 'English' (why do those words want to go into inverted commas?) that could be called writing, by people who say they *are* writers. As if there were any connection between what they do and the art of Writing that this is trying to be. Can you feel it *trying*?

No point in writing otherwise, this I thinks—even bad *real* writing has a connection to an idea of Art. Bad Art and good Art, if they are art, are culturally of a piece. Otherwise you are just doing it to make money (at least you are putting that first). Consciously or unconsciously. It might be your job (speaking as an ex-hack). … But if you do what sort of Art is possible?

(Art for my sake, said Lawrence. I'm always looking for a bit of real art, me. I need it.)

······

There are continual caring announcements as we wait, very audible, probably digital, voices: *watch your bags*, or someone may blow them up, keep back from the edge of the platform in wet weather, do not cross the lines elderly! disabled! on your own, someone will help you, someone will guide you over the bridge if you need help, if anyone is available ... and Northern Rail, 'in conjunction with' the Unions, have 'joined forces' to make this a (squawk) something-free zone; they are committed to protecting their *operatives* against assault, so they ask everyone to be *nice* to one another ... missed the next bit by laughing, yes the word was actually used ... *Nice.*

(You can't get away from a certain form of words, nowadays: the noise of caring, the noise of informing, the noise of selling. A friend once said that the Quiet Coach he had booked into would have been quiet if only the guard, *train-manager* sorry, restaurant manager, ticket collectors, had shut up, telling the 'consumers' about everything they could consume — and the apologies, how humble the poor employees are taught to be! Repeating their anxious formulae ... *We are now arriving into* — not *at.* Any problems see *myself* or a colleague. Not *me.* They must have to go on a course for it.)

It's in the air, as they say.

Turning to the very well-dressed middle-class lady who has joined 'one' in a smile, this *customer*, not passenger (get the register right), your present writer, says to her:

'So there, you'd better be nice to me, 'cause I'm going to be nice to you, even if you don't think I'm being nice.' To which she says, very firmly, with asperity 'I am *always* nice to everybody'. Another very nicely dressed nice lady laughs. My wife almost expressionless. I keep telling her women are much nicer than men, as the poet said. (Guess who for ten points.)

All very admirable, nothing is not thought of, caring and com-passion literally in the air (we also have a shop, no, a 'Centre' for that, even in Hexham, it goes with the Buddhist monastery up in the North Pennines: it says: **Kompassion Centre**). Think how much thought has gone into doing things professionally-correctly-properly, by Northern Rail. Nothing to be said against it. You took the words out of my mouth.

All this, this *I* is a part of. The words that go in his ears (and eyes) and round in his brain affect him-it. The form of them makes him conform.

So *it feels.*

(Strange person to think in this form (he does feel strange, a lot of the time, these days) thinking how many meanings the word *nice* has. How it is right at the heart of things. An economic word (look at that nicely dressed lady sitting there) a necessary word. That blends money with manners. As if always there. At the back of everything. Inevitable. More meanings than 'God', maybe.)

······

While we still wait, this same traveller (customer, consumer) now sees a collection of **ART** on the wall of the Waiting Room, in a setting of words of information and explanation, visual 'noise' surrounding a small group of drawings and paintings, with a headline:

PROMOTING YOUNG PEOPLE'S ARTWORK IN THE COMMUNITY

> ... these examples ... produced by young people across the North East Region ... are images selected through Northern Rail's latest community initiative ... with the aim of promoting a feeling of worth among young people through seeing their own artwork used in a positive way ... this enables your organization to demonstrate a commitment to helping to promote the well-being of the community in which you operate ... or do business ...
>
> If you produce posters ... or use a website for local community communications purposes then artwork produced by youngsters could be used as part of your design policy ... to illustrate point of sale advertising ... promote your services in advertisements or newsletter form ... Seeing their art ... used in the community would meet the need of most young people to make their mark in a positive rather than negative way ... in the community ...[1]

Even this I (remember the days of your Youth!) is able to find a better self within himself seeing this, a feeling of expectation in the conjunction of Youth and Art, gratitude to those who have done what they have done, NorthernRail.co.uk, out of goodwill, to encourage, and guide, and, er, *organize* towards ... fulfilment of talent. To make their mark. (You know what the Gospels say about talent.) And there is talent in what faces the observer ... a freshness and eagerness to please of young people, that you see in children, a form of hope for their lives, a *form* for them. One of them could draw, much better than this watcher ever could, this *critic*, who has always wanted to be able to

[1] Display at Hexham Station, Northern Rail, Winter 2016, 'in conjunction with local business'.

draw, much much more than this write, write, *write*. If only you could draw, had the eye, everything could follow.

But. (Something else speaks there as well. And the one thing doesn't go with the other.)

······

You see writing — no, 'writing' — like that, every day, you've just been *hearing* it … to the extent that you *don't* notice it, or you just notice what it says (the 'message') without at all registering the form of it. And if you don't think about it, it is part of you, you are in it, it has seeped into you — one or two people I've come across seem to be entirely made up of it, are the very form. The present Secretary of State for Education and the Under Secretary at the Department of Culture, Media and Sport (what an interesting conjunction), in Mr Cameron's Government (two women I'm sorry to say) Nicky and Tracey, are perfect examples. Being perfect is what they try to be. They dress carefully. And they talk: *Nice.* By talking this way they have got on and become Successes. They think they are literate ('talk the talk and walk the walk') and are there to teach others to be like/what they are. (That's what they call 'the subtext.') It is a de-natured form of words, and so they, however *nice* they are, are denatured too in their own words, which have no relation to literary or cultural form. It's worse than the hacks write. (The other available form.) The people who think it have only one instinct, this I, *one*, has another. So continually he comes up with a *bump* against an invisible wall that seems to mark him off from so many of his fellow-men, who now speak English as if it were a foreign language. Entre-preneur-*Nice*.

So now I, *this* I, this *he*, is staring at that example of that language — at that strange idea (strange to him, not to them) about 'using' 'artwork' in a 'positive' way.

The three letters **A.R.T.** seem to be void of all meaning. Bump. It might as well be *nail*, a thing secondary to another purpose. **NO POINT IN ITSELF.** Use it. But/And *what* could be the *negative* way in which art could be used 'in the community' — would Francis Bacon's, or Rothko's be such (struggling against nihilism and despair and form-lessness … revealing them) or Banksy's slick graffiti, or more likely, the 'kids' 'doing' their 'stuff' under Network Rail's bridges or over their carriages? Ah, perhaps a touch of fear there, fear on the part of 'Authority' (the rail companies working in cooperation with the rail-way police) of the disaffected young, or of any art untied from a particularly limited sense of the word 'community'.

(I must be disaffected too. Needing Art to ease my disaffection.)

······

It's as if this I is having a little epiphany (Joyce's use). A strange feeling comes over you, of seeing Everything in something seemingly trivial … The World in a grain of sand? In your eye, mate. Does your head in, more like, standing with the same sinking of the heart, caught between two impulses, cancelling each other: waiting for that train, the world telling me to be nice, trying to think nice thoughts, but helplessly thinking those that are not-nice, thinking that the intentions of my fellow man are good but that *me,* he doesn't do nice, and wondering whether whoever uses words like this, thoughtlessly, without mind, just words coming out, as if without real human intervention, coming from somewhere else, rattling down the shining chute, and all day long—do 'these people' realize what they are *really* saying? Language as coinage. Rattle, rattle, rattle.

What is going to be the effect of such a context of speech-acts upon the young people who hope to be artists (maybe in words too); what is the future of Art and art-speech, in a society that talks like this? I've heard their teachers use it, the educationists, the inspectors from Ofsted. Through the thin skin of good intentions, the essential motive sticks through like bone: a skeleton of not-quite-even clichés, collocation upon collocation, habitual formulations, hackwords, and caconyms. If the ear is deadened, what will happen to the eye? The sensory system battered by the media? Authority (the authority that has no authority anymore)'s unconscious fear of the Power of Art, of the individual, present in its attempts to incorporate it. It denatures and begets a distorted form of Art, of the Margate Express, the Chapman brothers, Martin Creed sniggering 'I don't know what Art is', Gormley (whose confused idea of public statuary stands just down the Northern Rail line, the Angel of the North, 'iconic')—'Artists' who have already been incorporated into the money-success-Prize-system via The State itself: *state-art* … And at the top of the pile Hirst. The skull covered with diamonds. Formaldehyded sharks. True statements about themselves, not Art. The State in the language, nothing-but the Economy, nice little earners for the Nation, via international global celebrity. Moral consciousness present in cynicism.

Poor young people, to have this around them: the example of 'the Margate Express' as the Professor of Drawing at the Royal Academy!

......

To go back. Backwards and forwards. Here are the essential words from above

Promote (3) Produce (3) Policy Positive Purpose Select Initiative

They tell you what **Community** is, *now*. The one word is defined by all the others: a mental concentration-camp.

When you have attuned yourself to the sound of them, though you hear and do not listen, switch on the radio for a few minutes, pick up your *Metro* and listen to the hum of it ... the words with always at the back of them the same thing, more ps: **process, procedures, professionalism**. Leading to ... **success.**

The material world working upon Art 'producing' the art we have.

And add further what is behind them, in further recession? All the **Ms.**

Material well-being. Money. Management. (Skills.)

And what is behind that?

The economy (stupid).

The mechanical organization of next to nothing.

This is the 'Community' this writer is in, mentally speaking, you can see it in the way he writes this, alas. He recoils ... the form of things, what it does to people, the young particularly.

......

Now the train for Carlisle comes in, and the likeable ladies, this unlikeable 'I', board it, setting off through the beautiful countryside along the upper S. Tyne, among many passengers plugged into their own ears, eyes fixed on Kindles, reading the papers, playing computer games, not noticing one another much, not-talking, not much using words, separate, warm, comfortable and some being nice to each other. One notices when one doesn't want to, thinking thinking thinking ... in the wrong form?

Even brooding on those things there and then in the waiting room, on the train, now here on the computer, makes this me feel guilty — to be read by kindly-meaning people? Don't want to upset *you*. Surely this *is* a benevolent society? ... Yes-but, no-but, but: is there not something behind it ... And now the words start going into inverted commas again: 'benevolent', 'kindly', 'art', those latest 'novels' and 'poems' I try to read, hear about from the culture-hacks, and try again ... As if the two sides of my old brain were at odds. All these clever people rattling away as if everything's all right. *Really.*

And if one were to meet the person who wrote the few words on which all this depends, you'd find s/he was 'enthusiastic', 'excited' by this 'initiative' (ah that's the word) ... doing good.

ii

The way the mind goes, is it going too far? Is this going too far?

Remember that scene at the beginning of *The Graduate,* with Dustin Hoffman, where the disoriented young man, going to be *successful,* just finished 'uni', swimming blindly about in goggles and flippers, in the huge family Californian wealthy-bourgeois swimming pool (*lovely* house, *lovely* gardens!). In the soundless warm water (all done with Art by Mike Nichols) ... then introduced to a large rich drunken *suit,* to have the hand come down on the shoulder like a weight and the voice snarl: 'I just wanna say one word to you ... *Plastics* ...'

There's a whole culture, just in that. Well-meaning? or 'well-meaning'? The whole of America. Good guys. What art, now? Art or 'Art'? Product: Jeff Koons. (And see David Foster Wallace, *A Supposedly Fun Thing I'm Never Going to do Again* on the state of America its Art and language.)

......

Jump: now to Mr Saatchi. Another wealthy benefactor, to and of this world and culture, yes; letting us all in free to his gallery off the King's Road. It is very *nice* of him, isn't it? Well, er ... better just talk about the art, not the man you have just read about in the world governed by Murdoch and Marketing-speak. This I has been in several times, while his wife and daughter window-shopped on the King's Road. (There are some really interesting phenomena in the shops there. A rich collection of human character.) Can't say it is *all* bad, yes, *interesting* — but is the *not*-bad, good? Or is it ... IT, at all? The words present a problem. Another little epiphany! Good or 'good', bad or 'bad'? Perhaps one is just jealous of the Successful and the Moneyed and confused by loathing of the celebrity-world. Fair enough. You can come to *hate* them. 'Nice' people. Because the produced Art is mostly only *what is called Art*. Mr S. has just sold Tracey's bed ... and he is part of the cabal that governs the distorted art-life of 'this Great Country' (Mr Cameron) which is-to-be-made-great-again. An associate of 'Sir' Nicholas Serota of State-Tate. Strange that such social forms should be able to affect the form of all art, as they do ... the Blairish faces of neo-everything, surely it's all a bit mad. Me too.

......

Back:

The form of language on the wall of our Hexham waiting-room isn't discontinuous with that world down there in the Great Global Media-Metropolis. We know the same things in the same sort of way. The 'media', social and all—twitter-twitter, tweet, tweet, tweet—is there when it is not-there, in the words in the air. It *makes* the form of the 'culture'. The State itself is now governed by It, the politicians are mere parts of the dance to the music of Murdoch; and our Arts Council tells us, pouring money in to whatever will justify itself, that it is doing what must be done ... here come all the **Ps** again ... **positively professionally promotes produces** ... (art must stimulate the economy) and **delivers** all sorts of things, even its own forms of human being like that Miller woman who fiddled her expenses, and Trace again, who has become a Cameron-admirer now she's rich. And don't any forms of excitement and notoriety bring in tourists and investment, and profits for Sotheby's and Christie's to this great city (Boris calls it endlessly) and all that sort of people, which will 'trickle down' (a lie) (with no other effects?) (but pushes up house prices), that sets the tone, distorting and deforming ... publicity, jobs, jobs in publicity, PR, jobs, marketing jobs (I've just come back from Scotland, and in Edinburgh at least, the country is a brand) more, more, more—curators, the President for Life with his gritty, steel-rimmed determined look, who never admits to anything. It *must* be exciting, or it won't get in the papers, and people won't come to the Tate (and pay £9.25 for a pint of lager); it all must be kept up, and stimulated. The media is the top of the Economy. There's the treadmill. You are on it. We're all on it. The Arts are an industry, the artists figments of it. A bit like footballers. (Except there are many who do it just for love.) But the young today are easily misled.

Has this I gone too far in deriving this state of the world from a randomly encountered collection of words?

Politics, Values,
Education and Language

Duke Maskell

British Values

Nobody used to talk about our values—'British values'—less still to say, like George Osborne, that we're proud of them. That was the way Americans talked, not us. (Waitrose too. It shares its values with its suppliers—and trusts that its customers think they compensate for its prices.) We might, or might not, be proud of the British Army or the British Broadcasting Corporation. But British *values*?

We didn't even have any until 14 January 2006, when Gordon Brown discovered them in a speech to the Fabian Society, 'The Future of Britishness'. Mr Brown found three—Liberty, Responsibility and Fairness—and that they were core. But nobody took much notice (except, of course, in derision[1]) until 7 June 2011, when the Conservative-LibDem Government gave them a massive boost in its *Prevent* strategy. The anonymous writers of *Prevent* couldn't locate responsibility or fairness but (perhaps under the influence of the Equality Act 2010) found lots of others, including equality of opportunity, freedom of speech, gender equality, equality before the law, tolerance of other cultures, rights of different faith groups, right to live free of persecution, encouraging participation and interaction, full participation, universal human rights, the rule of law, democracy and (under the influence of Ali G) respect. And whereas Mr Brown's British values were only core, those in *Prevent* were also fundamental or mainstream.[2]

1 Roger Scruton, 'Values are not learnt through teaching', *Daily Telegraph*, 16/05/06.

2 https://www.gov.uk/government/publications/prevent-strategy-2011.
Prevent is a politico-bureaucratic prayer wheel, from which the Government spins meritorious incantations, chants, mantras. It may not be inscribed with the eight auspicious symbols but—*Om! Om! Om!*—it has the four fundamental values, the four forms of pupil development and the five esoteric regulations. It makes knowable to the Faithful what only the Faithful may know: 'Over the life-time of this strategy, the Department will raise awareness of the parallels between *Prevent* and safeguarding guidance and procedures for adults and children to promote gradual mainstreaming of *Prevent*.' It's got questions to stump the Buddha himself: 'Is the standard relating to spiritual, moral, social and cultural development of pupils, together with the five regulations underpinning it, fit for purpose?' Who

In *Prevent*, human rights were just as much a British value as the rule of law but that was, of course, when the LibDems were influential in government; and, by the time Statutory Instrument 2014/2374 was introduced, they were on the way out, and human rights with them. The Instrument fixed British values once and for all, as democracy, the rule of law, individual liberty and mutual-respect-for-and-tolerance-of-differences, and as fundamental not core or mainstream.[3]

They may be only four but what uses they can be put to! The Queen of Hearts used flamingoes as croquet mallets? Pooh! Our Queen's Government uses British values as a Counter Terrorism Strategy, as Spiritual, Moral, Social and Cultural ('I think that wraps it up') development for schoolchildren and as a payload on its missiles (which gets us our *mojo* back and has us walking tall again—see below).

These wonders are to be achieved, firstly, by actively promoting our values in schools, by law. Not by *enforcing* them, quite—which might interfere with promoting the values of liberty and tolerance perhaps—but by enforcing the expectation of the promotion of them. And this enforcement by law of the expectation of the promotion of them will not only wonderfully develop children but also prevent them from turning into terrorists who blow us up or chop our heads off.

And our values are not only to be 'promoted', like a brand, at home, they are also to be 'projected' abroad, not merely like missiles, but *with* them, as an additional payload. (This is value for money in the Time of Austerity.) According to Mr Osborne—and the journalists who (without ridicule) report him—having a carrier force of 28 F35s (not yet bought) flying from two aircraft carriers (not yet built) will enable us to project abroad not only our power and our influence (I mean, these are arguments *any*one's going to listen to) but our *values*: 'Britain's got its *mojo* back. We're out there and proud about our values and project them. Britain's out there on the world stage projecting its values, protecting its people and walking tall again.'[4] Wow! That's talking the talk, man! And (when we've actually *got* the planes and the carriers) won't

can say? *Om mani padme hum*, ho-hum. (SMSC development, by the way, shouldn't be confused with PSHE provision.)

3 http://www.legislation.gov.uk/uksi/2014/2374/pdfs/uksi_20142374_en.pdf (last accessed 10/05/16). The beauty of Statutory Instruments is that they don't have to be debated in Parliament.

4 American Hero, in his 20/11/15 'Spending Review and Autumn Statement' and, three days earlier, talking to the BBC and *The Sunday Times*: www.gov.uk/government/speeches/chancellor-george-osbornes-spending-review-and-autumn-statement-2015-speech; www.bbc.co.uk/news/uk-politics-34893614; and www.thesundaytimes.co.uk/sto/news/uk_news/article1636101.ece (last accessed 10/05/16).

we be just walking the walk too? On stage, strutting our stuff, ripped, pumped up and smelling of Lynx. A TG Britannia for the 21st century. (But how funny that the values this Britannia projects from her F35s should be tolerance and suchlike. Good job it's not universal human rights too.)

One of the troubles with the phrase 'British values' is the word 'values'. Firstly, it is too conveniently vague, naming a class you can expand or contract as you please. *Prevent* contains many more 'values' than the Statutory Instrument but all in the same narrow range. What about all those that aren't there but have as good, or bad, a claim to be there. Things ranging from kindness or a sense of humour, say, to economic growth. (No one on dating sites ever says how important democracy and the rule of law are to him.) Websites for 'German values' (like punctuality, organization, politeness) do far more to justify their lists than the British Government does to justify its. Does that mean rationality is more of a German than a British value? And why are the four fundamental British values so comparatively paltry? What, for most of history, would have been everywhere accounted the truly important 'values' — such as Truth, Honour, Justice, Love — are all missing. Take, for instance, the choice of 'the rule of law' over its rival 'justice': was it love of the rule of law and due process or of truth and justice that kept those Liverpudlians protesting for 27 years about the causes of the Hillsborough disaster? Isn't the rule of law perfectly compatible with injustice? Wasn't it in the USSR and Hitler's Germany? By comparison with justice what the rule of law comes down to is the rule of lawyers. How much do you value that? What would you sacrifice for it? Hadn't those Hillsborough protestors had *that*, long before 27 years was up? But, queerly, it never satisfied them.

And then, although the value of something, of a diamond ring, say, or a human life can be plain enough, once make the word grammatically countable and it becomes treacherous. Once, like the Government, start counting your 'values', as if they were — as the military say — 'assets', like so many F35s or dollars in the reserves, and the word transports you into a wonderland on the far side of the looking glass. Created out of some strange confusion, it leads to other confusions stranger still.

Yes, we live as if we value some things above others but saying so isn't at all the same as saying we 'have values', less still ones we can list, count, project and take pride in or (if you're American) vote. What we show ourselves to value when we exercise our judgement and taste, or choose one course of action over another, isn't a kind of *thing*, abstractable from our judging and choosing. The sum of what we value isn't a list of items, in which each item is a criterion, available for

scrutiny (and valuation) out of the only element in which it can have any existence. What a strange thing it would be if it were, a value which, can itself, in its turn, have a value set on it: *this* value — of mine — is a good one, one I can be proud of, *that* value of yours bad, one to be ashamed of. For what enabled us to say so, with authority, would have to be some faculty or standard of judgement which itself had, and therefore was, a value. Our list has become a hall of mirrors in which our values stretch away in infinite regression.

The word 'values' is one of the things wrong with that phrase. The other is 'British' — it being a word that the British themselves are, mostly, I should think, a bit shy of. We are 'Brits', for instance, only to Americans (and to British actors wanting to suck up to American film producers). There's 'The British Grenadiers', of course, but that is early 18th century, so the grenadiers in question are probably as much Hanoverian-German as British. The word is too closely associated with the state and its reasons for it to speak to the peoples of Britain of their closest national loyalties. The English, Irish, Scots and Welsh alike all like to see the British Lions beat the Wallabies or the All Blacks (when they can) but that has more to do with loyalty to England, Ireland, Scotland and Wales respectively than to Britain. And this makes for a certain awkwardness when it comes to saying whose these values are that Mr Osborne takes pride in.

As there isn't a British language, *are* there any British, as opposed to English, values? As these British values of ours are expressed in English, perhaps they ought to be called English values. Where are our common values to be found, if not in the language common to all, in its use by Irish, Scots, Welsh and English? Which is English.

But if we said that what we're proud of is our English values, that, nowadays, would certainly offend the Irish, Scots and Welsh and it would suggest to immigrants that in coming here they were engaging to put off a character of their own and take on a foreign one, one with a definite content to it; whereas they might be British and remain ... well ... what *not*? A multicultural England is, if not a gross untruth, an obvious piece of wishful thinking, but a multicultural *Britain* has associations of rainbows and harmony. So — for harmony's sake — we associate the values we are proud of not with the people whose language we speak of them in, the English, but with the British state and its reasons, its laws, its administration, its political structures — upon which we can project, perhaps, any character we like and to which our loyalty need be only provisional and limited. Whereas

'English' denotes a character and a loyalty, 'British' ('Briton' too) need denote no more than a legal status.[5]

So we call our values British. For what the word 'British' is *most* fit for, in British English, is things that are not, for the most part, dense with cultural implication, things that are, if not all things to all men, at least many things to many men. It might be difficult for Americans to call *anything* 'American' without calling up American exceptionalism; for us, the proper use of the word British is in such phrases as British Home Stores and the British Meat Processors Association. It is a good habit of our language — to deflate the claims of the state on us. And it is a habit Messrs Cameron, Gove & Osborne want to take advantage of but only opportunistically; for if, in that phrase, 'British' diminishes the claims made on us by 'values', 'values' enlarges those made by 'British'. British values are ones that, while not too offensively distinguishable as *ours*, we nevertheless 'promote' and 'enforce' by law at home, 'project' through our military power abroad and are proud of.

But do those four so-called values sum up what is both distinctive and worth valuing in the peoples of Britain and their way of life? That they vote? And are law-abiding? Does no one else vote? Is no one else law-abiding? Were we not British when we believed in kings, kingdoms and kingship? Is Shakespeare unBritish? Did we not begin to be British until 1832? Is it unBritish to pray 'Thy kingdom come'? Ought it be 'Thy (or Our) democracy'? Were we less British in the days of the Border Reivers (now much admired on both sides of the Border)? Would we be any less British if we lost or gave up the vote in some unlikely but possible political revolution? Were we less British when we believed that only a man and a woman could marry? Or that the woman should obey and serve the man as well as love and honour him? Or when Cavaliers fought Roundheads? Or Protestants Catholics? We were undeniably *different* when we could both display 'racism' and simultaneously mock it ('Wogs begin at Calais'); were we fundamentally less British? (Or perhaps *more*?) Germany today is no less a democracy, no less ruled by law, possesses no less individual liberty and, arguably — judged by its government's treatment of refugees — much *more* mutual-respect-for-and-tolerance-of than Britain does. Does that make it fundamentally more, or less, German than it was in 1933?

5 Hence such headlines as 'Briton jailed for enslaving wife', in which the word 'Briton' is an odd sort of code (odd because there's no one who can't decode it) for, 'Someone with British citizenship but otherwise not really British at all.' The Briton in this case was Safraz Ahmed. His wife, Sumara Iram, also British, had lived in the country for four years, without learning any of the language and scarcely venturing outdoors: *The Times*, 02/04/16, http://www.thetimes.co.uk/tto/news/uk/crime/article4726341.ece.

Does it, perhaps, make the Germans, today, arguably, a shade more fundamentally British than the British? Ditto the Dutch. And Scandinavians.

For the really funny thing about 'British values' is how little of anything especially British there is about them. But how could there be if what is British about the British is looked for outside the English and the English language? Take Englishness out of Britishness and what *could* you be left with but some such list as voting rights+freedom-under-the-law+religious tolerance—things shared not just with the whole of the rest of the 'West' but much of the 'East' too, and belonging, for the most part, not to what we live for but to the political machinery that lets us live for it. Most Syrians might wish they had 'British values' but not in order to be British, only more happily to get on with being Syrian.

These so-called British values have, in fact, no special connection with the British people at all. As Roger Scruton says, '"British values", as understood by the Government, are really Enlightenment values, with no intrinsic connection to the history, loyalty and shared experience that define our country.'[6] They haven't been derived from any inward acquaintance with our way of life, at its best or worst (or even observation of it from outside); they are merely, arbitrarily, *required*, of schools, by the Government. And the Government requires these particular things to be taught in schools, all schools—the importance of being democratic, law-abiding, free and tolerant—not because the British people are, uniquely or above all else, to be described as democratic, law-abiding, free and tolerant but because Britain has a large and growing Muslim minority which includes many who, the Government fears, with reason, *aren't*.

If British values were actually derived from what the British, in their political life at least, seem actually to value wouldn't they reduce to one: growth? It's growth, stupid. In the great referendum debate, other questions than those of economic growth featured only in defiance of most of our political class. What will give us more growth? In or out? Trade deals, and the ease, or difficulty, of their making, that's the big thing. A nation which, 100 years ago, through a comparative handful of ex-public schoolboys, could govern an empire on which the sun never set and, 75 years ago, without an ally and with scarcely an army, could elect to fight on against an all-conquering Germany—and announce (just *how* unrealistically?) that its war aim was *victory*—such a nation has become one half-petrified by the difficulty of ... making trade deals. *Let us so bear ourselves* ... that we can still afford Belgian chocolate

6 Scruton, *Telegraph*, 16/05/06.

and German cars. God help us. For we no longer seem a people capable of helping itself.

'British values' has so little to do with British life that, according to Ofsted (the government bureau that polices their promotion), you can be undeniably British, unto the umpteenth generation ('of White British heritage'), and also be, at 18 years of age, of too exclusively Christian an education to understand them.[7] Or you might be British but of too exclusively Jewish an education to be (in a variation of the phraseology) prepared 'adequately for life in modern Britain'. Fortunately, Ofsted is there to help. Your teachers and governors will have to be re-educated, of course, in 'special measures', but, as long as they 'show great humility and willingness to learn' (from Ofsted), 'heed expert advice' (from Ofsted) and take correspondingly 'wise action' (at the behest of Ofsted), you will all emerge nine or so months later as well prepared for life in modern Britain as Tom the chimney sweep was for life underwater once the fairies had given him gills and turned him into a water-baby. He was cleansed of soot; you will be cleansed of unBritish values.[8] British values: now you got 'em, now you don't.

'British values' has nothing to do with the British people. It's just a government policy—devised on the quick to counter the consequences of other longer-standing policies, which have encouraged the mass immigration of people of a very different culture from our own. 'British values' is a feeble pretence by the present Government that it can shield us from the consequences of the multiculturalism sponsored by itself and so many of its predecessors. It speaks of a governing class that has lost its faith in Britain, certainly in England. How much of British life, as it has been lived for the better part of 2000 years, does it leave out? The whole of the Christian influence, for a start (that 'Christian civilization' whose survival Churchill in 1940—poor sap—thought we were fighting for): the Ten Commandments, the Sermon on the Mount, the King James Bible, the Book of Common Prayer, the Church of England. And what of English *literature* gets in? Not *Paradise Lost* obviously. *Any*thing before the 18th century? Anything after that isn't part of the

[7] http://reports.ofsted.gov.uk/inspection-reports/find-inspection-report/provider/ELS/138567, report for 26/11/14, pp. 3 and 9.

[8] http://reports.ofsted.gov.uk/inspection-reports/find-inspection-report/provider/ELS/138698, a Jewish High School in Manchester, particularly the reports of September 2014 and July 2015. For Ofsted reports on the school before it became an Academy (same school, different legal entity), http://reports.ofsted.gov.uk/inspection-reports/find-inspection-report/provider/ELS/134196 (all last accessed 11/05/16). The differences between the two sets of reports illustrate the effect of Statutory Instrument 2014/2374. My allusion is to Charles Kingsley, *The Water-Babies* (first published 1863).

Enlightenment? Anything of classic status *at all*? Nothing not of politics, and even that excludes Burke. As if the British were a people who had no character but what might be on show at a well-conducted council meeting. Who'd *want* to be British if that were all it amounted to, a sort of politicized 'live and let live' or mutual indifference? If that's all British values are, the sooner we acquire some foreign ones the better. A country has to offer its citizens a bit more than *that* if it wants their loyalty, or love; and it needs governors able to say what that 'more' might be, where found, how acquired.

The trouble with 'British values', which the British political elite invites the British people (for no one else is interested) to be so proud of, is that—unlike actual and historical Britain—it is practically content-less, deliberately so, it seems. The sum of all the Enlightenment multi-cultural virtues associated with it makes of Britain a mere geographical location of economic activity, ready to be a home to ... well, what *not*? All races, ethnicities, customs, religions and no-religions, living together in, it might be said, from one point of view, peace and harmony or, from another, mere indifference to their differences. It's an ideal of Britain as a nothing-in-particular, an incoherence, yes, but, we are to think, not one that will come to bits (if not already in bits) but one that will maintain itself in a steady-state, like, as some cosmologists used to think, the universe. Come here, our governors say, as anything, in any state of mind—love or hatred or desperation or just looking for a better job (aspirational?)—and you will be ... well ... not exactly *welcomed* but accepted or, perhaps, it would be more accurate to say, *tolerated*. And we hope you like it or are prepared, at least, to lump it, to tolerate us, as we tolerate you. And with each tolerating the other ... we hope you won't want to behead or bomb us. We look forward to your becoming as indifferent to the different beliefs and customs of your neighbours as they are to yours. This is peace. This is harmony. This is modern Britain, which you prefer to wherever it is you came from.

······

There only came to be any point in saying what 'British' was when there came to be present in Britain large concentrations of people who *weren't*—except, perhaps, in the legal sense—and didn't, in any other, want to be—not if that meant getting drawn into the free-thinking, secular world of modern Britain, in which what we value above all else is, according to the state, voting rights, freedom under the law and tolerance (for *all*, *equally*, men *and* women, hetero- *and* homosexual, believers and unbelievers alike).

Neither party, it seems to me, has got a *very* good bargain out of mass Muslim immigration. Except for the opportunity to have their

tolerance tested, I can't see that the natives benefit.[9] And what benefit did our governors ever expect us to get from having come to live amongst us lots of uneducated peasants from the Pakistani Punjab or Sylhet in Bangladesh? It's not as if the relationship between us and them is any longer what it was in 1914 when hundreds of thousands of them (poor sods) volunteered to fight for the King-Emperor and our country, without any idea of what they were being let in for. It's a mystery why they fought then (bravely, evidently, illustrating the truth of 'Gunga Din') and even more of a mystery why we have let them in in such numbers now. (It's hardly gratitude for services performed 100 years ago, and largely forgotten.) How many of us would ever have *chosen* to share our lives on this not very large island with large, fast-growing concentrations of people of such a different culture, many of whom, unlike their forebears, find Britain nothing to be loyal to, let alone love, a mere *locus*, where they can enjoy a better standard of living than at home; some of whom, on the quiet — or not so quiet — despise us as loose-living *kafirs*; and *some* of whom want to, and try to, and sometimes *do* blow us up or cut our heads off, at home and abroad? Who can doubt, had we ever been asked, what our answer would have been?

The immigrants themselves are, materially, immensely better off, of course, but they are going to have to pay for it. And what they will be asked to pay with is their faith; for the forces which have dissolved and swept away all but the remnants of ours threaten theirs too. The innumerable and seductive benefits of our world are not to be had except at a price; and the character of the price is innocently revealed in those 'British values'. For what but discouragement to faith is there in the great British promise of equal votes, equal freedom under a secular law and mutual tolerance? What encouragement does such a promise make the Faithful? What does absorption into such a world promise but the dilution and perhaps, eventually, the dissolution of Faith?

And the great trial — the *ordeal* — for devout Muslims (and what first generation Muslim is not devout and not bent on his children being so?) is *school*. What uneducated immigrant doesn't want education — if not for himself — for his children? But beware what you want. The education that enables someone to thrive and get on in our world — the education the British state requires all children to be given — is not friendly to religious belief, not even to Christianity. It is part of a scientifically habituated world, where truth is what conforms to evidence and is always provisional. It is not just *unlike* the education of

9 Unless, of course, our GDP is bigger as a consequence and the bigger the GDP the better, no matter what makes it so and no matter the cost.

a madrassa or yashiva, it is a form of education by whose standards such schools don't educate at all: they don't merely fail or neglect to educate, they un- or dis-educate. Ours is a form of education which, one can say, is to other forms as predator to prey. Which is why Haredi Jews live amongst us but, if they can, sensibly keep themselves to themselves, even when it's at the price of remaining poor.

Our form of education spreads what Cardinal Newman called an 'all-corroding, all dissolving scepticism', 'that universal solvent', the 'deep, plausible scepticism [which is] the development of human reason, as practically exercised by the natural man' and which leads to 'a simple unbelief in matters of religion'.[10] English schools and universities don't *teach* such a scepticism, of course, not explicitly; they take it for granted, like the ground under their feet. It is learned with the language and is infinitely more threatening to devotion than any explicit belief or doctrine. It can't be replied to. And if a devout Muslim thought he needed to protect Muslim children from it, who could blame him? Especially who could blame him when what he has been hearing, for forty years and more, not just from successive British Governments but from the entire British educated class, is that Britain — no longer part of Churchill's 'Christian civilization' — is a multi-multi society, multiracial, multifaith, multicultural and proud of it. If Muslim parents and teachers do their best to ensure that the education their children get in British schools is compatible with the faith they have brought here from their homelands, who can be surprised, let alone blame them?

Some such collision between our education system and Islam as that which took place in the so-called Birmingham 'Trojan Horse conspiracy'[11] was inevitable. From their own point of view, what else were those Muslim teachers and parents doing but trying to ensure that their children got a genuinely Muslim schooling as part of a wider Muslim upbringing? The head of extra-curricular activities at Park View, one of the schools involved, is reported as saying to Ofsted inspectors: 'It is only natural that as parents we seek to protect our children from the values of secular culture by inculcating within our children the pristine values of Islam.'[12] And he's right. It *is* only natural. And it is doubly natural when they have been so frequently and so earnestly told for so long that their faith is as welcome here as what used to be our own.

[10] John Henry Newman, *Apologia Pro Vita Sua* (first published 1865); http://www.newmanreader.org/works/apologia65/chapter5.html (last accessed 11/05/16).

[11] https://en.wikipedia.org/wiki/Operation_Trojan_Horse and elsewhere.

[12] *Idem.*

What were they doing but taking seriously all that talk about celebrating diversity and multiculturalism, and acting as if it meant a bit more than First schools doing the Nativity one year and Diwali the next?

But, equally, what else but natural was it that the Government should try to protect its schools from what was reputed to be an Islamist takeover? It could hardly tolerate taxes being used to establish in secular, state-funded schools an ethos tending to encourage the blowing-up and head-chopping-off of the very people paying the taxes that made it possible. And even if there wasn't much evidence of *that* in the schools, even if all that was going on was that some parents and teachers were trying to run secular state schools as if they were religious and private, the Government still had to put a stop to it. It couldn't tolerate its schools being turned, on the quiet and at the taxpayer's expense, into anything like madrassas. Almost certainly, what went on in Birmingham was underhand and dishonest, and must have involved more than a bit of bullying of the uncooperative. The Clarke report may have found 'no evidence of terrorism, radicalization or violent extremism' in the schools but what it did find was bad enough: 'coordinated, deliberate and sustained' attempts 'by a number of associated individuals, to introduce an intolerant and aggressive Islamic ethos'.[13]

The Government's response might have been natural. It wasn't intelligent (and definitely wasn't educated). The affair was revealing of the poverty of the idea of education held by the modern right-minded and of the hollowness of the 'multiculturalism' they profess (which, as later developments in the row have come to show, is as hostile to the idea of a Christian, or Jewish, education as a Muslim one). If anything in English written on the subject of education deserves to be thought a classic—and is, amongst the educated, commonly reputed to be so (even when not read)—it is J.H. Newman's *The Idea of a University*; and one of the things Newman says there—as someone saying something too obvious to need further comment—is 'education is a higher word ... and is commonly spoken of in connexion with religion and virtue'.[14]

But not any more. In modern Britain education is understood, officially if not always explicitly, as serving the economy. Schools and universities train people in skills which are useful and profitable both to their possessors and to the country as a whole. The Spiritual-Moral-Social-Cultural development bit is just window-dressing or sideshow,

[13] *Idem.*
[14] https://www.gutenberg.org/files/24526/24526-h/24526-h.html (last accessed 10/05/16).

not-serious. No one in our educational establishment takes religion seriously. None seems to have a language in which it can be taken seriously, least of all if he is spokesperson for it. All that then can be heard is the 'mouth profession' of Bunyan's Talkative, in *The Pilgrim's Progress*, most plainly voicing disbelief when trying to do the opposite. Elizabeth Truss, for instance, as Conservative Schools Minister, commends our 'rich diversity of faiths' but with so little faith of her own, or even understanding of the faith of anyone else, that with her next breath she promises 'the support and resources to deliver high quality RE teaching',[15] as if she were industry Minister promising investment in high-grade steel production. She thinks not that RE *is* 'very important' but that it '*remains*' so (after, presumably, its subject matter has died) and that what it remains very important *for* is not breathing new life into dead matter but understanding 'the rich diversity of faiths and communities in the UK and their part in shaping the values and traditions of this country', that is, confirming the death of Faith by studying its sociology. What members of any of our richly diverse faith communities could trust such a woman with the religious education of their children? Who could trust the men—largely men— who appointed her? What respect for any faith is there there?

Religious education is never understood by any member of the educational establishment as learning to be religious but only ever as learning about religion, as one might learn about rift valleys or osmosis or the burial customs of South Sea Islanders. As George Grant, the Canadian philosopher/theologian, puts it: 'the study of religion increasingly tends to be objectified into antiquarianism. The religions become like flies caught in amber, worthy objects for libraries and museums, but not living realities in a living culture.'[16]

And studied like flies in amber is just how our national Senior Management Team, from Ministers down to NLEs, SLEs and mere LLEs, thinks they ought to be studied. And it is no good saying to it, as Stephen Shashoua, director of the Three Faiths Forum (an organization that's hardly a centre for intolerance and prejudice), does, 'We believe in demonstrating lived belief. There are some things a textbook can tell you, but most a textbook can't',[17] for it cannot hear. The difference

[15] *Religious Education in schools (England)* Briefing Paper, Number 07167, 4/1/16, p. 5. Researchbriefings.files.parliament.uk/documents/CBP-7167/CBP-7167.pdf (last accessed 11/05/16).

[16] 'Faith and the Multiversity', *The Compass*, No. 4, Autumn 1978, p. 12; also *Collected Works*, Volume 4, pp. 385–402 and, greatly expanded, pp. 607–639.

[17] http://www.thejc.com/comment-and-debate/analysis/123661/faith-lacking-religious-studies-plan.

between teaching about religion as from a textbook and demonstrating a lived belief is one it cannot see.

The phraseology of all officially-sanctioned documents and spokespersons on the subject, without exception, shows plainly that the purpose of RE lessons, as officially understood, is to teach pupils religious tolerance by teaching them to study all religions, including their own, as if they were dead flies. Pupils are 'to learn about more than just one religion', 'to understand different religious beliefs', 'to be provided with a broad and rigorous study of religions', 'to be provided with knowledge and understanding of the diversity of religious beliefs', 'to have information and knowledge conveyed to them in a pluralistic manner', 'to know about and understand a range of religions and worldviews', 'to express ideas and insights about the nature, significance and impact of religions and worldviews', 'to gain and deploy the skills needed to engage seriously with religions and worldviews', 'to know and understand the religions and beliefs which form part of contemporary society, Christianity, other principal religions, other religious traditions and worldviews', 'to be provided with access to knowledge about different faiths, communities and cultures'.[18] I don't suppose it is deliberately meant to foster atheism (it is more likely to be the result of sheer blankness of mind) but it might as well be. One curiosity is that none of all these people at the tip-top of the educational tree, telling the rest of us all about it and how to do it — none, not one of them — has an educated understanding of the import of his own words — the very thing, above all, that would, you'd think, be the mark of an educated mind and the essential qualification for telling anyone else anything.

And this understanding of RE gets back-up from Ofsted inspections. So the reports on those Birmingham Muslim schools typically say such things as 'pupils' understanding of other religions is scant, as the religious education curriculum focuses primarily on the study of Islam', governors 'endeavouring to promote a particular and narrow faith-based ideology', pupils have 'a limited knowledge of any religion apart from Islam', some teachers trying to introduce an 'Islamising agenda', 'too few books about the world's major religions other than Islam', 'balanced views of the world' not taught, 'contact with different cultures, faiths and traditions is too limited'.[19] Well, *of course*. They *believe*. And their belief is not nominal (as we may presume anything

18 Compare Winifred Inger's influence on Ursula Brangwen in chapter 12 of Lawrence's *The Rainbow*; also 'Seek true religion. O where?', *The Human World*, 1, 1970, pp. 58ff.

19 Wikipedia on Trojan Horse again.

resembling religious belief is amongst Her Majesty's Inspectors) but actual and alive. These Birmingham Muslims have a *faith*; and—as that head of extra-curricular activities at Park View said—naturally, they are *faithful* to it; it commands their *fidelity*. It's Islam that commands their fidelity, not some wretched 'balanced view of the world'. And if the 'respect' that Cameron, Gove, Morgan, Osborne pretend to and commend to the rest of us had anything real about it they would recognize and have some sympathy for the trials of conscience faithful Muslims must undergo now they have come to live in—have been allowed to come and live in—our secular and unbelieving world.

What our inspectorial *apparat* complains of is something that is simply in the nature of belief. The inspectors use the English word 'faith' without attaching any meaning to it. For one thing they definitely *aren't* saying is that these Muslim schoolchildren should pay any particular attention to Christianity, as the religion of the land their parents or grandparents have emigrated to. British values are, it seems, no more, or less, Christian than Taoist. They are the values upheld in and by the act of holding oneself aloof, and at an equal distance, from all beliefs. So there's an odd sort of asymmetry between the actions of the so-called Islamist conspirators and the reaction to them of the British Government. The conspirators act on behalf of a particular religion and the particular culture it belongs to; the British Government acts on behalf of all religions and no religion, and for the one culture that holds the ring for all cultures, including any that might want the ring to itself. Where the Islamists assert the truth of Islam the Government asserts not a contrary Christian truth, as it would have done from say the 10th to the 20th century, but the truth of Enlightenment scepticism, truth's suspension.

And in doing as they did, those Birmingham Muslims were maintaining a truth about education that the British are now too enlightened even to remember: that religion isn't something that's apart from and stands over against education, something alien to be expelled if it creeps in, but belongs to it by its nature, and not just as a subject within it or through the part played by the Church in its spread but as an intrinsic part of its foundation and purpose. How could education ever be itself but not concerned with what Tolstoy called 'What men live by', Newman 'the end of ends' or F.R. Leavis (not someone ordinarily accounted a religious man) 'What for—what ultimately for?'?[20]

[20] Leo Tolstoy, *What Men Live By* (first published 1885); Newman, *The Idea of a University*; F.R. Leavis, 'Two Cultures? The Significance of Lord Snow', Richmond Lecture, reprinted in *Nor Shall My Sword* (London: Chatto & Windus, 1972), p. 56.

Education reduced to professional training and undertaken for the sake of increasing individual and national wealth no longer *is* education. What would a medical 'education' be if it were nothing but technical training, took no note of the end of medical ends, was unconcerned whether it served the good or the bad? As things stand, such questions as whether abortion is unquestionably a medical treatment or not fall within Medicine but we can imagine things standing otherwise. We can imagine a Medicine without the Hippocratic oath, in which ethical questions were regarded as extraneous; and then we are imagining Medicine as a nightmare, a home for concentration camp experiments and organ harvesting. And, if education is concerned with ends and is a form of the pursuit of the good, how is religion to be kept out of it and, if allowed in, how except on its own terms? For, if it were admitted but not as living faith, only as dead flies, that would hardly be admitting it at all.

Only too obviously, what is said about Islam in those Birmingham schools could also be (and, under the doctrine of multiculturalism, *must* be) said about Christianity, Judaism, Hinduism and any and all others of that rich diversity of faiths a Schools Minister likes conscientiously to celebrate and take pride in: that what, above all, RE lessons must *not* be used for is to teach anyone to believe anything in particular. RE lessons are to institutionalize unbelief, not as in the Soviet Union, as plain-speaking doctrine but, much more effectively, as unadmitted assumption; anything else is consorting with extremism and in conflict with British values.

You'd think this creed of democracy, freedom under the law and mutual tolerance would be mild and itself tolerant when set in action. But not at all. It is proving as extensive in its claims and as militant as any religion. Thou *shalt* be tolerant of all faiths, and genders. And thou shalt prove it to the Inspector. Or else. If you think that marriage can only be between a man and a woman, you *may* say so as a teacher, but not if what you say either (1) exploits the vulnerability of or discriminates against any pupil who might be homosexual or (2) shows you to be acting outside the new legislative position that permits homosexuals to marry.[21] So go ahead, feel free. Freedom of speech is one of our values. Like tolerance. It's what makes us British.

And the new, secular inquisition is equally active and vigilant outside school. You might run a bed-and-breakfast business and not want to take homosexual couples. *Do.* You might be a baker who doesn't want to bake a wedding cake with a puff for homosexual marriage on

21 Quoted http://www.theguardian.com/society/2012/dec/11/gay-marriage-quadruple-lock-religious-groups (last accessed 10/05/16).

it. *Do.* If you are a magistrate and think it better that a child have a man and a woman as parents than two men or two women, then say so publicly and find yourself a Person of Interest to the Judicial Conduct Investigations Office and sacked by the Lord Chancellor and the Lord Chief Justice for misconduct and bringing the magistracy into disrepute.[22] The magistracy brought into disrepute by a magistrate saying what, until just a few years ago, the whole world for the whole of human history had taken as self-evident, what the whole world outside the West still takes as self-evident and what the vast majority of those outside the politically influential classes *in* the West still do too![23] But to say so, now, here, where we tolerate homosexuality but not doubt that it's all it's officially cracked up to be. *No.* (We'll teach these religious ideologues the virtues of freedom and tolerance!) And if—secretly— you'd prefer (if you've *got* to have immigrants) to have them from, say, Poland or Czechoslovakia rather than, say, Bangladesh or Burundi, please don't say so. And even if you don't like to see burkas in the streets or minarets on the skyline, if I were you, I wouldn't say that either.

The justification for disciplining those Muslim schools in Birmingham was that there was reason to think that they might be, if not encouraging jihad, then doing too little to discourage it. But who thinks anything like that is going on in any Christian or Jewish school? No one, but so what? For the sake of non-discriminatory multi-culturalism, if Islamism in Muslim schools is a danger to the state and its citizens, Christianity in Christian schools must be identically treated as such a danger, and Judaism in Jewish schools too. If symptoms of radicalization are to be looked for and rooted out in Muslim schools, they have to be looked for and rooted out in Christian and Jewish schools. What they are to be rooted out with is Statutory Instrument 2014/2374; and what is to be planted in their place is British values and the earnest belief they express in the supreme merit of not believing anything too earnestly.

And symptoms of incipient radicalization can, if you are vigilant enough, be detected in the least likely places; Trinity Christian School, Reading, for instance, registered to take as many infants, as make eight between the ages of five and eight. It was highly praised on its first inspection, including on the grounds that 'Pupils are well prepared for life in modern, multicultural, democratic British society through the

[22] *The Times*, 10/3/16.
[23] What an idea of misconduct and the disreputable! What Third World village is as parochial as Westminster and its environs? And this is the 'wider society' that—see below—Muslims must strive to connect with.

teaching of the Christian principle to "love thy neighbour", as found for example in the teaching of the biblical story of the Good Samaritan'.[24] But that was before the Instrument, and, since, merely to love your neighbour isn't enough. You must actively promote his faith alongside your own, even if it is to only a handful of infants.

Because the school applied to increase the upper end of its age range from eight to eleven—enabling its handful to stay on—it had to have a second Visit. But because this one took place *after* the Instrument, its findings were very different from those of the first. The report wasn't published but its findings are summarized in a Christian Institute *Fact-sheet*.[25] The inspector found evidence of the school teaching Christian values where it ought to have been teaching British ones. It promoted a particular, Christian lifestyle. It *wasn't to*. It taught that all people were equal before God and had an inherent human dignity *as if* that were all the respect and tolerance it needed to show towards other faiths and other communities. It *wasn't*. What *was* needed was to promote other faiths *actively*, by, for instance, bringing Imams into assemblies and lessons. And if this wasn't done, if the old, Christian value of merely loving thy neighbour weren't replaced with the new British one of being as indifferent to the truth of his beliefs as your own, a full inspection might be required, which might result in your school being closed. Meanwhile, permission to allow your handful of 8-year-olds to stay on until 11? *Denied. Next!*[26]

And what for? To comply with the *Prevent* strategy. To keep us safe from Christian extremism.

What, supposedly, made the Muslim children in those Birmingham schools 'vulnerable to extremism' was 'the promotion of a culture' that would have brought about a 'disconnection from wider society and cultural isolation'.[27] But is it maintained that Christian infants are going to be 'culturally isolated' in a country with 1500-odd years of

[24] See reports.ofsted.gov.uk/provider/files/2296141/urn/138968.pdf (last accessed 10/05/16).

[25] http://www.christian.org.uk/trinitychristianschool-factsheet (last accessed 10/05/16).

[26] Of another Christian school, Grindon Hall in Sunderland, after laying down the usual politically correct, multicultural law, the inspectors had the cheek to say the school insufficiently encouraged its pupils to see 'alternative viewpoints' and 'think for themselves'. Helpfully, they glossed what thinking for oneself meant: 'to reflect about the fundamental British values.' *Got it?* Well then, W-I-N-D-E-R. *C-l-e-a-n* it! 'We go upon the practical mode of teaching, here, Nickleby' (Charles Dickens, *Nicholas Nickleby* (first published 1838–9), Ch. VIII.

[27] http://www.publications.parliament.uk/pa/cm201415/cmselect/cmeduc/473/47304.htm (last accessed 11/10/16).

Christianity behind it and an Established Church with the monarch as its Head? And, anyway, the assertion that isolation leads to extremism is just ... an assertion. The Mennonites of North America deliberately isolate themselves from 'wider society'; so do the Haredi Jews of Gateshead. Are either 'vulnerable to extremism'? If there is a connection between cultural isolation and extremism among some Muslims, that says something about some Muslims not cultural Isolation. 'Co-ordinated, deliberate and sustained' attempts 'to introduce an intolerant and aggressive Islamic ethos' into a group of secular state schools *isn't* a case of people isolating themselves anyway. It's more like the opposite, muscle-flexing and taking over.

And if what was found in those Birmingham schools was evidence not of extremism but merely of disconnection ... well ... what was it evidence of but the multiculturalism we are always being told to celebrate? What does that involve—by definition, *require*—but some degree of disconnection between the parts and 'wider society'? What does multiculturalism mean, if it means anything at all, but that the parts that make up the multicultural whole are not themselves multi-cultural but distinct (uni-)cultures, keen to preserve themselves and stay distinct? They are found, by those who belong to them, lovable, honourable and commanding of loyalty in a way in which no one could love or honour or be loyal to multicultural tolerance and voting rights. In Birmingham, what the multiculturalist whole came up against was the distinct culture of one of its parts, Pakistani Islam, the definite, content-full culture of people not satisfied to be part of an incoherence, not only taking the official doctrine of multiculturalism at face value but showing that it understood it better than its progenitors.

And its progenitors didn't like it. What they wanted was a multi-culture composed not of different cultures with competing beliefs held in earnest but a multiculture in which all the parts partake of the multi-culturalism of the whole and in which the beliefs and practices of one part never come into serious collision with those of another, i.e. not a *multi*culture at all. And *there* is the deep contradiction at the heart of the whole multicultural project: it celebrates a multiculture whose parts don't seriously differ. Without any earnestly held belief of their own and without the imagination to recognize one in anybody else, its celebrants entertain a merely folkloric or picturesque idea of culture. Our Governors, in so far as they are themselves Christians, are post-Enlightenment Christians, that is, post-Christian; and when they imagine Britain as a multiculture what they imagine is post-Christians, post-Muslims, post-Jews, post-Hindus, living tolerantly side-by-side, each with nothing about them that any other could possibly find intolerable.

The mass immigration permitted by a succession of Governments has been, I believe, a terrible mistake whose ill consequences (*and* perhaps their good too) are a long way from working themselves out. Multiculturalism, as officially conceived, is a self-deluding and self-contradictory gloss on the mistake which satisfies neither natives nor immigrants.

There used to be phrases current—often symptoms of war-time paranoia or totalitarian propaganda—like 'fifth column', 'the enemy within' and 'enemy of the people'. What they denoted, no matter quite who used them or for quite what purpose or with quite what justification, was *enemies*—enemies of the state and the people, working, from within, to bring about your downfall or defeat by some clearly identifiable enemy without: if you were British, in 1914 or 1939, German; if you were German, throughout the thirties, International Jewry; if you were American or British, during the Cold War, Soviet; if you were Soviet, from 1917 to 1989, all the various manifestations of international capitalism.

Such phrases no longer have any life in them, scarcely the life even of jokes. But new phrases, wonderfully current and full of life—or use at least—have taken their place, phrases like 'extremist', 'divisive' and 'undermining British values'. But these new phrases aren't quite the same as those they've replaced. What the old spoke of as threatened was a discrete and identifiable *something*, an *us*, a Britain or Germany or Soviet Union, a people and the state identified with it, the threat to which was similarly discrete and identifiable, a *them*, the enemy, another hostile country or ideology.

But not only are the so-called British values that extremists threaten found outside as well as in Britain but what threatens them comes as much from within as without. It's from 'extremists' of every kind, including those who, by any measure, undeniably belong to *us* and wish us well. It includes, of course, British jihadists who want to shoot us, bomb us, behead us, absorb us into a Caliphate and impose Sharia Law on us and who are connected with an external enemy, fellow-jihadists in ISIL and Al-Qaeda and so on. But (according to Theresa May) it also includes 'neo-Nazis', not *German* neo-Nazis wanting to refight the Second World War, our own neo-Nazis, belonging, presumably, to such organizations as the British National Party and the English Defence League, organizations which not only fight local council elections but whose names declare their patriotism. They may want the jihadists bombed or beheaded but they not only have no wish to bomb or behead any of the rest of us but they don't seem to advocate doing so even to the jihadists. Nevertheless, in the new lexicon, in the interest of even-handedness, they, just as much as the jihadists

themselves, are part of what in the old lexicon would have been called 'the enemy within'. *This* enemy, it seems, may be someone who is too partisan a friend.

To complicate matters a bit more, both sets of extremists are, from the perspective of the new lexicon, part of *us* too, because what they have in common—both those anxious to bomb us and those not—is that they *divide* us, divide the larger Muslim community, which the jihadists belong to, from the larger still Christian and post-Christian society, which the neo-Nazis belong to. Both are part of the threat and both are part of the threatened, so much so that *young* would-be jihadists are what are called 'vulnerable young people'—young people 'vulnerable', that is, not to being beheaded or bombed themselves but to bombing and beheading others!

Talk of 'fifth columns' may have been, for the most part, a symptom of paranoia but at least you knew where you were with it. But this new way of talking is nonsense squared, it's Big Brother through the Looking Glass, Humpty Dumpty talking Newspeak. (And, now, there, perhaps, *is* a fundamental British value.)

······

'Values', British or otherwise, aren't listable, only liveable—which is why they are hard to speak of convincingly. A foreigner learns them not from a list but by—more onerously—sharing the life of the natives and acquiring and using their language; and he will best see them— including the possibilities of conflicts between them—in the best of the language, its literature. If there could be any formal teaching of 'British values' it couldn't be by Government-inspired Ofsted *diktats* but by something like teaching English literature with conviction. As Dominic Lawson said, 'to study English literature is to share in a culture that goes much deeper than any definition dreamt up by politicians'.[28] And, even then, it depends what, quite, you mean by 'teaching'. The kind of teaching involved couldn't be what F.R. Leavis used to call 'authorita- tive telling'. The teacher would have to recognize that 'values are matters of practice, not of theory. They are not so much taught as imparted. You learn them by immersion'.[29] Which means that it would be the most awful mistake merely *to make use of* literature, to ransack it for illustrations of what one already knew were the 'values' to be imparted. The sort of imparting needed can only be done by 'teaching' the literature disinterestedly and from the conviction that it is valuable for its own sake and the sake of the education it is in itself capable of

[28] *Sunday Times*, 15/06/14.
[29] Scruton, *Telegraph*, 16/05/06.

giving, from — you might say — love. As a strategy for preventing terror-ism, radicalization and violent extremism, this might seem chimerical, but it's not half as chimerical as trying to prevent them by 'promoting British values', in the spirit of our Secretary of State for Education, Nicky Morgan's, 'We have taken action to remove and continue to take action to remove people from being in schools who don't follow British values'[30] (a remark which I cannot hear except as, 'Für you, Mohammed, school is over').

There is, of course, an interesting connection between Ofsted reports and literature. Whatever else an inspector of schools needs to be, he needs to be educated. How else could he be fit to judge how well or badly others were being educated? And to be educated, he must be literate. And it's not a bare 'functional literacy' that is required of him. No matter how well qualified he might be in — let's say — some scientific specialism, unless he is to a very high degree literate he is not fit to be an inspector. He has, after all, not only to judge all the things he hears and reads in the course of his inspection but the upshot of his inspection is itself a piece of writing, one in which he makes his own judgements and the quality of his own education available for the judgement of others. He ought, it seems to me, to be well read; but, whether well read or not, what he cannot do without is a command of English prose — which involves something more than the ability to form correctly used words into grammatically correct sentences. If we speak of 'prose' we speak of something that involves the exercise of taste and discrimination.

So what about a prose of which the following is a good example?

> A National Leader of Education (NLE) and a Specialist Leader of Educa-tion (SLE), both from a local Teaching School, have variously supported the restructuring of the senior leadership team, to strengthen perform-ance management processes and lines of accountability, the improve-ment of the governing body's clerking arrangements and the intro-duction of formal procedures for the approval of policies. Transparent recruitment procedures and processes for reporting to governors have also been put in place.[31]

It would be tempting to call that bureaucratic, if it weren't that 'bureau-cratic' doesn't do justice to just how bureaucratic it is. It's not just about management, it's spoken by the Management. Its viewpoint is the managerial, that is, it denies that any*body* is responsible for it. It

[30] Quoted http://www.theguardian.com/uk-news/2015/may/03/birmingham-headteachers-say-subject-campaign-intimidation (last accessed 10/05/16).

[31] http://reports.ofsted.gov.uk/inspection-reports/find-inspection-report/provider/ELS/138698, March 2015 letter to the Beis Yaakov High School, p. 3 (last accessed 10/05/16).

describes impersonal processes and procedures as if it were itself the result of impersonal processes and procedures, against which there can be no appeal. It shouts out: 'There ain't no one here!' Its source is American scientific business management. And what educated man or woman could write and think like it?[32]

Compare it with the style of an earlier generation of school inspectors, that of the writers of the 1921 Newbolt Report on the teaching of English in schools, for whom Matthew Arnold was still a living presence and influence:

> The fundamental importance of English as something more than a subject is certainly not fully appreciated by the schools. A ready assent is, indeed, given to the formula that English is the concern of every teacher. Yet it is clear that in some cases what is everybody's concern proves in practice to be nobody's, and that in some schools the situation is only saved, so far as it is saved at all, by the presence on the staff of some one enthusiast for English literature, with a gift for stimulating those who pass through his form.[33]

What makes such a passage particularly illuminating is that there isn't anything particularly remarkable about it. It is an example of a merely good, ordinary, discursive prose but — what by our standards *is* remarkable — one widely distributed throughout an entire educated class. It's the prose not of managers but of an educated bureaucracy, composed of — there can be no doubt — actual, living men and women, personally responsible for their own words and judgements. And we have progressed from that to Ofsted in practically no time at all. (I mean, in 1921 my own father was already ten years old.) To return is to feel like Elizabeth Bennet when she listens to her uncle Mr Gardiner talking to Darcy:

> [She] could not but be pleased, could not but triumph. It was consoling, that he should know she had some relations for whom there was no need to blush. She listened most attentively to all that passed between them, and gloried in every expression, every sentence of her uncle, which marked his intelligence, his taste, or his good manners.[34]

Read some Newbolt, after some Ofsted, and know there was a time when you had no need to blush.

[32] See Robert Protherough and John Pick, *Managing Britannia: Culture and Management in Modern Britain* (Exeter: Imprint Academic, 2003).

[33] http://www.educationengland.org.uk/documents/newbolt/newbolt1921. html, p. 106 (last accessed 11/05/16). (The report contains 18 references to Matthew Arnold.)

[34] Jane Austen, *Pride and Prejudice* (first published 1813, Harmondsworth: Penguin, 1972), p. 276.

The Newbolt Report, like Statutory Instrument 2014/2374 and all the Ofsted reports that derive from it, is concerned with the development of what it calls a 'national culture' in which all classes are united. (This was before, of course, what was needed was a culture uniting not just all classes but all cultures.) It reports Arnold, sympathetically, as lamenting, in the middle of the 19th century, 'the absence from the schools of genuine culture' and any *'humanizing* instruction' (italics original). If Arnold were alive today what he'd be lamenting is the absence of those qualities not from the schools and their pupil teachers but from his own successors, the inspectors themselves and their political masters, like Nicky Morgan. *There's* an example of that 'change' politicians are always promising nowadays.

Ian Robinson

Politics as Language
Language as Politics

Politics presupposes states, and has to do with what happens within and between states, but the definition is incomplete without human consciousness, thought and intention. Politics is the common under-standing of action (or inaction) by a polity or part of a polity. States may be affected by events of which there is no awareness and over which they have no control. Changes in the mean atmospheric temperature may certainly affect a state, but may not be noticed for some time and, at least before the last fifty years or so, would in any case have been thought of as 'acts of God'. Before it is noticed, climate change can have nothing to do with politics. And if, as in numerous science fiction plots, the approaching end of the world (perhaps by a predicted collision by a meteorite) is kept secret by an absolute dictator, that too is not politics. Anything becomes political when statesmen begin thinking about it and asking what to do, so now, climate change is one of the most popular political matters.

For anything to be political, common consciousness is a necessary condition. I here follow both Aristotle and Dr James Alexander; the latter argues (though the formulation here is mine not his) that politics is action following consideration/discussion by a human group, that is to say, not just public action (or passion) but action as connected with intention and understanding, characteristically the upshot of discussion or debate.[1] If a monarch simply announces such-and-such a decision, for instance 'That at what time ye hear the sound of the cornet, flute, harp, sackbut, psaltery, dulcimer, and all kinds of musick, ye fall down and worship the golden image ...',[2] though the proclamation is certainly an action of the state it is not quite politics, for it tells us nothing about either how and why the decision was made or how it was understood. Later in the same book we *are* given the political

[1] James Alexander, 'Notes towards a Definition of Politics', *Philosophy* 89, 2 (2014), pp. 273–300.
[2] Daniel, iii: 5.

reasons for throwing Daniel into the lions' den: the action follows a plot by the 'presidents and princes' who 'sought to find occasion against Daniel'.[3]

This brings politics into the subject matter of history in Collingwood's sense of history. Political history (which used just to be known as history) is the record of actions as answers given to public questions by those in power: that is, the narrative not only of events but of how politicians understood and tried to control events.

When the polity is a nation state, the ordinary vehicle of politics as common understanding is a common language. (Even India, with its huge range of languages and religions, has a kind of common language, thanks to Macaulay.) Even this may understate the importance of the language of politics if it suggests that the reality is something underlying language, something which just happens to take the form of our language of politics and which could take many other forms. Where is common understanding of the body politic if not in what we say or write? And though we may deceive ourselves, and though a historian may discern forces and motives of which the politicians and electorate are unaware or only partly aware, there is no substance to politics other than what people feel and think about what in public they do or suffer; and the substance of what we feel and think is what we say and write. So political discourse is one of the main expressions of the character of a nation.

How to discuss the health of the politics of a nation? I think we need D.H. Lawrence's phrase 'depth of vital consciousness'. This includes how events are commonly understood, how policies and actions square with principles, and what are the common 'values' which at present we hear much about.

One of the ways the United Kingdom has been a great nation is in its own understanding of itself. This does not imply universal agreement. On the contrary, the understanding worked out by a number of men and women often originated in controversy. Both sides in the Civil War had understandings of what the nation is, and of what is the common good, which went deep. In the following century, Burke was provoked into his idea of the nation by the prospect of a revolution that some of the Whigs thought a logical development of the Glorious Revolution. Thatcher was even more controversial and provoked in a few of her opponents some clearer conceptions of the national good. Enoch Powell and Michael Foot had profound disagreements within

3 Daniel, vi: 4. The status of politics is the same whether the book is history or fable.

what it would not be unfair to call a love of country. Then, perhaps, looking back, we see them

> Of no immediate kin or kindness,
> But some of peculiar genius,
> All touched by a common genius,
> United in the strife which divided them ...[4]

When politics is in a good state, the common genius is known and loved. This, I regret to have to observe, is not our present condition. Aristotle's idea was that politics has to do with the *good* of society. At present (2016) we hear much about solidarity, equality and growth (of the economy) but the word *good* is hardly used.

......

Where there is universal adult suffrage, politics — the understanding of decisions concerning the state — becomes an activity in which most people one way or another engage, even if only by voting or abstaining in general elections. After the Second Reform Act of 1867, when it began to be clear that the nation was moving in the direction of what is now called 'democracy',[5] a link was perceived between extension of the franchise and the universal education that was enacted in 1870[6] — education of girls as well as boys, though votes for women had to wait another half century. Everybody will be called upon to exercise

[4] T.S. Eliot, *Little Gidding* (London: Faber and Faber, 1942), p. 13.

[5] For two hundred years from the Restoration of 1660 *democracy* was a very suspect word in the United Kingdom. 'Kingly power, thus ebbing out, might be / Drawn to the dregs of a democracy' — a terrible fate, in Dryden's view (*Absalom and Achitophel*, in *Dryden: Selected Poems*, eds. Paul Hammond and David Hopkins (London: Longman, 2007), p. 177). One of the British objections to the American rebels was their inclination to their own idea of democracy. It was common ground to Liberals and Conservatives in the manoeuvres leading up to the Second Reform Act that the extension of the franchise did not imply democracy; Disraeli would never have got the Bill through the Commons if he had suggested otherwise, though so clever a man must surely have seen where we were heading? Carlyle, whom Disraeli later tried to honour, certainly did: see *Shooting Niagara — and After?* (*Macmillan's Magazine* XVI, April (1867), pp. 674–83).

[6] Matthew Arnold may have been the first to get this clear. His distinguished career as inspector of schools is closely linked to *Culture and Anarchy*. As early as 1851 he wrote to his newly wedded wife, 'I think I shall get interested in the schools after a little time; their effects on the children are so immense, and their future effects in civilising the next generation of the lower classes, who, as things are going, will have most of the political power of the country in their hands, may be so important' (*Letters of Matthew Arnold*, ed. George W.E. Russell, 1895, vol. I, p. 17).

judgement in important state matters, so everybody must be educated, for the sake of the nation as well as individuals. Otherwise, 'our new masters'[7] would just demand bread and circuses and the political parties would have to speak in language accessible and acceptable to the uneducated masses.

The history of the United Kingdom of the last century and a half has included the long and sometimes noble effort to educate the whole population, to make us all capable of exercising our electoral rights seriously. This struggle is now being lost, along with the idea of education itself. (We have university-educated ministers of education who think education can only justify itself by increase in gross domestic product.)

There is no necessary connection between illiteracy and thoughtlessness or shallowness of judgement, but in a modern 'democracy', though we should remember the serious public meetings (Gladstone's Lothian campaign and successors), judgement has largely to be formed in 'the media' which, from 1870 until after the First World War, were almost wholly confined to the printed page. In the following century, newspapers are still important, though it is now commonly thought that televised 'debates' between party leaders have more effect on voters.

What has happened over the last half century or so is that the parties and MPs, particularly in the run-up to elections, have just about given up serious politics in the media, and increasingly in the House of Commons (the debates in the Lords are usually of a much higher standard), in order to win votes by talking in a language they suppose the masses will understand.

To the extent that they succeed, their success will be invisible. It will be just the way things are that politics is conducted in sound bites and that nobody need have any deep or even very clear understanding of what is going on before casting their vote with a good conscience. But the more important question then arises whether in these circumstances the parties themselves have any better understanding.

A few examples follow. Read them with the question in mind: do the originators know that what they are writing or saying is vacuous, and could they if called upon say or write anything that is not vacuous?

7 Cf. Thomas Wright, *Our New Masters* (first published 1873; reprint ed. New York: Augustus M. Kelley, 1969).

······

Alastair Campbell's diaries[8] record many events and conversations from the time when Campbell was recognized as a very powerful man because of his position as Director of Communications and Strategy to Mr Tony Blair. I have not read the Campbell diaries all the way through, because I find that the call of duty cannot sufficiently overcome my disgust, but I am confident of the judgement that all the time and on every page they are without any sense of the nation which Mr Campbell was helping to govern. His enthusiasm for his Prime Minister — perhaps it can even be called love — is not in doubt. But there is no answer to the question what Alastair Campbell thought the Blair government was trying to do.

'I believe Britain is a better country as a result of the economic, social and political changes made since 1997 …'[9] Blair's listed achievements begin with the genuine 'progress in Northern Ireland' where, at least, politics is no longer conducted by violence. Then the list of 'many other' achievements continues:

> … an independent Bank of England, a Scottish Parliament and Welsh Assembly, elected [he means in some places directly elected] mayors, a reformed House of Lords, regenerated cities, something close to full employment, a minimum wage, improved investment in reformed schools and hospitals, student numbers rising, particularly among people from poorer areas, spending per school pupil doubled, health spending trebled, the biggest hospital-building programme since the NHS was founded, crime down substantially, new rights for gays which the Tories now feel they have to support, the fall of Milosevic, London 2012 [= the Olympic Games?], progress in Africa, Britain stronger in Europe if not, as he would have wished when we started out, in the euro. As for Iraq, I hope that the pages that follow will add to a debate that will take years, decades, to settle.[10]

The last remark is surely optimistic. Less than one decade later it would be hard to dispute the disastrousness of the invasion of Iraq: not only an act of aggression but disastrous in its effects on the peace of the whole region, resulting from the ill-informed American neo-con belief that all you had to do was 'topple' the statue of Saddam Hussein for Iraq to function as a Western democracy. The occupation of the Basra region also demonstrated, not coincidentally, the alarming weakness of the ill-equipped British army which was the responsibility of the Blair

8 Alastair Campbell, *The Blair Years: Extracts from the Alastair Campbell Diaries*, ed. Alastair Campbell and Richard Stott (London: Random House, 2007; paperback edition: Arrow, 2008).

9 Ibid., p. xxix.

10 Ibid., p. xxix.

government.[11] The 'progress in Africa' was too early to take into account Boko Haram, and the 'failed states' that now include Libya; ten years later the new hospitals are suffering from the public-private finance initiatives characteristic of New Labour's liking for large-scale debt. The independence of the Bank of England did not avert the near-collapse of the financial system of 2008. Whether the rising student numbers and doubling of spending per school pupil have anything to do with education, and if so what, is a question Campbell is not capable of asking.

As recorded by Campbell all the actual politics, the discussions as situations developed and elections were fought, are, without exception, empty. The emptiness is that of all the participants, not just Campbell: the talk at the top of the Labour Party in the inner circle was, to start with, Americanized and vulgar. President Nixon's White-House tapes seem to have set a precedent. When Mr Campbell was being courted to join the Blair team Mr Blair began by offering him a seat in the Commons and 'thought I could become a huge player in the government'.[12] Peter Mandelson's reported words of encouragement were 'TB thinks you have a future as a key executive player'.[13] The modern phraseology is more than accidentally taken from games. This directly follows a report of a meeting between Mr Blair and 'union general secretaries': '… when he was losing it with them—he called them "you guys", then it was "listen, you guys", then it was "for heaven's sake, you guys".'[14] *Guy*, I suppose, no longer counts as slang, though it had a curiously long period of introduction. In the 1940s *guy* certainly was American slang, sometimes intentionally in the comic form 'youse guys'; what is more, in those days everybody knew that at least in public American slang was to be avoided. It is now, however (in England at least), modern, that is, 'cool'.

Campbell records much of what used to be called swearing, and much commonplace blasphemy. 'The guy from *The Sun* was a total wanker.'[15] 'I said to TB that as the day [of the 1997 general election] nears, the focus will get ever harsher on you and Major, and it's now shit or bust. "God, it's terrifying," he said.'[16] This is in the tradition of

11 Cf. Richard North, *Ministry of Defeat: The British War in Iraq 2003–2009* (London: Continuum, 2009). On the trial of Milosevic cf. John Laughland, *Travesty: The Trial of Slobodan Milosevic and the Corruption of International Justice* (London: Pluto, 2006).

12 Campbell, *Blair Years*, p. 71.

13 Ibid., p. 71.

14 Ibid., p. 70.

15 Ibid., p. 125.

16 Ibid., p. 178.

the memoirs of Harold Wilson, whom the perpetual excitement never failed to inspire; but the language is more vulgar.[17] On one exciting day 'the phones were going mental at home'.[18]

According to Campbell the vulgarity is endemic in the Labour leadership. This is the former leader Neil Kinnock at a family dinner-party:

> 'Oh Margaret Thatcher, not too bad you know, not such a bad person, quite a radical, and of course you had to admire her determination and her leadership—that's what the fucking leader says.' 'Now now,' I said, trying to calm things, but he was in that phase where anything you said just became a spur to further verbal violence. 'Don't "now now" me. I'll fucking tell him too—radical my arse. That woman fucking killed people.'[19]

It was of another occasion that Campbell records, 'It was one of those sinking moments when the words "Oh fuck" flashed right across the mind.'[20] His reaction to the Prime Minister of Australia: 'I took to Keating big time.'[21]

So what was the historic achievement of the first Blair governments, as understood at the heart of government? What was the real politics of New Labour? '[Blair] had a clear objective the whole time—the modernisation of Labour leading to the modernisation of Britain ...'[22] Campbell records his

> ... real sense of privilege, in terms of witnessing history, to be in the room with one leader of the Labour Party explaining to another why and how he was changing the Party's constitution as a means of giving real power and symbolism to the modernisation process the older man [Kinnock] had started.[23]

The important thing is not that the constitution should be better but that it should be more modern. So Mr Blair's conviction was that he needs to 'go big on the modernisation message'.[24] But what is 'modern'? 'Modern' was what Mr Blair happened to want at any given moment. It was modern to increase university numbers and build more hospitals; it was also modern not to pay for either. It was modern to bomb Serbia (when the R.A.F. managed to hit that quite big target) and

[17] Cf. Ian Robinson and David Sims, *The Decline and Fall of Mr Heath* (Swansea: Brynmill Press, 1974).

[18] Campbell, *Blair Years*, p. 85.

[19] Ibid., p. 78.

[20] Ibid., pp. 84–5. N.B. 'the' mind: the common language.

[21] Ibid., p. 75.

[22] Ibid., p. xxx.

[23] Ibid., p. 18.

[24] Ibid., p. 82.

Afghanistan and Iraq and … and modern to reduce tax reliefs on pension savings. But what connected these instances of modernity it was and is hard to see. What was modern was not clear until Mr Blair had made his mind up about the problem of the moment. In a car journey Blair was 'rattling out ideas, me rattling out phrases' (did Mr Blair's ideas come without phrases? It is easier to notice that Campbell's phrases are without ideas), of which the only example is 'Only a modernised Labour Party can modernise Britain'.[25] It can be asked why *modern* should be, whatever it means, the modern replacement of *the good*.

The Blair governments' idea of modernity was in fact wholly a question of style. When Campbell was being courted as Tony Blair's (significant title) 'Director of Communications and Strategy'[26] he reflects that 'Historically the Labour Party has not been blessed with really talented people in the area of politics and political strategy …'[27] In this view, strategy, politics and the publicity are much the same. So the Director of Communications is also in charge of Strategy. The inevitable consequence is that the politics will be understood in the language of sound bites, press releases and what is now usually called spin. Let us bear in mind that the understanding is the actuality.

The question of sincerity can hardly arise. 'Labour Party Conference, Brighton. We had been working [*sic*] till late but TB was up at 5, and me at 6. I did the final uplifting "spirit of Britain" stuff and worked on a couple of jokes about Hague.'[28] The insincerity is so unashamed and industrious as almost to be sincere. There is no pretence that 'spirit of Britain' might mean anything or that it could be treated with anything but contempt — as long as the contempt is well enough disguised. But what if the nation really has, in Matthew Arnold's terminology, a best self? It could not possibly be visible to Campbell or, if he allows his speeches to be made in this way, to Blair.

It is noticeable that writing his daily entry Campbell sometimes lacks the ordinary mastery of prose which for some centuries was taken for granted. It is not necessary to the spin doctor. Sometimes he is barely literate. 'A truly dreadful day. TB was useless, I was tired and useless and fed up. I was worried it was all about my health, I could not get going. I was having one of my fed up with TB days.'[29] The commas where there should be major punctuation aid the vagueness.

25 Ibid., p. 86.
26 '… [N]ot only did I support the New Labour strategy, in large part I devised it …' (ibid., p. 79).
27 Ibid., p. 7.
28 Ibid., p. 474.
29 Ibid., p. 127.

What is the antecedent of *it*? Tiredness, etc.? Whatever, this has the vagueness of something not literately expressed. These are of course hastily jotted entries often at the end of an excitingly busy day. But Campbell was not under that pressure when he wrote the Introduction to the paperback edition and declared that he continued 'to defend politics and the vast bulk of politicians'.[30] I guess he meant 'majority', not 'extreme obesity'. On the next page he tells us his 'goal was to record the past without jeapordising the future'.[31] Even if the spelling is corrected, what could it mean?

Sometimes the absence of sense is almost explicit. One sound bite was: 'Power devolved is power retained.'[32] What could 'devolution' then possibly mean? Could it be reversed? *New Labour, New Life for Britain*, the title of the 1996 party manifesto, is rhythmically well made, with crafty double alliteration, but does it actually mean anything except emotional uplift?

······

To Blair-Campbell, the sudden accidental death of Princess Diana was the publicity gift of a lifetime, coming just at the right moment when New Labour had only been in power a few months. Here was a chance to show us what New Labour really is! The glamour of the modern! Constitutionally the question arises why the Blair government thought the matter had anything to do with them. They succeeded, however, in bullying 'the palace' into letting them take over the organization of the mourning and the funeral; to run, one must say, the whole show. 'What was clear was that we should shape the event.'[33] Campbell was a soulmate of the late Princess; and about her he produces perfect Hollywood phrases like, 'There was something about her eyes that went beyond radiance'.[34] Though she had enough propriety to refrain from engaging in party politics, the Princess could be shown as a kind of modern New Labour martyr. (By the Princess's own reported account she had 'gone for the caring angle'.)[35] Blair was (of course) intent on establishing 'the

30 Ibid., p. xii.

31 Ibid., p. xiii.

32 Ibid., p. 123. Cf. the old 'shared sovereignty', a mysterious phrase much used during the debates about accession to the European Union.

33 Ibid., p. 235. 'Those invited to the funeral in Westminster Abbey [about which a Church of England canon remarked to me that he thought the Abbey would need reconsecrating] included the Al Fayeds but not all the Lords Lieutenant' (p. 236).

34 Ibid., p. 59.

35 Ibid., p. 152.

new modernised monarchy',[36] and his opinion of Diana was that 'You tap deep into the psychology of the nation'. She was, anyway, an even more naturally gifted communicator with the media than Campbell himself. Between them they made a great national occasion — telling *what* about the nation? Full of demonstrative emotion, signifying ...? 'We agreed that it was fine to be emotional, and to call her the People's Princess.'[37] 'She will become an icon straight away,' said the PM, noting that if she had survived to have issue by Dodi Fayed, her popularity could have slipped, 'But this will confirm her as a real icon'.[38] It was Campbell's job to make sure the prophecy was self-fulfilling. Princess Diana was an incarnation of the *modern*, 'a real asset, a big part of "New Britain"'.[39] Neither *icon* nor *People's Princess* nor *New Britain* has any connection with the British constitution. Campbell wept.[40] Oh for an Evelyn Waugh to make a novel out of it! But in fact his son Auberon was as overcome as Campbell.[41]

······

Since Socrates rebuked and defeated Gorgias, rhetoric has had a very mixed reputation. Classical rhetoric, including gestures, pointing, even biting the thumb, can still be found practised by barristers who notoriously are there to persuade judges and juries of the rightness of their client's case, whether or not that coincides with the establishment of the truth. Witnesses who have sworn to tell the truth, the whole truth and nothing but the truth will be restrained if they try to make it persuasive. But then the Old Testament prophets were convinced they were telling the truth, and truth of a kind that could not have been expressed without poetic language.

The concept of 'spin' is the modern version of what Socrates thought of as sophistry and rhetoric. But this assumes that the rhetorician has a better notion of the truth, which the spin is deliberately misrepresenting. My question is whether for Campbell and/or Blair there was any *what* behind the spin: did they know what they were spinning? Or was spin their own first language? Campbell, the *Mirror* man, thinks the media have got worse[42] and he had to feed them what they demanded. But has he anything else? Was all the spin

36 Ibid., p. 152.
37 Ibid., p. 232: 'The People's Princess was easily the strongest line ...' (p. 233).
38 Ibid., p. 232.
39 Ibid., p. 233.
40 Ibid., p. 233.
41 Cf. Appendix 3 to my book *Untied Kingdom* (Bishopstone: Brynmill Press, 2008).
42 Campbell, *Blair Years*, pp. xxvii, xxix.

just for public consumption, underlying which deep thoughts were going on in Mr Blair's office? The evidence of the diaries gives no support for this hope. The language of spin was the language of politics, and the Labour Party has never been so successful before or since.

> Up by 6 and in to see TB who was already at the table in the window, and in full flight. He had decided on the 'age of progress' and 'achievement' as a driving theme, which everyone but him thought was crap, and the first thing to do was persuade him to go for one or the other, and achievement it was. It was more aspirational ...[43]

But had either of the competitors, 'age of progress' or 'achievement', any meaning? The same speech included, to bring the house down, 'Labour's Coming Home'.[44]

It is not irrelevant to notice that Mr Blair, like his predecessor Mrs Thatcher, was a committed Christian. He celebrated leaving office by being admitted with fanfares into the Church of Rome. But there was a kind of dissociation of sensibility. What the Christian faith actually meant to Mr Blair was not apparent in his words or his actions. Campbell's famous remark 'We don't do God' did not, apparently, provoke the further question, 'Why not, if your leader is a serious Christian?' Campbell gives the reason: 'I could see nothing but trouble in talking about it.'[45] The invasion of Iraq was not, despite the natural interpretation of the followers of Islam, a crusade; in fact one of the direct results has been the near-extinction of the Church in Iraq, which did not as far as I know worry New Labour. What did Blair think the invasion was for?

The same question is to be asked of the enthusiastic bombing of Libya ordered by the later Conservative premier, with comparable results. For it is, alas!, not true that the senselessness of politics is restricted to the recent not-quite Left. Contemporary with Mr Blair was the Conservative opposition led, after two changes, by the present (2016) Prime Minister. He too has his spin apparatus and the question we have had to ask about Blair-Campbell arises again: is there anything to be spun or is the spin itself the substance? At the time of writing Mr Cameron's first 'director of communications' has been released early from gaol. His qualification for both was his editorship of the most

[43] Ibid., p. 135. This, 01/10/96, was *before* Labour came to power.
[44] Ibid., p. 135, caps. original.
[45] Ibid., p. 111. He seems not to know much about British religion. 'They had not said prayers specifically for her at Balmoral' — for Princess Diana, that is, after her death. Prayer for the dead is unorthodox in both the Church of England and the Church of Scotland.

senior of the Sunday tabloids, the *News of the World*, which after a long history of profiting from lubricious scandal was closed down after its own phone-hacking scandal. Rebekah Brooks, *also* a former editor of the *News of the World* and *The Sun*, has resumed her career with Murdoch newspapers after acquittal on charges of complicity in phone-hacking. Mrs Brooks was a personal friend of Prime Minister Cameron and they are reported to have gone riding together.[46] Is it not likely that Mr Coulson, Mrs Brooks and Mr Cameron all speak the same language—that of the Murdoch tabloids? It was Mr Blair who brought in the practice of making important policy statements in them—including the *News of the World*[47] – not the House of Commons, and the Conservatives have not discontinued it. Naturally, whatever is written in *The Sun* has to be within the range of what it is thought the *Sun* readership can take. Which again raises the question: is there anything underlying the *Sun*-style declarations?

Mr Cameron does give the impression of trying to be serious; but he lacks the language.[48] I have in mind one piece of legislation with which Mr Cameron will always be personally associated, the bill legalizing what in spinese is called 'gay marriage'. The Conservatives were under no obligation to introduce this legislation, which did not appear in their manifesto. It should also have raised, not for the first time, the unanswerable question what right Parliament has to legislate on morality, if what is right or wrong cannot be settled by majority vote. Mr Cameron must surely have had compelling reasons, and an understanding of the nature of marriage in English society. He is on record several times as saying that the UK is still a Christian country. Surely he had thought hard about how it can be good to introduce a kind of marriage that cannot be administered by the Church of England? There is no evidence that he ever gave the matter any thought at all, or that he has much understanding either of marriage or Christianity or England —because his mind and his language are unclear. All he said was that he was 'passionately' in favour of gay marriage, because marriage is such a good thing it is a pity to deprive homosexuals of it. *Why* Mr

46 During her troubles, however, '"Cameron and that lot have just dropped her and run away," Dunstone said this week, though Tony Blair remains loyal … "Her connections with powerful people like Tony Blair will be a valuable asset in any organization," said PR consultant Mark Borkowski' (*Guardian*, 27/06/14; http://www.theguardian.com/uk-news/2014/jun/27/what-next-rebekah-brooks-future).

47 Campbell, *Blair Years*, p. 24. Statements drafted by Campbell.

48 Cf. on the Edgeways website, http://www.edgewaysbooks.com/columns.html, columns 62, 65, November 2010 (on how Aneurin Bevan was so much better educated than Eton-and-Oxford David Cameron).

Cameron thinks it a good thing is quite obscure, and why he thinks it is *the same* thing if extended to homosexuals is obscure. Some reasoning was necessary, but the declaration of passion took its place. I noted at the time the grounds on which the three most senior members of the Cabinet after the Prime Minister supported the bill to allow same-sex marriage, in a letter published in *The Daily Telegraph* on the decisive day for the bill, Tuesday 5 February 2013. Everything offered in support was subject only to the Blair criterion of the Modern. 'We have moved on ... whether it is any longer acceptable ... evolved over time ... a substantial majority of the public now favour ... support has increased rapidly.' The Modern conclusion necessarily followed: 'This is the right thing to do at the right time.' So right is not the opposite of wrong and not the opposite of unreasonable, but is what the mood of the age dictates.[49]

This is also the line taken by our whole establishment when dealing with serious challenges to its methods, assumptions, 'values'. There is no need to argue about the last, and a good thing too, because (see below) it is hard to produce an articulate statement of 'British values'. All you need is three words, *extremist*, *populist* and *radical*. Attach them to your opponents and your work is done, with no disturbance of establishment equanimity. (Do not worry about the contradiction between the disapproval of *populism* and your adherence to *the will of the people*, because nobody will notice it.) *Extremist, populist, radical* and *radicalization* are as effective as *racist* or *sexist* in putting down people who disagree with the establishment on some counts, effective as 'Open Sesame' for getting into the cave of the Forty Thieves. Smaller implements are *unacceptable* and *inappropriate*. All these have in common the characteristic of refraining from any gesture towards thought or reason. If something is unacceptable that's that and there is no need to say why. To the extent that these terms mean anything they all mean 'not modern', and 'modern' means anything we happen to do at present. But does not politics need something more like reason for the formation of common consciousness?

······

Two sources that can be taken to represent the general level of British politics, in the view of people whose livelihoods depend on knowing

49 Blair missed the chance to anticipate Cameron, but Campbell reports him as instinctively leaning 'to the right' about 'some moral choices we had to face' (Campbell, *Blair Years*, p. 221). Campbell gives as an example of this leaning the question of homosexual marriage: 'TB said he was in favour of gay marriages but would skirt around it in public' (ibid., p. 221).

what will interest most people: the home page of the BT website, and the free papers distributed at railway stations and on the London Underground under the title of *Metro*. BT, also known as British Telecom, is the descendant of the denationalized telephone service, and still has a monopoly of the maintenance of the wires. Here is a complete list of the headlines on its home page of 13 October 2015.[50] They do include a few political matters, but not very centrally:

World news
Playboy to axe 'passe' [*sic* not passé] images of total nudity
UK news
Nearly one in four Britons 'did not go on holiday in the past year'
UK news
Report into downing of flight MH17 'will say shot by Russian-made Buk missile'
UK news
Police to record anti-Muslim hate crimes as a separate category — PM
Latest News Headlines Editor's choice
Science
Could the woolly mammoth be making a comeback?
TV news
Dance Mums host Jennifer Ellison's top dancefloor tips
Phones & Tablets
Lights, camera, kitchen: 9 ways to control your home from your smartphone
More
Meet the woman who can remember everything
World news
Can you spot the inappropriate item in this hand luggage?
Family
Beat the bugs, colds and flu: How to keep your child healthy this winter

Just a glimpse of a later page, 6 December 2015: the headline when I accessed it was 'I'm a Celebrity 2015: Ferne McCann's spider trial prompts hundreds of complaints'. I don't suppose that any of the complaints were that it was not news.

As to *Metro*, 'The World's most popular free newspaper' (masthead): on 4 November 2015 the front page story did have some connection with politics: 'Junior doctors offered 11% rise to call off strike.' The other stories featured on the front page were: 'Richard Herring: Old flames? watch out for their gadget'; 'Gilded Lily: James is in bloom at top women awards'; 'Adele: Why I won't marry my boyfriend'; 'Farewell to brave miracle girl Kirsty'; 'Lashed Cowell lashes out at Malik'. *Metro* is not a celeb and gossip magazine such as take up so much of the space in supermarkets (three sides out of four of a

[50] The URL for BT's website is www.home.bt.com/news.

rectangle in the local Tesco) and which, after all, people have to decide voluntarily to buy. In the opinion of the experts in public relations who run *Metro*, these are the matters that occupy the British mind; and this is self-fufilling prophecy, for the passengers picking up their *Metro* have no alternative. 'The thousand sordid images / Of which your soul was constituted.'[51] Is celeb-fascination the bedrock British value?

British values are to be a compulsory part of the school syllabus. The Home Secretary in both the Cameron governments, Mrs Theresa May, is determined to make sure that hatred of Britain is not taught in our schools. Pupils who have been captivated by the ideals of the *jihad* are to be re-educated. Teenagers thought to be in danger of going off and fighting for ISIL or similar are to be subjected to compulsory de-radicalization sessions with experts in the art of moderating extremism. (If this had been in a communist country during the Cold War it would have been called *indoctrination*.) So it becomes necessary to be able to state, and with some evangelistic afflatus, what British values are. This is not easy. Firstly, as suggested above, our governing class don't know themselves what British values are, beyond the assumption that they are whatever happens to be taken for granted in Westminster, beginning with freedom to believe what you feel like and liberty to do anything that doesn't break the law. But, if British values are just agreement to differ, the evangelistic project is difficult, because the targets may object that they are only practising British values by having their own opinions and beliefs. Freedom, they might observe, is a sham if it is limited to what the ruling classes find 'acceptable'. It seems to me that the Government aims would be more coherently carried out if they restricted themselves to enforcing the law. If schoolchildren are being incited to practise acts of terrorism, the teachers are acting unlawfully and can and should be prosecuted. But if the state, increasingly detached from the Church, has recognized it has no authority to impose unitary morality (though it can ignore this in legislating about marriage), how can it rightly indoctrinate the children? And if British values are just agreement to differ and not impose our views on our fellow-citizens by force, they somehow don't sound very inspiring, or appropriate to the occasion of trying to re-educate the 'radicalized' young away from their 'extremist' tendencies. What is there in the programme of thought-control to make anybody *love* the poor old country?

But perhaps, if there really are British values, they cannot be made very explicit. Values are there, if anywhere, in the way words become

51 T.S. Eliot, 'Preludes', in *Collected Poems, 1909–1962* (first published 1917; London: Faber & Faber, 1963), p. 24.

value-charged, not in statements of definition. I wonder whether we would do better to think of 'value' rather than values.

That thence the *Royal Actor* born
The *Tragick Scaffold* might adorn:
 While round the armed Bands
 Did clap their bloody hands.

He nothing common did or mean
Upon that memorable Scene:
 But with his keener Eye
 The Axes edge did try ...[52]

In these lines there is a sense of the nation that went deep — as there is in the lines of Eliot we started with. Marvell does not need to add, 'And here we see British values, which are so-and-so', and if he had done so, the values would somehow have evaporated with the poetry. This 'making' of value is not by way of afflatus and the dulling of intelligence, nor by way of hoping for agreement. About the 'value' of the nation, almost any of Cromwell's letters could also be quoted (thanks to Carlyle, who saw their importance). They all create and express love of country. Two hundred years later, Churchill's war speeches likewise show, *inter alia*, the value of the nation, not by asserting but by assuming it. When he does assert, it can be comic, as when he retorted (in Ottawa in 1941) to what he reported as the defeated French generals' warning that in three weeks the Germans would wring the neck of the British chicken, 'Some chicken! [applause and desk-thumping] Some neck!'[53] The comic awe there does more work than pages about British values.

· · · · · ·

But, it may be objected, isn't what I call vacuous and thoughtless just politics? Has it not always been like this? Plenty of fun is made of elections by our 19th-century novelists, from Dickens a number of times, and from one who certainly knew all about it from the inside, Disraeli. I nevertheless think firstly that in Disraeli's time there may have been something more thoughtful going on behind the scenes, including Disraeli's own thoughts about two nations and the sense to be made of the second Reform Act of 1867. There was a change beginning, I think,

[52] Andrew Marvell, 'An Horatian Ode upon Cromwel's Return from Ireland', *The Poems and Letters of Andrew Marvell*, ed. H.M. Margoliouth (Oxford: Clarendon Press, 1927; reprint ed. Oxford University Press, 1967), I p. 88.
[53] Speech to Canadian Parliament, 30/12/41.

in the years of Macmillan, Heath and Wilson, and I commented on the vacuity of one Labour manifesto at the time.[54]

> The Country needs fresh and virile leadership.
> Labour is ready. Poised to swing its plans into instant operation. Impatient to apply the New Thinking that will end the chaos and sterility.
> Here is Labour's Manifesto for the 1964 election, restless with positive remedies …

So many years later, the rhetoric appears old-fashioned (nowadays *our* country is *de rigueur* and dependence on alliteration on *p* and *r* might have been less overdone). As I remarked at the time, this New Thinking does appear to be of a new kind, that is, thinking without thought. And with Wilson-and-Heath we are moving to the present situation, where the question is whether the powers behind the manifestos know any better. I think they still probably did, though not Wilson himself. In those days, though Aneurin Bevan was already dead, the Labour Party still included its future leader Michael Foot, and the Conservative Party Enoch Powell. During the next two parliaments they made sure, though they (narrowly) lost the votes, that in the debates on the great constitutional question whether we should join the EU, the gravity of the decision, what it really meant, was not altogether lost sight of. I doubt whether anything similar will be able to be said of the 2016 Referendum campaigns on continued membership.

A nation *is*, it exists as, what it understands itself to be. Sometimes this has to be revealed by politicians — or by prophets. (Ezekiel did not have to agonize over the values of Judah.) As I write, the Parliamentary Labour Party is in turmoil because of the election as their leader of a principled man who can reasonably state and explain what he thinks is good for the nation. Conscious of the scandal of the televised Prime Minister's Questions as a weekly few-holds-barred stage-managed shouting match, he has taken the revolutionary course of actually asking questions. We shall never get back to power like this, think the Blairites (who didn't get back to power as Blairites). In the media the gossip is about whether Corbyn will survive for a year as Leader of the Opposition. As one who differs from him rather fundamentally I hope so, for the sake of British politics.

[54] Cf. an essay in the regrettably short-lived *Oxford Review*, Hilary, 1968.

Michael DiSanto

The Multiversity
Has Lost Its Mind

The word 'university' derives from a shortening of the mediaeval Latin phrase 'universitas magistrorum et scholarium', meaning the whole body of teachers and students, united as a *community*. The word carries connotations of autonomy (albeit autonomy sometimes threatened), collegiality and communality in the pursuit of knowledge and understanding. This invokes an ideal which was not, needless to say, always realized in the long and chequered history of actual universities; but until relatively recently the connotations of the word 'university' still had some congruity with the reality of much of what it denoted.

We may well think that even this residual congruity has now been lost. In Britain, the Further and Higher Education Act of 1992 (England and Wales) set in train a process which eventually allowed, in effect, almost any organization, above a certain size, providing post-secondary-school 'education', to be designated as a 'university' and to assume, at least in theory, most of the legal status and privileges associated with that title. But perhaps the ease with which the relevant edicts were agreed upon and implemented merely confirmed their essentially cosmetic character as bureaucratic endorsement of a long-standing state of affairs, in which many of the universities themselves were no longer universities. The situation is not less troubled on this side of the Atlantic. A person who came to a Canadian university after working in the United States once joked that anyone with a driver's licence and a credit card can open a school and call it a university (or the closely associated term 'college') in that country.

For years before this, thoughtful academics throughout the western world had been dismayed by changes occurring in, or imposed upon, their institutions. The significance of the element 'uni' in their designation as universities had become weakened, if not *entirely* lost. In Canada, the distinguished philosopher, George Grant, registered this

by coining the 'ugly neologism "multiversity"'.[1] The substitution of
'multi' for 'uni' signified a major change: instead of maintaining a
space, physical and intellectual, that inspired the cultivation of learning
in the unified pursuit of truth—in my discipline what was once called
'the common pursuit of true judgement'—the 'university' had
gradually become the site of a mere congeries of multiple specialisms, a
facility which was not truly self-governed but *managed* like a factory.

In his essay, 'Faith and the Multiversity', Grant, who witnessed this
transformation from his position at McMaster University, wrote:

> [The multiversity] is an institution which has only realized itself recently
> in Europe and the U.S. ... In Canada it has only been realized in the last
> thirty years. I often meet people of my generation who speak as if the
> institutions their children or grandchildren are now attending are really
> the same as those they went to. But this is simply an illusion. The names
> for these places are the same, but they are such different places that they
> should have different names.[2]

Grant's essay is in the tradition of 'Signs of the Times' and 'Character-
istics', in which Thomas Carlyle observed the condition of England in
his time, and sought to understand it:

> We were wise indeed, could we discern truly the signs of our own time;
> and by knowledge of its wants and advantages, wisely adjust our own
> position in it. Let us, instead of gazing idly into the obscure distance,
> look calmly around us, for a little, on the perplexed scene where we
> stand. Perhaps, on a more serious inspection, something of its perplexity
> will disappear, some of its distinctive characters and deeper tendencies
> more clearly reveal themselves; whereby our own relations to it, our
> own true aims and endeavours in it, may also become clearer.[3]

According to Grant, 'The dominating paradigm of knowledge' that
determines the character of the multiversity is 'the project of reason to
gain objective knowledge ... the summoning of something before us
and the putting of questions to it, so that it is forced to give us its
reasons for being the way it is as an object'.[4] Among many academics in
the humanities and social sciences the contemporary parlance is
'interrogation', as in to interrogate a text, to interrogate a cultural

[1] George Grant, 'Faith and the Multiversity', *The Compass: A Provincial Review*,
 4 (1) (Autumn 1978), pp. 3–14, quote from p. 7. A later, expanded version
 appeared in *Technology and Justice* (Toronto: House of Anansi Press, 1986),
 pp. 35–77.

[2] Ibid., p. 6.

[3] Thomas Carlyle, 'Signs of the Times' (1829, reprinted in *Criticism of Thomas
 Carlyle*, ed. Michael DiSanto, Bishopstone: Edgeways Books, 2006), p. 19.

[4] Grant, 'Faith' (1978), p. 6.

practice.[5] Grant suggests that in some areas of the humanities and social sciences, 'the project of objectivity most obviously shows its limitations'. (I am not sure that this claim can be made with assurance today, because people in those disciplines are hindered from, or rendered incapable of, perceiving them.) But he nevertheless acknowledges that the 'minority voices' in those areas of the institution 'will not turn the multiversities from their determined end. ... the destiny of western civilization, as far as learning is concerned, is the project of researched objectivity'.[6]

Like Carlyle in the England of 1829, we now occupy a 'perplexed scene' regarding institutions of higher education. We don't know where we are. As Grant indicates, a significant part of the problem is language. We continue to use the word 'university' when the proper meaning of the word—the reality it evokes—is of the past, not the present. By continuing to call these places 'universities' we keep ourselves from seeing them as they are. To borrow from Nietzsche's manner of thinking for a moment: the university is an idol, the multiversity is a reality. This problem in our language is not limited to the name of the place, but extends to the language current in the institution.

In writing this essay, my situation is like Grant's, who says in the later, expanded version of 'Faith and the Multiversity', 'I am concerned here as one of those who find themselves trying to live seriously in the multiversity'.[7] Grant suggested that to understand this situation one might well start by pondering the significance of Charles Darwin. It is true that Darwin's 'discoveries had a determining effect on modern biology'[8] and, as Grant argues, the methods of science are intertwined with the emergence of the multiversity.[9] He also insists on the significance of the fact that, as English speakers, we inherit the literary tradition to which Darwin belonged as both reader and writer.

For the purposes of this essay, I want to consider not Darwin's science, but his own account of his reading habits and their relation to

5 The word is used with a peculiar naiveté, as if the academics are oblivious of recent history and the 'advanced interrogation techniques' made infamous during the administration of President George W. Bush.
6 Grant, 'Faith' (1978), p. 11.
7 Grant, 'Faith' (1986), p. 62.
8 Ibid.
9 Duke Maskell and Ian Robinson see that it 'is a place bewitched by science, or by a sort of folk idea of science—by its practices and language, of course, but also by its organization or structure' and the 'non-sciences model[...] themselves on the science in the (sad) hope of reproducing their success'. *The New Idea of a University* (London: Haven Books, 2001), p. 164.

changes in his mind and thought. Most people have heard of Darwin's *On the Origin of Species*, which was published in 1859. I expect few people know that Darwin wrote an autobiography in 1876, less than twenty years after the publication of *On the Origin of Species*, and fewer people have read it. With this in mind, I will reproduce the relevant passage at length.

> I have said that in one respect my mind has changed during the last twenty or thirty years. Up to the age of thirty, or beyond it, poetry of many kinds, such as the works of Milton, Gray, Byron, Wordsworth, Coleridge, and Shelley, gave me great pleasure, and even as a schoolboy I took intense delight in Shakespeare, especially in the historical plays. … But now for many years I cannot endure to read a line of poetry: I have tried lately to read Shakespeare, and found it so intolerably dull that it nauseated me. … On the other hand, novels which are works of the imagination, though not of a very high order, have been for years a wonderful relief and pleasure to me, and I often bless all novelists. A surprising number have been read aloud to me, and I like all if moderately good, and if they do not end unhappily—against which a law ought to be passed. A novel, according to my taste, does not come into the first class unless it contains some person whom one can thoroughly love, and if a pretty woman all the better.
>
> This curious and lamentable loss of the higher aesthetic tastes is all the odder, as books on history, biographies, and travels (independently of any scientific facts which they may contain), and essays on all sorts of subjects interest me as much as they ever did. My mind seems to have become a kind of machine for grinding general laws out of large collections of facts, but why this should have caused the atrophy of that part of the brain alone, on which the higher tastes depend, I cannot conceive. A man with a mind more highly organized or better constituted than mine, would not, I suppose, have thus suffered; and if I had to live my life again, I would have made a rule to read some poetry … at least once every week; for perhaps the parts of my brain now atrophied would thus have been kept active through use. The loss of these tastes is a loss of happiness, and may possibly be injurious to the intellect, and more probably to the moral character, by enfeebling the emotional part of our nature.[10]

If the multiversity had Darwin's level of self-awareness it would acknowledge a similar regression in itself. English poetry, drama, novels, and criticism have no real place in the multiversity. They are not recognized as serious forms of thought in a milieu dominated by unexamined scientistic assumptions, according to which thinking is wholly in the province of science. The displacement of literature entails

[10] Charles Darwin, 'From the Autobiography of Charles Darwin' (1887/1958, reprinted in *On the Origin of Species*, ed. Joseph Carroll, Peterborough: Broadview Press, 2003), p. 443.

the loss of the rich life of the language embodied in it, and of the ways of inquiring into and knowing the world and our lives that are particular to it. The 'curious and lamentable loss of the higher aesthetic tastes' in individuals engenders a loss in the life of the institution to which they belong, which is analogous to what Darwin observed in himself.

Despite saying that he could not conceive of the reason for this loss in himself, he immediately suggests that he might have avoided the atrophy, injury and enfeeblement he suffered by continuing to read Shakespeare and other poets.[11] The language and ways of knowing and thinking found in them are necessary for the mind to be 'highly organized' and 'better constituted'. The need to contemplate the relationship between the person who reads and what is read — the language of one and the other and the interrelations and interactions between them — is imperative.

Suffering from a disease that is analogous to the devolution of mind Darwin experienced, the multiversity too has repudiated Shakespeare, the pinnacle of our literature, and his descendants as 'intolerably dull' and 'nauseat[ing]'. The greatest mind in the English language — 'If I say therefore', Carlyle tells us, 'that Shakespeare is the greatest of intellects, I have said all concerning him'[12] — the writer who most fully realizes the life of the language, has no meaningful place in the highest educational institutions. Where he is taught he is made the subject and/or object of the 'approaches' of various schools of so-called literary 'theory' instead of being recognized as a mind that subsumes and envelops the reductive and simplifying tendencies of our contemporary age.[13] Why?

11 Gillian Beer and others demonstrate how Darwin's reading the language of Shakespeare, Milton and Wordsworth helped form the mind capable of discovering evolution and articulating it in *On the Origin of Species*. The language Darwin found in these books contributed to the organization of his mind, his thinking about the questions of the natural world that preoccupied him. Gillian Beer, *Darwin's Plots: Evolutionary Narrative in Darwin, George Eliot and Nineteenth-Century Fiction* (Cambridge: Cambridge University Press, 2009).

12 Thomas Carlyle, *On Heroes, Hero-Worship, and the Heroic in History* (1841, reprint ed. with Introduction by Michael K. Goldberg, Los Angeles: University of California Press, 1993), p. 91.

13 *The Western Canon: The Books and School of the Ages* (New York: Harcourt Brace, 1994) and *Shakespeare: The Invention of the Human* (New York: Riverhead, 1998) are two works in which Harold Bloom demonstrates Shakespeare's pre-eminence as a thinker and his ability to read, as if by postfiguration (to use a word of Bloom's), contemporary theory. Graham Bradshaw, *Misrepresentations: Shakespeare and the Materialists* (New York: Cornell University Press, 1993) makes an excellent argument analogous in kind.

The answer is simple: the multiversity has no understanding, cannot even begin to think, of the centrality of language in living. For that understanding, it would need to turn to those thinkers and writers who are most alive in language, past and present.

George Whalley diagnoses the illness that many academics and their indoctrinated students have:

> [W]e are very much inclined not to recognize how profoundly the quality of our thinking is affected by the state of mind we bring to the thinking. If we imagine that we are not changed by what we know, if we imagine that we are knowing-machines that are not modified by their own knowing, our attempts to get to know can become aggressive and can destroy what we thought we wanted to know.[14]

The mind becomes increasingly mechanical and the world it sees is an image of itself—a machine. I cannot claim to be immune. As the language of the institution in which I work changes, the words that are necessary for me to think are changing too. This is in the nature of language: we are all responsible for its health in our daily living, in the thinking and feeling we do in and with it. As we are constantly making and remaking the language, the language is making and remaking us.

The seemingly ubiquitous belief—I am sure it is not a shibboleth of the academic, because I've heard it outside the multiversity—that 'language is a tool' is a symptom of the disorder. We must be disabused of this dangerous and stupid nonsense. We cannot manipulate words as we do hammers or scalpels. A person of whom I am fond often tells me that if we, as professors, just look past the unintelligible writing and inarticulate speaking of those students performing poorly in our courses, we will discover there are valuable (perhaps even exceptional) ideas behind or beneath or in between the words. The intended generosity and kindness is founded on an error. In *Sartor Resartus* and his essays Carlyle corrected the 18th-century mistake of seeing language as the dress of thought by arguing that thought is *embodied* in language.[15] Later John Henry Newman followed Carlyle in arguing 'Thought and speech are inseparable from each other. Matter and expression are parts of one: style is a thinking out into language'.[16] Two aspects of one event, like thunder and lightning as Wittgenstein writes somewhere I believe, simultaneous in being and not one the cause and

14 George Whalley, 'Teaching Poetry', in *Studies in Literature and the Humanities: Innocence of Intent*, eds. Brian Crick and John Ferns (Montreal: McGill-Queen's University Press, 1985), p. 223.

15 Thomas Carlyle, *Sartor Resartus* (1833–34, reprint ed. Kerry McSweeney and Peter Sabor, Oxford: Oxford University Press, 2008).

16 John Henry Newman, *The Idea of a University* (1873, reprint ed. Martin J. Svaglic, Notre Dame: University of Notre Dame Press, 1986), p. 208.

the other the effect. If we do not come to a real view of the relationship between language and thinking, there is little hope for us to think better than we do now. Language has a life of its own, one in which all of us share and realize ourselves, and exerts a force on individuals that cannot be completely controlled or resisted. 'Language is no mere instrument,' George Whalley argues, 'and, if an instrument at all, the instrument plays on the musician as much as the musician plays on the instrument'.[17] In the 'Author's Note' to *A Personal Record*, Joseph Conrad makes a closely related observation when he dismisses the idea that he had to make a choice between writing in English and French. He explains,

> English was for me neither a matter of choice nor adoption. The merest idea of choice had never entered my head. And as to adoption — well, yes, there was adoption; but it was I who was adopted by the genius of the language, which directly I came out of the stammering stage made me its own so completely that its very idioms I truly believe had a direct action on my temperament and fashioned my still plastic character.[18]

Mark Halpern, in making a case against Noam Chomsky's linguistic theories regarding language and the innate faculty he calls a 'Universal Grammar', articulates an insight that complements Conrad's account:

> [T]he mind of the infant — or better, his brain — is so plastic, so malleable, so much more impressionable than even the traditional philosophic *tabula rasa*, that *it does not acquire, but it is formed by, the language it hears*. What accounts for an infant's picking up his mother tongue so quickly and effortlessly, under this hypothesis, is not that his brain is pre-structured in a certain way, but just the opposite: that his brain at birth is almost completely unstructured — he doesn't even have a *tabula* — and does not learn a language, but is shaped by it, literally organized by the language he hears. It is language that turns the brain into a mind, and it would be more accurate to say not that the child acquires the language, but that the language acquires the child.[19]

Having formed our infant minds, the instrument of language continues to play on us throughout our lives. It does not cease to shape us because our characters never lose their plasticity entirely. Within the multiversity, life is degraded not so much by the academic acquiring an

17 Whalley, '"Scholarship"', p. 82. Whalley was sensitive and alive to language from a young age, as he explains in an autobiographical reflection recorded in 1977 (which can be heard here: http://georgewhalley.ca/gwp/node/1802), and also a gifted amateur pianist.

18 Joseph Conrad, *A Personal Record* (1912, reprint ed. *The Mirror and the Sea & A Personal Record*, Oxford: Oxford University Press, 1988), p. v.

19 Mark Halpern, 'How Children Learn Their Mother Tongue: They Don't', *Journal of Psycho-linguistic Research*, 30 May (2015), pp. 2–3.

institutionalized and degraded language, as by that language acquiring the academic.

In some of his observations on the 'Age of Machinery' Carlyle might almost have been diagnosing the disease to which Darwin felt himself to have succumbed, when his mind became 'a kind of machine for grinding general laws out of a large collection of facts'.[20] In this respect the mind of the multiversity, and most of our public institutions and government ministries and offices, is an image of Darwin's in its later condition. (Dickens's satires on bureaucratic offices and its officers, among the best ever written, might also be mentioned here: Conrad surely had Dickens in mind when he depicted the Company Accountant in *Heart of Darkness*.[21]) Carlyle witnessed the emergence of the mechanical character of our modern world and calls attention to

> A mighty change in our whole manner of existence. For the same habit regulates not our modes of action alone, but our modes of thought and feeling. Men are grown mechanical in head and in heart, as well as in hand. They have lost faith in individual endeavor, and in natural force, of any kind. Not for internal perfection, but for external combinations and arrangements, for institutions, constitutions — for Mechanism of one sort or other, do they hope and struggle. Their whole efforts, attachments, opinions, turn on mechanism, and are of mechanical character.[22]

The transformation was unbounded: everything, in Carlyle's view, came 'under the same management'.[23] Every branch of life 'teaches and practises the great art of adapting means to ends', which forces everything to be done 'by rule and calculated contrivance' because 'some cunning abbreviating process is in readiness'.[24] Even education, Carlyle sees, has its machines to guarantee that 'Instruction, that mysterious communing of Wisdom with Ignorance, is no longer an indefinable tentative process, requiring a study of individual aptitudes, and a perpetual variation of means and methods ... but a secure, universal, straightforward business'.[25] Carlyle brings into view that which we have inherited: the mechanization and managerialization of the world. This includes the multiversity. In it one discovers everywhere the same

[20] Carlyle, *Signs*, p. 22; Darwin, *Autobiography*, p. 443.

[21] Thomas Carlyle (1795–1881), Charles Darwin (1809–1882) and Charles Dickens (1812–1870) were contemporaries.

[22] Carlyle, *Signs*, p. 22.

[23] Ibid.

[24] Ibid., p. 20.

[25] Ibid., p. 21.

spirit that animates Aunt Norris, who assures Sir Thomas Bertram that the 'most difficult thing' can 'be easily managed'.[26]

Gobbledygook: How Clichés, Sludge and Management-Speak are Strangling our Public Language, by Don Watson, is a valuable little book on the disorders prevalent in our contemporary speech and writing. Though the primary focus of the argument is not the multiversity, the book ought to be required reading for any academic.[27] As Carlyle did for the Victorians, Watson articulates the signs of the times for the contemporary world. While Grant is focused on the new religion of technology in the multiversity, Watson grapples with 'the new religions of technology and management', the latter having gained strength and prominence after Grant's time.[28] That much of what Watson says is true is explanation enough to understand why the book is not better known. A few years ago after I first read it I contemplated giving copies to the senior administrators of the multiversity in which I am employed, but desisted in my plan because they lacked the sense of humour and the critical self-awareness requisite to read the book. Watson has a clear view of the ever-advancing managerialization of the world. He has collected a wide range of specimens of the language that pervades it, words and phrases with which anyone employed in a multiversity is familiar: 'knowledge management', 'knowledge mobilization', 'deliverables', 'strategy', 'process', 'enhance(ment)', 'engage(ment)', 'learning outcomes', 'quality assurance', ad nauseam. What he says about the multiversity is uncontestable:

> In institutions where we might expect the most resistance the capitulation is most complete. … Now they talk about *achieved learning outcomes*, *quality assurance mechanisms* and *international benchmarking*. They throw *triple bottom line*, *customer satisfaction* and *world class* around with the best [he might have said worst] of them. …

26 Jane Austen, *Mansfield Park* (first published 1814, Oxford: Oxford University Press, 2008), p. 9. Is Aunt Norris related to Mr Collins? He is shown to be an ancestor of Sir Ronald Dearing by Maskell and Robinson in their lively dismantling of his 1997 report on higher education in which they begin with an examination of Jane Austen's *Pride and Prejudice* as a great work of literature about education. *New Idea*, pp. 63–71.

27 Don Watson, *Gobbledygook: How Clichés, Sludge and Management-Speak are Strangling our Public Language* (London: Atlantic Books, 2003). The other books that immediately come to mind, in addition to Maskell and Robinson, *New Idea* and Newman, *Idea*, are Alan Bloom, *The Closing of the American Mind: How Education Has Failed Democracy and Impoverished the Souls of Today's Students* (New York: Simon and Schuster, 1987); and Bruce Bawer, *The Victim's Revolution: The Rise of Identity Studies and the Closing of the Liberal Mind* (New York: Broadside Books, 2012).

28 Watson, *Goobledygook*, p. 16.

> The debates at the centre of Western civilization are now truly
> academic because they cannot be conducted in the language of
> managerialism or taught under managerial criteria in universities. Not
> only is managerial language an inadequate tool with which to explore
> these fundamental questions about the nature of truth, it has no respect
> for them. It is not a language for serious inquiry or explanation, or even
> for thinking.[29]

Like Whalley, Watson understands the reciprocal relationship between
the instrument and the musician. A development that arises from the
managerialization of the multiversity is the proliferation of policies and
procedures that comprise an essential 'piece of machinery which dis-
courage[s] human interference'.[30] The unpredictability of the human
must be removed; conduct must be prescribed and proscribed when-
ever possible. When a person does something unexpected that is not
regulated by a policy or procedure, a fear of the unexplainable means
new ones are quickly added. Bureaucracy abhors a vacuum and hates
the appearance of the random or unpredicted. The race for more
policies and procedures in institutions of higher learning has a comical
resemblance to the arms race between East and West in the last century.
Look at the University of Toronto website.[31] It has one hundred and
fifty policies and procedures. My institution is currently attempting to
achieve something commensurate with this big league standard. A
characteristic policy, one that epitomizes how the multiversity has
become a caricature of the university, is Service Excellence. The multi-
versity makes itself over to share the spirit of that epitome of our
current culture, the shopping mall, in order to compete for the huge
numbers of potential students who, after spending their teenage years
communing in one, have had their sense of the world formed by it.[32]
This means it must be 'committed to creating an organizational culture
of continuous quality improvement with a high focus on service
excellence and satisfaction'.[33] The customer comes first and is always
right, which leads to the belief that 'Enacting Service Excellence pro-
vides the foundation on which our attitudes and behaviours are
shaped'. And because nothing higher than a faith in customer service
can be imagined, the doctrine becomes the foundation for and

[29] Ibid., p. 121.
[30] Charles Dickens, *Hard Times* (1854, reprint ed. Oxford: Oxford University
 Press, 2008), p. 58.
[31] http://www.governingcouncil.utoronto.ca/policies.htm.
[32] See Maskell and Robinson, *New Idea*, Chapter 9, 'The Tree of Knowledge or
 a Shopping Mall?'.
[33] Algoma University, 'Service Excellence 2014', 30 November 2015, https://
 www.algomau.ca/administration/human_resources/serviceexcellence/.

guarantee of education of the highest quality: 'Service Excellence when modeled by every Algoma staff and faculty member creates an extraordinary learning environment in which our goals of academic, professional and personal excellence are achieved'.[34] And with this, the pursuit of truth is shown the exit.

Maskell and Robinson identify the problem clearly in this way: 'If we say that the language in which the universities now habitually conduct their affairs, and the language about public debate about education, denies the existence of the university ... we are making use of the fact that there is no separating judgement from language.' If the only language in the multiversity is 'a language which is itself the destruction of thought', then the multiversity doesn't have the capacity to know itself, to judge rightly of its own existence.[35]

Dickens understood Carlyle's lesson and in his novels caricatures many of the perverse and perverting uses of language that Watson catalogues. In *Hard Times*, which is inscribed to Carlyle, Dickens anticipates the changes in education and thought that precipitate the emergence of the multiversity. The story parallels, and may have been partly inspired by, the educational experiment that James Mill made with his son, John Stuart Mill, who wrote about the emotional and intellectual collapse he suffered as a result of it in his *Autobiography*.[36] Literature imitates life, and life imitates literature. As Darwin confesses, in his later years he became a version of the ideal student propounded by Thomas Gradgrind, the educationalist in *Hard Times* who begins with a desire to deliberately make a child's mind into 'a kind of machine for grinding general laws out of large collections of facts'. Unlike Gradgrind's daughter Louisa, who collapses after an education that leaves her struggling to live without any way to make sense of her feelings, Darwin's wound was self-inflicted. Louisa was deprived of poetry from birth, while Darwin lost it later in life.

The opening chapter of *Hard Times*, which introduces the character of Thomas Gradgrind, is entitled 'the one thing needful', an ironic allusion to Jesus's words to Martha.[37] For Gradgrind, the one thing needful, far from being the word of God, is the accumulation of *facts*:

[34] Ibid.

[35] Maskell and Robinson, *New Idea*, p. 62.

[36] See Chapter 5, 'A Crisis in My Mental History. One Stage Onward,' in John Stuart Mill, *Autobiography* (1873, reprinted, London: Penguin, 1989), pp. 111–44.

[37] This alludes to the story of Mary and Martha, Luke 10:42, in which Jesus commends Mary for putting the 'one thing [which] is needful', hearing His words, above household duties.

'In this life, we want nothing but Facts, sir; nothing but Facts!'[38] This short chapter shows us what Dickens, with a mind fully alive in the language, can do with style. It is a *tour de force* of style: the four short paragraphs are an exhibition of the significance of style as the embodiment of thought. As the Comte de Buffon said, '*Le style c'est l'homme même*' — the style is the man himself. Only minds fully alive in language can see the world and others in this way. This is one thing truly needful. It is exactly what Gradgrind and his descendents in the multiversity lack, because the language is deadened in their handling of it.

Another is revealed in the penultimate chapter of the first volume during a dialogue in which Gradgrind tells Louisa of a proposal of marriage made by his associate Josiah Bounderby. She asks him a number of questions: 'Do you think I love Mr. Bounderby?'; 'Do you ask me to love Mr. Bounderby?'; 'Does Mr. Bounderby ask me to love him?' The father cannot answer any of them. As many theorists do when a word, idea or problem which they are ill-equipped to handle because their isms and ologies do not allow for its reality, Gradgrind is evasive and tells his daughter 'the reply depends so materially, Louisa, on the sense in which we use the expression' and it 'may be a little misplaced'. The means of escape is always at hand through the simple recourse of denying the existence of a reality: 'The ignorant and giddy may embarrass such subjects with irrelevant fancies, and other absurdities that have no existence, properly viewed — really no existence.'[39] Dickens shows us the importance of language, especially the words academics have at best neglected and at worst desiccated (love, wonder and virtue come to mind). He also shows us the importance of conversation in this non-conversation. Father and daughter cannot have a real conversation because neither understands the meaning and significance of marriage and love. For Dickens, conversation is another thing needful. And the quality of the conversation depends on the language and ideas of the persons involved in it. For Dickens, as for Jane Austen, George Eliot and other novelists in their tradition, conversation is life, and life is conversation.[40]

In *The Idea of a University* Newman writes of the importance of educating the whole person, of education making a person whole: 'it is an acquired illumination, it is a habit, a personal possession, and an

[38] Dickens, *Hard Times*, p. 7.
[39] Ibid., pp. 94–5.
[40] See Maskell and Robinson, *New Idea*, Chapter 3, pp. 63–71, 'Jane Austen, Leading Authority on Liberal Education'. Austen is a leading authority because she understood and represented conversation as central to our living.

inward endowment.'[41] In the multiversity, this notion has no place because it is not measureable. It has been replaced with the drive to inculcate the use of tools and skills. And these things are bound together with the ologies and isms that have taken the place of the pursuit of knowledge and truth. Students arriving in the multiversity today are greeted with 'the general injunction' to 'go and be somethingological directly'.[42] The advantage of becoming something-ological is that the difficulty of disciplining the mind to think well and of making arguments is rendered unnecessary: 'the most complicated social questions [are] cast up, got into exact totals, and finally settled.'[43] Another advantage is that one must only learn a narrow language and style dictated by and formulated in some combination of ologies, isms and ations (of the last, the ones most often repeated within my hearing are internationalization, indigenization, differentiation and prioritiza-tion), and in this language and style render the world and its inhabi-tants into explanatory categories with ease and simplicity. The mind ceases to notice subtle complexities in existence and what it does see is coloured by ideas bound up with whatever intellectual hobbyhorse dominates. Louisa's mind is shaped by economics and numbers as she registers the population of her town as

> Something to be worked up so much and paid so much, and there ended; something to be infallibly settled by laws of supply and demand; something that blundered against those laws, and floundered into difficulty; something that was a little pinched when wheat was dear, and over-ate itself when wheat was cheap; something that increased at such a rate of percentage, and yielded such another percentage of crime; and such another percentage of pauperism; something wholesale, of which vast fortunes were made …[44]

The world becomes a collection of things: individuality and particu-larity evaporates. The professors have been trained to be somethingo-logical. They train the students to be somethingological. A number of those students go to graduate schools to become more specialized in somethingological and either take that disposition out into the world or, for the few who can secure academic jobs, back into the multi-versity. Another group of students go to what are now called teacher education programmes and, for those who can secure employment in education, carry their somethingological dispositions into the schools.

[41] Newman, *Idea*, p. 85.
[42] Dickens, *Hard Times*, p. 22.
[43] Ibid., p. 93.
[44] Ibid., p. 149.

Their students hear the ologies, isms and ations in the schools and arrive in the multiversity already initiated.

The multiversity has both a language problem and a conversation problem, although in our age it isn't acceptable to acknowledge problems: they are therefore translated into 'challenges' or 'barriers' and any threat they pose is diminished by holding firm to the belief, as if following the example of Aunt Norris, that these are readily overcome with the proper application of skills and tools. The best prescription to decrease the symptoms and perhaps cure the illness is a wide range of reading in the best of literature, what Matthew Arnold referred to as the best that is thought and known. Those who spend more time with Shakespeare and Austen will encounter conversations conducted in a language that doesn't have a home in the multiversity. What we become 'depends on what we read, after all manner of Professors have done their best for us', as Carlyle wrote, 'The true University of these days is a Collection of Books'.[45] We must make our own collection.

The multiversity — those of us who inhabit it and are willing to acknowledge the failures of it and ourselves — might prepare a confession for the historians who later arrive at a better knowledge and look back on this period: 'I beg to be allowed to assure you that I have had no particularly evil intentions, but have glided on from one step to another with a smoothness so perfectly diabolical, that I had not the slightest idea the catalogue was half so long until I began to turn it over. Whereas I find … that it is really in several volumes.'[46]

[45] Carlyle, *Heroes*, p. 140. 'What we become' is the phrase used at the start of the passage in today's popular reproduction of the remark easily found on the internet: 'What we become depends on what we read after all the professors have finished with us. The greatest university of all is a collection of books.'

[46] Dickens, *Hard Times*, p. 216.

Bogus Radicalism, Cultural
Frivolity and Criticism

Edward Lucie-Smith

Avant-Garde Lite
and Magical Thinking

The tendency for art to detach itself from any duty to reflect observed reality manifested itself in avant-garde art production almost from the beginnings of the Modern Movement in art. It is already present in pure form in Malevich's drastically reductive *Black Square*, which consists of exactly that, a black square on a white ground.

It is interesting to note the way in which this work was exhibited when it was first put before the public. Shown in St Petersburg, newly renamed Petrograd, in December 1915, in *The Last Exhibition of Futurist Painting 0.10*, it was hung high up in the corner of the room, across a corner. For a Russian audience, it was immediately apparent that it had been placed in the sacred spot that an icon of a saint would occupy in a traditional Russian home. In other words, it was an emanation of the sacred.

It is also interesting, however, to note further that recent technical research into the primary version of Malevich's painting has revealed a handwritten caption on the white border surrounding the square. It seems — rather surprisingly — to read 'Negroes battling in a cave'. This, researchers say, may be a reference to an 1882 all-black painting with a similar title by the French dramatist and poet Paul Bilhaud (1854–1933), which was exhibited in 1882 at the Paris Salon des Artistes Incohérents — a forum for satirical writers and artists. The image gained a wider circulation when it was appropriated in 1887 by another 19th-century French humourist, Alphonse Allais (1854–1905), and published as one of a whole series of blankly monochrome images in a satirical illustrated book entitled *Album primo-avrilesque* (*April-foolish Album*).[1]

Contemplating the *Black Square* today, the mind ranges further, and perhaps much more irresponsibly. It is hard for the contemporary spectator to avoid reading it, not as a thing in itself, but as a window leading to some mysterious world beyond the one in which the

[1] See http://www.wikiart.org/en/alphonse-allais/negroes-fighting-in-a-tunnel-by-night (last accessed 02/03/16).

spectator stands. It is, in these circumstances, ironic to reflect on the advice given by Leonardo da Vinci to artists in search of inspiration for a figurative composition:

> Look at walls splashed with a number of stains, or stones of various mixed colours. If you have to invent some scene, you can see there resemblances to a number of landscapes, adorned with mountains, rivers, rocks, trees, great plains, valleys and hills, in various ways. Also you can see various battles, and lively postures of strange figures, expressions on faces, costumes and an infinite number of things, which you can reduce to good integrated form.[2]

In fact, the history of Modernist abstraction has been both a search for the transcendental, and a flight from it. This is part of a more wide-spread phenomenon, embracing many ways of making art, including a number of now highly fashionable Post Modern forms.

On the one hand the supposedly avant-garde art of today has become increasingly quasi-religious, something that can be linked to what the Modern Movement inherited from Symbolism. This tendency has grown ever stronger in recent years. So much so that there has been an increasing shift of focus from what the artist actually produces — the object endowed with some kind of 'sacred' significance — to the personality of the artist himself or herself. Joseph Beuys, arguably the most influential figure in German art in the years immediately following World War II, embraced the idea of artist as shaman, saying:

> So when I appear as a kind of shamanistic figure, or allude to it, I do it to stress my belief in other priorities and the need to come up with a completely different plan for working with substances. For instance, in places like universities, where everyone speaks so rationally, it is necessary for a kind of enchanter to appear.[3]

Since Beuys's death in 1986, this concept has been taken still further by performance artists such as Marina Abramović. In May 2010, Abramović 'performed' (if that is the word) a piece called *The Artist is Present* at the Museum of Modern Art in New York. This is how a writer for *The New Yorker* described the event:

> Three years ago, when the performance artist Marina Abramović sat in the atrium of the Museum of Modern Art *for seven hundred and fifty hours* [italics hers], many of the people who had waited in long lines to sit across from her melted down in her presence. Abramović remained silent and still, enduring thirst, hunger, and back pain (and speculation as to how, exactly, she was or was not peeing), while visitors,

2 Codex Urbinas 35V.
3 Quoted in Caroline Tisdall, *Joseph Beuys* (New York: Solomon R. Guggenheim Museum/Thames and Hudson, 1979), p. 23.

confronted with her placid gaze, variously wept, vomited, stripped naked, and proposed marriage.[4]

In other words, contemporary art can now, in the eyes not only of a major official cultural institution, and also in those of the mass public drawn to that institution, be simply the impact produced by a certain kind of charismatic personality. It has become a substitute religion, though one without any kind of stable theological framework. And certainly without any central body of doctrine (disputed as this might be on occasion by various competing sects).

As another celebrated performance artist, Tino Sehgal, put it, in a public dialogue with the journalist Tina Brown at a recent Basel Art Fair: 'If it's art or not, I don't know if that even matters. But it's a kind of approach to contemporary life, which has surged in the last years. I don't know if these things would have been possible seven years ago.'[5] As his entry in Wikipedia states:

> All of Sehgal's works exist ephemerally and are documented only in the viewer's memory ... Sehgal's pieces are choreographies that are regularly staged in museums or galleries, and continuously executed by trained individuals he refers to as 'interpreters' for the entire duration of a show. The artwork is the constructed situation which arises between the audience and the interpreters of the piece.[6]

Sehgal was awarded the Golden Lion at the Venice Biennale of 2013, and was short-listed for the Turner Prize here in Britain in 2014. In other words, he is undoubtedly an 'official' artist—in no sense an outsider in the world of international contemporary art.

Even when the focus remains on the object rather than on a charismatic individual who may or may not actually create objects, the artwork often becomes what has been described as a 'crypto-relic'. Its visual attractions, if it possesses any, are secondary to its purely symbolic value.

When contemporary art throws itself into the arms of primitive forms of magical thinking, as is apparently the case in the examples I have just cited, do its claims to be genuinely innovative become greater or less? Certainly it isn't offering its target audience anything that genuinely hasn't happened before. Sporadic outbreaks of mass hysteria, mysteriously motivated, seem to have taken place in most of the human societies now known to us. What took place formerly in sacred circles, or in great cathedrals, now happens in the museums that

4 Emma Allen, 'The Rapper Is Present', *The New Yorker*, 11/07/13.
5 https://news.artnet.com/people/tino-sehgal-tina-brown-art-basel-308991 (last accessed 02/03/16).
6 https://en.wikipedia.org/wiki/Tino_Sehgal (last accessed 14/04/16).

have replaced these as numinous, consecrated locations. Museum spaces are also, in the society we now have, indubitably part of the whole framework of official culture, often, though not invariably, financed by the state. This is, perhaps paradoxically, what gives what happens within them added emotional force.

To return to Malevich: abstract art continued to flourish, and remained firmly within the world of objects during the concluding years of classical Modernism, and has survived successfully within the new artistic universe created by Post Modernism. It nevertheless, within this changed context, raises questions of its own about the idea of avant-gardism, as this was inherited from the Modernism of the early decades of the 20th century. The Minimalism that in the later 1960s challenged the exuberant success of Pop Art put forward the idea that the art objects should be non-referential things-in-themselves, closed off from social interaction. The Puritanism of Minimalism seemed initially to be intended as a rebuke to the hedonism and materialism of Pop. In fact, matters were a good deal more complicated than this, and have become yet more complicated since.

Pop was a celebration of the dominance of American culture—even when, as in the case of one of the earliest and most seminal of Pop works, Richard Hamilton's *What Makes Today's Homes So Different, So Appealing?* (1956)—the art was the product of someone looking at popular American culture from outside.

It is, however, significant that *What Makes...* is a collage, which incorporates pre-existing images. 'Appropriation' has recently become a term much used by commentators on contemporary art, very often in terms that suggest that this is a very up-to-the-minute, avant-garde thing to do. Pop artists appropriated from the very beginning. Jasper Johns's *Flag* paintings, which also date from the 1950s, are appropriated from the familiar stars-and-stripes of the American national flag. What makes the work a painting, rather than a flag, is the use of encaustic paint (molten wax combined with pigment), which gives the work a seductive surface of lumps and smears.

Andy Warhol's *Marilyns*, which are among his most characteristic works, made immediately after the actress's death in 1962, are based on a publicity photograph issued in connection with the film *Niagara*—a photograph not taken by Warhol himself.

Roy Lichtenstein's *Drowning Girl* (1963) is a somewhat more complex example. The image is lifted from a comic strip, but also alludes to Hokusai's print *The Great Wave at Kanegawa*.

It can be argued that in all these three instances—Johns, Warhol and Lichtenstein—the artist concerned was following an age-old practice. Artists have always borrowed from pre-existing images, just as (we

now discover) Malevich did when producing the *Black Square*. They have then re-made what they borrowed.

By re-contextualizing, the leading Pop artists were transforming images that scarcely deserved to be described as art, in the form in which the artist first encountered them, into what would immediately be recognized as art, like it or not, in a perfectly traditional sense. In other words, they were playing a complicated game of hide-and-seek with the more sophisticated part of the art audience, In fact, it is quite possible to claim that Pop Art, in some of its most typical manifestations, is not at all populist. On the contrary — it is élitist.

Since then, appropriation has become an increasingly popular practice among contemporary artists seeking to establish avant-garde credibility. Lichtenstein graduated from using comic strip frames as raw material to making copies of various long-established Modernist masters, among them Picasso, but presenting them as if they had been subjected to typical comic strip printing processes. In 2013 his comic-strip pastiche of a Picasso portrait of Dora Maar sold at Christie's for $56.1 million, including fees. The purchaser, celebrity jeweller Laurence Graff, commented: 'It's a masterpiece and when you see one like this come up for sale, you only get one chance to get it.'[7] The fact is that Picasso's original of this bust-length portrait, painted c. 1939–40, would very probably have sold for much less. The Picasso is not a major work by the artist, and it does not come from the very best period of his work. $15 million would have been a high price, even in today's booming art market.

The appropriationist impulse met self-righteous Minimalism head-on when, during this later phase of his career, Lichtenstein produced some comic-strip versions of abstractions by Mondrian.

Other recent examples of appropriation, much publicized and often greeted with enthusiasm by professional commentators, are Sherrie Levine's series *After Walker Evans*, re-photographed from books illustrating Walker Evans' work; and more or less the entire contents of the retrospective exhibition *Double Trouble*, by the recently deceased American artist [Elaine] Sturtevant (1924–2014), presented at the Museum of Modern Art, New York, from November 2014 to February 2015, with a further showing at the Museum of Contemporary Art, Los Angeles, from March to July of the same year.

Sturtevant was until recently fairly obscure, though the MOMA press release for the show 'identifies her as a pioneering and pivotal figure in the history of Modern and Post Modern art'. Her rise to

7 http://wsj.com/articles/SB10001424127887324767004578486044238329314 (last accessed 02/03/16).

posthumous celebrity, accompanied by celebrations of her work in major institutions, has been astonishingly rapid, though it conforms to the old saying that the only good artist is a dead artist.

What did Sturtevant do? Essentially she made versions of works by better-known artists, not at all similar to one another in style, who happened to be her contemporaries. MOMA celebrated her activity as follows:

> Though her 'repetitions' may appear to be simply mimetic exercises in proto-appropriation, Sturtevant is better understood as an artist who adopted style as her medium and took the art of her time as a loose score to be enacted and reinterpreted. Far more than mere copies, her versions of Johns's flags, Warhol's flowers, and Joseph Beuys's fat chair are studies in the action of art that expose aspects of its making, reception, circulation, and canonization.[8]

An additional twist is that, in doing this, she often received full cooperation from the artists she copied. Warhol, for example, gave her one of the silk-screens used to produce his *Flowers* series, which was itself based on an image lifted from a Kodak ad. Robert Rauschenberg also cooperated with her.

Both Sherrie Levine and Sturtevant can perhaps be defended, at least to some extent, by saying that they have a position within the history of feminist art, repurposing images originally created by men. However, re-purposing is by no means the same thing as re-creating. Sherrie Levine's photographs of reproductions in books of Walker Evans' original prints can most readily be classified as 'the same thing, but done worse'. As such, they don't really do much to promote the cause they support.

Even less can be said, in positive terms, for the recent activity of Richard Prince, a celebrity artist represented by the powerful Gagosian Gallery, who originally made his reputation with paintings featuring cowboys, based on billboards advertising Marlborough cigarettes. His *New Portraits* exhibition, seen in this year's edition of the Frieze NY art fair, and recently also on view in London, are ink-jet printed enlargements largely taken from Instagram images found on a feed that belongs to a punk-rock/punk-burlesque group called Suicide Girls. Discovering that their images, in this guise, were being offered for sale priced at $90,000, the group retaliated by offering them to the public for $90 apiece.[9]

[8] http://press.moma.org/2014/04/sturtevant/ (last accessed 02/03/16).
[9] https://news.artnet.com/art-world/the-suicide-girls-richard-prince-302384 (last accessed 14/04/16).

There are of course examples in the art of the past when artists became obsessed with making new versions of existing artworks, to the point of ignoring what they saw in front of them. The court artists of the later phases of the Qing dynasty in China, endlessly making versions of works by Song and Yuan masters, offer a case in point.

What is different here is the element of double-think already alluded to — the conviction that contemporary art can manage to be both élitist and populist. Appropriation art approaches the spectator with a nod and a wink. You have to be aware of what is being appropriated to get the message — and you take satisfaction from the fact that you know what is being copied and others don't. The intended message doesn't get across unless the spectator has, somewhere in his or her memory bank, an image of the prime original. Appropriation, in its fully developed form, is addressed to the art-literate only.

There is also, though in a somewhat different guise, an element in 'appropriation art' of the magical thinking demanded from her audience by Marina Abramović and others like her. You frequently have to convince yourself that an image that makes a point of its entire lack of any element of what could be described as 'original', in any normal use of the adjective, must nevertheless be regarded as something radically new, something that contravenes all accepted rules in art, and deserves applause for its insolent courage in doing so.

One could, I suppose, claim that in these circumstances the idea of an avant-garde survives simply because of our continuing stubborn belief in things that, outside the framework supplied by what one might today call 'traditional avant-gardism', are self-evidently irrational. We need the myth, even when both reason and observation tell us that it has lost its relevance. Many things can be found in today's fictional avant-gardism that are, one might say, the gibbering ghosts of what existed when the concept was still valid. Only superstition keeps these concepts alive.

If one looks at today's supposed avant-gardism one sees certain very specific forces at work. They usually do not have any direct relationship to the traditional core functions of experimental art. Some of these forces are to do with changing attitudes towards sexuality. During the past few decades attitudes to sexual representation, at least in democratic societies, have evolved with astonishing rapidity, in step with attitudes towards sexuality in general. A measure of this, for those who, like myself, are based in Britain, can be found by looking back at the trajectory of the so-called YBA group. In 1997, when they first made a significant public impact, with the *Sensation* show at the Royal Academy, the YBA artists well deserved the descriptive title. Much, though of course not all, of the impact was created, here in London and

at a later showing in New York, by details of sexual representation—
mannequins by the Chapman Brothers with penises for noses; a Virgin
Mary by Chris Ofili, with images clipped from pornographic maga-
zines in the background and a breast made from a lump of elephant
dung. This painting recently fetched £2,882,500 at a Christie's auction.
The online *ArtDaily* report of the sale described it as 'a generation
defining work'.[10]

Last year (2015), at the British Pavilion at the Venice Biennale, there
was a solo show of work by a ranking YBA, Sarah Lucas, organized for
the occasion by the British Council, the agency responsible for pro-
moting British culture and British values abroad. This, among other
items, featured plaster casts of the lower halves of female torsos (some
modelled from the artist herself) with cigarettes stuck up their anuses
and/or their vaginas. The exhibition met with mild approbation, as
being 'less boring' than the stridently political content of much of the
rest of the Biennale. In other words, no element of shock—just a mild
dig in the ribs, evoking, maybe, a hastily suppressed snigger.

Sarah Lucas is now aged 53. Her career has followed a familiar
pattern in the history of British art—familiar long before the existence
of the Modernist avant-garde. David Hockney, banner carrier for the
cause of homosexual rights in the 1960s, is now OM, CH and a member
of the Royal Academy. Tracey Emin, prominent YBA, not backward in
coming forward with images intended to deliver sexual shock, often
mentioned in the same breath as Sarah Lucas, is, like Hockney, a Royal
Academician.

Can we honestly say that these sexual gestures from a solidly estab-
lished middle-aged artist, exhibiting in Venice as the official repre-
sentative of her country, had any perceptible contrarian effect? Did
they in fact embody any challenge of the kind we have been taught to
associate with the concept of avant-gardism? The answer must surely
be 'no'. The transvestite potter and tapestry designer Grayson Perry,
yet another R.A., has delivered the Reith Lectures on BBC television,
dressed in full fig when he did so. The segue from Lord Clark of
Civilization to the Frocky Horror Show was startling, but the ideas
expressed were pretty down-to-earth, eminently suited to a middle-
class, middle-aged BBC audience. Sarah Lucas's exhibition at the
British Pavilion in Venice fitted neatly enough into the same context.
Both events, sure enough, were emblematic of the cultural situation
from which they sprang.

10 http://artdaily.com/news/79658/Christie-s-London-Post-War-and-Cont
 emporary-Evening-Auction-achieves--150-069-359 (last accessed 02/03/16).

More important even than the transformation of attitudes towards both sexual orientation and the free use of forthright sexual imagery has been the shift in relationships between contemporary art of any supposedly radical tendency, and the general political scene. As the audience has become more and more inured to visual challenges — supposedly radical ways of perceiving the world — the emphasis has more and more tended to veer towards politics.

The problem often is that art, to communicate political ideas effectively, often has to renounce radical ways of seeing and aim for the lowest common denominator. The bulk of the art produced in the Soviet Union, from its foundation until final decade in the 1980s, offers ample proof of that.

The 2015 Venice Biennale, viewed on a wider scale, was surely a good case study of what happens when the supposed avant-garde tries to embrace political activism, while at the same time preserving a recognizably vanguard identity There can be no doubt about the strongly political orientation of the event, nor of its political intentions. The main exhibition, entitled *All the World's Futures* and curated by Okwui Enwezor, offered an 'epic live reading' — the description is quoted from the Biennale's official website — of all three volumes of Karl Marx's *Das Kapital*.[11]

Was this ritual actually going to convert anyone to Marx's ideas, rooted in the 19th century and already tested to destruction in Russia during the three-quarters of a century between 1917 and 1991? Clearly not. The readings were a rite, modelled on marathon readings of other major religious texts — the Bible, Testaments both Old and New, and the Holy Koran. They offered a clear idea of the current ritualization of politics within the context of art. Mouthing the words, making the politically correct declarations is more important than inducing any actual change in a wider arena.

To put things more brutally, was any substantial part of the large audience of tourists drawn to the Biennale going to go away converted to radical political ideas by anything put on view at this over-whelmingly huge display of today's art? Obviously, that was not going to happen. In contemporary society, with all the resources of modern technology available to ideologists and propagandists, activity here, despite the number of visitors, would not, by any stretch of the imagination, be an efficient way of delivering a message. The context forbids its reception. Hedonism wins hands down.

11 Okwui Enwezor, *All the World's Futures*: exh.cat. (Venice, 56 International Art Exhibition: La Biennale Di Venezia, 2015).

The truth is that the Biennale as a whole, and other regular events like it, in Istanbul for example, or in São Paulo, was yet another magical act, this time executed on a gigantic scale. Its efficacy can be judged by the extent to which the opening days of the event have become one of the preferred festivals of the international rich, happy to ignore any radical political content, even content aimed at their own way of life. 'Have another glass of champagne, darling—how lovely to see you here!'

As for the artists who also attended the big opening—yes, they had a purpose too. Their job was to maintain the fiction about artistic 'progress', and at the same time to provide the patrons with a petting zoo.

The situation was well described in a recent AICA Bulletin, published in conjunction with a recent AICA conference, held in London in October 2015. It quoted an exasperated outburst from the conceptual artist Hito Steyerl, whose work has been seen at the ICA, one of the most venerable—oh, the irony of that adjective in present conditions!— of London's avant-garde institutions. 'To brutally summarize a lot of scholarly texts,' he says, 'contemporary art is made possible by neo-liberal capital plus the internet, biennials, art fairs, parallel pop-up histories, growing income inequality.'[12]

This provides an almost perfect description of what I have myself described, in an earlier essay, as the situation needed for the growth and propagation of a world-wide brand called 'Avant-garde Lite'.[13] That is, we still have something we happily describe as an avant-garde, but we do not in our hearts expect it to have any discernible social or political effect. We would, most of us, probably be deeply upset if it showed genuine signs of doing so. Effective consumer advertising hyperbolically describes the sizzle in order to sell the steak—or that is what I was taught many years ago, when I worked as a junior copy-writer in an ad agency. The bulk of the audience for contemporary art would now prefer to have just the sizzle, and leave the steak to grow cold on the plate. Any appetite for real innovation has gone. The *appearance* of innovation will do well enough instead.

Here, for example, is a neat recent snapshot of the mood that now prevails at big contemporary art fairs, and at kindred events, such as the big international Biennials. It appeared in the *Evening Standard Magazine* (30 October 2014), and comes from a piece published in the wake of that year's Frieze art fair:

> As I navigated the giant Carsten Holler mushroom sculptures and the
> sleeping security guard who may or may not have been a work of art at

[12] http://aicainternational.org/en/congress-theme/ (last accessed 02/03/2016).
[13] *The Jackdaw*, No. 119, Jan/Feb 2015, pp. 8–9.

the VIP preview of Frieze art fair earlier this month, my focus drifted from the exhibits to the people standing studiously in front of them. Take away the art and you'd be forgiven for thinking you were at London Fashion Week—every turn revealed a glossy gallerist or collector with a Céline coat draped over her shoulders, power-walking the halls in Chanel trainers. There's a reason that Alexander McQueen and Gucci are both sponsors of the fair. Designer stores report bigger sales during Frieze week than at any other time of year (even Christmas). Now in its 11th year, Frieze has evolved into an unbeatable style barometer.

Just to be clear, the article in question wasn't primarily about contemporary art. The quote comes from a fashion report, centred on the demise of the so-called 'It-Bag'.

Since this piece appeared, Marina Abramović—already mentioned here—has announced her alliance with the couture house of Givenchy, founded in 1952 and a member of the Paris Chambre Syndicale de la Haute Couture. Givenchy is also now part of the powerful LVMH luxury group, which has outlets worldwide. It is in fact reported to be, in sales terms, the second largest company in the group, next only to Dior.

Ms Abramović and Riccardo Tisci, current creative director of Givenchy, were not previously strangers to one another when this new announcement was made. In 2013 she sold him her townhouse in NY's Soho for more than $3 million (well below market price, but still about $666 per square foot). Not long before, in 2011, Tisci edited a hardcover book published by *Visionaire* magazine, in a limited edition of 3000 copies priced at £385 apiece. It featured a photograph of Abramović breast-feeding him. I can't help feeling that there was something wrong with that image. What it should have shown is Abramović sucking on Tisci's male tit.

To revert to the Venice Biennale, as perhaps the most egregious recent example of the situation I'm talking about, here's a quote from the American critic J.J. Charlesworth, published on the internet site ArtNet News, just as the 2015 Biennale opened:

What the Biennale doesn't want to investigate is the mystery of its own creation. Why should it? Who really needs this vast moot for an increasingly homogenous and international style of slightly-political, issues-based art? Not the visiting public, for sure—we'll look at anything, but we're not the ones making it happen. No, who really needs it is the new global class of cultural entrepreneurs for which art has become a truly international opportunity, as the emerging economic regions seek to assert themselves on the world stage through the vehicle of the new global art culture. But however political these curators and artists think themselves, the art itself changes absolutely nothing. The Chinese still need oil, the European Union still shuts the door on

immigrants, Libyans still drown in ships sinking in sight of the coast of Italy—little more than subject matter for yet more self-regarding political art.[14]

Meanwhile resident Venetians, in a city that makes its living from mass tourism, could relax in the knowledge that, in a Biennale year—never mind the carbon footprint—the number of visitors was bound to go up. And with it the amount that visitors spent in Venice's hotels, restaurants and souvenir shops. Long live Avant-Garde Lite! It feeds many, but disturbs no one. It makes a valued contribution to the settled order of things, now, in the second decade of the 21st century.

[14] https://news.artnet.com/art-world/56th-venice-biennale-politics-jj-charlesworth-295350 (last accessed 02/03/16).

David Lee

State Art and
Its Commissars

Arnold Goodman, Chairman of the Arts Council from 1965 to 1972, observed: 'It is not the job of an unelected body to make cultural policy.'[1] Implicit here is an understanding that the Arts Council, whose members are unelected and minutes for whose meetings are not published because they are not taken, must respond to what artists produce and not presume to impose conditions upon them. Goodman's common sense might have been true of the Arts Council in those innocent days, but it couldn't be further from the case now. Today, in the visual arts, not only has the Council arrived at a hard-line policy uncompromisingly enforced by true believers, but they are also apparently unconcerned that their chosen protocol excludes the majority of artists whose needs the Council was originally set up to meet.[2] Unfortunately, all other major institutions responsible for contemporary art's organization subscribe equally ardently to the same prescriptive credo. This divisive policy was not the creation of any one of these bodies alone, but—as we shall discover later—the result of coinciding attitudes occurring in all of them at more or less the same time.

For twenty years I have been referring to this closed shop as 'State Art'—a phrase deliberately chosen for its echoes of autocratic regimes —because what we are forced to endure in Britain in the visual arts represents just as narrow a tyranny as the Soviet Union's adoption of Socialist Realism as its approved style. Both represent intolerant and oppressive dictatorships, the only difference being that the battle between futurism and populist realism continued in the USSR for

1 Quoted in Roy Shaw, *The Arts and the People* (London: Cape, 1987), p. 53.
2 The Arts Council, Great Britain was set up in 1946, but replaced by separate National Arts Councils for each of the constituent nations in 1994, with the Council for England being renamed Arts Council England (ACE) in 2002. In this essay, post-1994 references to the Arts Council are specifically to that for England.

fifteen years from 1917, after which the latter won. Our own version of
State Art is declaimed by an exclusive élite, who claim specialist knowl-
edge and insight about work that is solipsistic and cannot be judged by
any agreed criteria. Ruthlessly untraditional, this frequently puerile
individualism is imposed upon the rest of us. Of course, we enjoy the
freedom to seek out other work if we can find it, but State Art's domi-
nance, and especially its close partial control of the purse, ensures that
this is made difficult and inconvenient. As officially sanctioned ideol-
ogues of approved taste, there is little to choose between Serota and
Zhdanov. State Art is a lockdown.

During the 1980s a definite ideology for the visual arts achieved
critical mass. It was based on a belief which had been slowly
fermenting over several decades. Its motivation was a desire to
discriminate against conventional art styles and mediums now con-
sidered old fashioned, boring, irrelevant and unnecessary. What was
traditional and familiar would play no further part in any official policy
for the visual arts. Thus, by promoting only what was by its novel and
experimental nature unfamiliar and difficult to grasp for most viewers,
the Arts Council showed contempt for the needs of its potential
audiences, those whom, or so it claims perennially in official docu-
ments, it is endeavouring to please. In short it began to give to viewers
the kind of work preferred by those who ran the organization, not what
its intended audiences might wish to see, and certainly not what the
majority of artists were producing.

Many will have forgotten just how shamelessly corrupt was the Arts
Council's administration at that time. A Visual Arts Committee,
scrapped in the mid-90s following a campaign of bad press in the
Evening Standard and *Art Review* (all inspired by Michael Daley's
groundbreaking research published in the correspondence columns of
Art Monthly from July 1981 onwards), comprised in large part those
who were themselves major recipients of the Council's largesse.[3] Not
surprisingly, and while they had the chance, they voted for the con-
tinuation of their own livelihoods. Nakedly self-serving, the whole
edifice stank, but a precedent of keeping all decision making securely
in-house had been established. Only reliable supporters of the new
direction would ever be allowed close to the levers of control. This
policy remains intact today.

3 'Who gets what awards?', *Art Monthly*, correspondence July 1981–
 November 1982. See my evidence to Culture, Media and Sports Committee,
 Funding of the Arts and Heritage, Third Report of Session 2010–11, Vol. 2
 (London: Parliament, House of Commons, 2011), p. 76.

Simply stated, the Arts Council's adopted policy is one in which a single mindset alone is tolerated. Newspapers call it 'Conceptual' or 'Minimal', roughly equating it with work featured annually in the Turner Prize; that is, in the opinion of State Art's chosen apostles, the most outstanding contribution made by a visual artist under 50 during the previous twelve months. It is, of course, taken as read that the most outstanding contributions will always be 'conceptual' in nature. With typical vagueness, the Arts Council calls its preferred work 'innovative' or 'challenging', with additional reference to its favoured demographic, 'young and emerging artists'.[4] The Council has the nerve to describe this narrow perversion as 'encouraging *good* practice' (my italics). Good as opposed to bad; bad meaning the majority who refuse to conform knowing that such a decision will condemn them to permanent obscurity.

This obsession with the young introduces the ugly realization that the Arts Council's visual art department operates an age bar. This bias prevents established artists of different generations and stylistic inclinations from receiving the retrospectives that their long careers merit, and which only a generation ago they would have received in the Council's expanding network of galleries. For example, in 2012 the last living Official War Artist of the Second World War, Leonard Rosoman, died at 98. He had a long and varied career in illustration, painting and poster design and had been a member of the Royal Academy for nearly forty years. So where was the curator in any of our many public galleries curious enough to bring together a commemorative survey of his work? On the other side of this coin are ranged the fashionable middle-aged conceptual artists many of whom are on their second touring retrospectives courtesy of the Arts Council. Perhaps some, like myself, may remember those days when public galleries organized retrospectives of older artists as they approached the end of their career. This is no longer encouraged, with the result that tracts of significant art history have vanished on the wind. Through the Arts Council's obsessions we have lost far more than has been gained.

The preferred State Art style is one from which conventional art skills have been extirpated, the kind of work from which actual 'making' by the artist himself can be entirely absent. The principal tool of the favoured State Artist would appear to be the mobile telephone, used to commission others to make the work they can then exhibit as

4 E.g. http://www.artscouncilcollection.org.uk/collection/acquisitions (last accessed 08/04/16). Arts Council England, *A Review of the Arts Council Collection, British Council Collection and Government Art Collection* (London: Arts Council England, 2012), p. 19.

their own. Reflecting the bewilderment of many at this 'advance', Sir Tom Stoppard commented when speaking as a guest of honour at a Royal Academy dinner: 'The term artist isn't intelligible to me if it doesn't entail making.' He was roundly denounced by protectors of the State Art flame for being reactionary—which was rich coming from them.[5] What does he know anyway? Perhaps he should commission someone else to write his next play—he could describe roughly what he requires and then pass off their work as his own because it was, after all, his idea in the first place.

In a successful inversion of ancestral art practices, the new culture commissars have made a virtue of lauding the unskilled; to be without craft is State Art's chief membership qualification. There are those among the sort of brainwashed drones competing for preferment on the slopes of State Art who talk and write with approbation about the de-skilling of art education, as though this were laudable. Only in contemporary art could such a posture be treated other than with derision. Try applying so perverse a position to any other art form. What might 'de-skilled' acting look like? And what would 'de-skilled' musicianship sound like? Since when was learning skills so oppressive? The entire world is 'skilling up' whilst in British art education it is deemed desirable to skill down by teaching nothing at all.

The finished policy of State Art is, of course, a travesty of what should reasonably be demanded of a body disbursing public money. And it is unashamedly nepotistic in allocating subsidy only to those in its immediate family who exhibit similar sympathies, funding now being contingent on rigid compliance with the doctrine.

This orthodoxy has, nevertheless, enjoyed the tacit approval of politicians happy to allow an organization nominally under its control to prosecute their prejudices using the sacrosanct convenience of 'The Arm's Length Principle'. This had been established in the 1940s because there was a need to be seen to be avoiding imposing an official, Government-approved art. (A century earlier, in a remark echoed by many Culture Secretaries down the decades, the then Prime Minister, Lord Melbourne, warned against government interference in the arts.)[6] After all, theoretically at least, our artists were freer than those in the Soviet Union. They could do whatever they liked, even if what was produced meant nothing to anyone except other artists and critics. Maynard Keynes was the first to realize that ministerial intrusion in

[5] E.g. *The Telegraph*, 01/06/01; *The Guardian*, 16/06/01.

[6] In 1835, according to Haydon, Melbourne remarked 'God help the minister that mingles with art'. *The Diary of Benjamin Robert Haydon*, Vol. 4, ed. Willard B. Pope (Cambridge, MA: Harvard University Press, 1963), p. 222.

decision making was undesirable. Appointed head of CEMA (Council for the Encouragement of Music and the Arts), a precursor to the Arts Council during the Second World War, he deviously insisted on reporting to the Treasury not to the arts or education ministries, who might interfere in matters of taste about which he naturally considered himself better qualified.[7] In many ways Keynes's superior attitude (he was an apostle of his older contemporary Roger Fry in this respect) provided the matrix for subsequent art bureaucrats, a breed who always think they know best what's good for everyone else—and which always conveniently equates to what they themselves prefer.

State Art has cleverly capitalized on this 'arm's-length'. It allows its functionaries to say one thing in public, thereby satisfying their pay-masters that they are doing the right thing for everyone, while implementing quite other policies in private. Piffle such as the Arts Council's recent legend 'Our mission is Great art and culture for everyone' (the emphatic capital is one of their specialities) is a typical example of this species of barefaced lie.[8] Their narrow policy in the visual arts works against achieving anything remotely approaching that claim. That they've got away with such prejudice and misrepresentation for so long is astonishing. The result is that the opposite of what the Government believed was the intended purpose of subsidy—that is, something from which everyone might benefit—has come to pass.

And it gets worse. This is a state establishment that has, furthermore, decided—again in the Arts Council's own words in a letter to me—that there is the 'right kind', and by implication the 'wrong kind', of artists.[9] This has nothing to do with the quality of the work an artist might execute. It comes down to this: if you do not work in the designated conceptual or minimal manner, preferably with a nod and wink to 'digital' media (the latest of their fads) you are the 'wrong kind' and will not have your work exhibited, promoted or collected. Figurative painters or sculptors working today, for example, will not only almost never have their work exhibited in Arts Council galleries but also only exceptionally will it be collected by any of the bodies designated to preserve works in national or major regional collections.[10]

7 Robert Skidelsky, *John Maynard Keynes: Fighting for Britain, 1937–1946* (London: Penguin Books, 2002), p. 287.

8 E.g. Arts Council England, *Corporate Plan, 2015–18* (Manchester: Arts Council 2015), p. 5, http://www.artscouncil.org.uk/sites/default/files/download-file/Corporate-Plan_2015-18._Arts-Council-England.pdf.

9 See e.g. David Lee, 'Who exactly are "the wrong kind of artists"?', *The Jackdaw*, No. 45, February 2005.

10 A sample of some recent Arts Council acquisitions can be seen at http://www.artscouncilcollection.org.uk/collection/new-acquisitions (last

The stranglehold of conceptualism across all sectors is virtually abso-
lute. As the distinguished figurative painter Stuart Pearson Wright
described this system in 2001:

> Few people these days really know how to paint well. Representational
> painters work in isolation because there is little critical or magazine
> coverage of this kind of work. Left to their own devices at art school, it
> seems that the only way to learn about figurative art is to study the
> work of the masters. It is easy enough to see the work of Rembrandt or
> Memling in the National Gallery but where can one see the work of
> one's contemporaries? ... Whose responsibility is it to buy for the nation
> worthwhile landscape, narrative scenes, portraits of anonymous sitters
> or other forms of representational painting? There is no national
> collection of contemporary representational painting as there is of
> installation, conceptual or minimal art. ... The most worrying manifesta-
> tion of this artistic dictatorship is its impact on art schools. Anyone who
> has attended a London art school in the last five years and has
> attempted to paint an easel picture will be aware of the feelings of
> antipathy towards representational painting that have passed down
> through the art establishment hierarchy and now strangle young
> painters. The pressure from tutors on young impressionable students to
> conform to the dictates of the market for trendy installations is
> inescapable for all but the most wilful individuals. I have heard a
> talented student warned by a tutor with great authority: 'Include those
> self-portraits in your degree show and it will adversely affect the
> outcome of your grade.'[11]

State Art's easy authority is assisted by the fact that little criticism of it
ever surfaces. No one dare question its absolutism, and few seem even
aware that a problem, or indeed an alternative, exists. Rare voices who
speak out against these excesses — and they tend to be older commenta-
tors with memories of better times — are derided for being mad or
ignorant, not looking properly or refusing to be open-minded, or are
accused of opposition for the sake of devil's advocacy and self-
promotion. Details of their arguments are contemptuously disregarded
and ignored by apologists who never offer convincing explanations as
to why State Art warrants its special exclusive status as a monopoly.
Like any other religion, State Art demands blind faith from its
adherents.

Apart from *The Jackdaw*, no voice now exists in print media
identifying the built-in bias State Art represents, not least because
many have grown up knowing it as the only show in town. Too many
arts correspondents, critics and other commentators are wary of

accessed 06/04/16). Of 33 acquisitions, only one was a work of figurative
painting of a recognizable kind.

[11] *The Jackdaw*, No. 11, September 2001, p. 29.

offending officialdom, in case privileges—free trips home and abroad, parties, prizes, books, catalogues, commissions, whispered promises of 'curatorial' patronage and other perquisites—are withdrawn or forgotten. And the BBC is no exception to this. Contrary to its charter, it makes shameless advertisements for State's Art's most favoured. Nearly 20 years ago now I was advised that my services wouldn't now be required on a television programme about a weak but over-promoted fashionable sculptor (now knighted!) because the artist's gallery had said it would refuse cooperation unless all contributors were first approved by them. So much for independent commentary. In 1994 when the *Evening Standard* art critic, Brian Sewell, dug in his heels against the ubiquity of State Art, which he dubbed 'The Serota Tendency', those benefitting from the system he lampooned, and whom in some cases he had mocked as little better than charlatans, orchestrated a letter against him asking for his voice to be silenced on all matters pertaining to contemporary art which, they claimed, he didn't understand.[12] Only those from within the system are considered reliable enough to comment upon it.

In 2001 *The Jackdaw* conducted a survey of broadsheet press coverage of the visual arts for a full year. The results, published in February and March 2002, demonstrated compellingly that only State Art was covered in newspaper criticism (and there is no reason to think that anything has changed in the last fifteen years). The only private galleries ever prominently reviewed in 2001 were those supplying nominees to the Turner Prize—indeed (no surprise here) they were the four galleries who supplied nearly all the first fifteen winners of that prize. *The Jackdaw*'s editorial in March ended:

> The coverage of visual art in newspapers does a disservice to the majority of artists while serving to keep their readership in ignorance of the true diversity of contemporary art. A related irony was illustrated early last year by the sad, premature death of the painter Sarah Raphael. Every paper gave news prominence to this tragedy as well as featuring extensive obituaries in which she was routinely declared a major figurative artist. None of these same papers, however, would ever have thought of reviewing her exhibitions. Why? Because if they are very lucky young figurative artists may, *may*, be vouchsafed a listing.[13]

If State Art's intolerant approach were replicated in an academic department of a serious university the lack of impartiality would be considered intellectually indefensible. Students would rebel. In art

12 See e.g. *The Independent*, 21/09/15.
13 David Lee, 'State Art: We show it exists', *The Jackdaw*, No. 16, March 2002, p. 7.

colleges, which have alarmingly high dropout rates, students do indeed vote with their feet. In a 2006 survey of student satisfaction in higher education, six of the bottom ten institutions were art colleges and the worst performing of all was the University of the Arts London (UAL), an unwieldy amalgamation of once distinguished colleges with distinctive characters. In 2015, UAL was in equal 158th place out of 160 higher education institutions for student satisfaction.[14]

The dictatorship ruling the visual arts is against the fundamental principles of any fair art subsidy; namely, that it should have no policy, express no preference and recognize excellence wherever it alights on the widest possible spectrum of styles, attitudes and mediums.

How State Art Emerged

After 1945 a slow-motion revolution took place in art, and especially in its education, exhibition and collection. Changes evolved alongside a growth in public funding. It would be a crude but not an entirely inaccurate simplification to say that as subsidy increased so the further away from its traditions art travelled. At this early stage in its development it would also be an exaggeration to claim causal dependence between change and subsidy, because change, especially in art education, appeared inevitable anyway. Now, in 2016, we can say incontrovertibly that, without Government support, art of the State-Art species would not exist. Indeed, so entrenched is State Art today that the only sure way of eradicating it would be by removing its life-support machine of public funding.

The Arts Council was created in 1946. It grew seamlessly out of a body established in December 1939, the Council for the Encouragement of Music and the Arts (CEMA), whose job was 'to rescue those cultural activities and interests which are threatened with extinction by wartime conditions'.[15] In the visual arts this took the form of touring temporary exhibitions to far-flung places unused to hosting such events. Their purpose was to help artists through difficult times; to make art accessible to as many as possible; to decentralize interest in art; and to maintain morale amongst a blitzkrieged, half-starved and overworked civilian population. As early as 1936 in *The Listener*, Keynes had noted 'The position today of artists of all sorts is disastrous'.[16]

14 http://www.hefce.ac.uk/lt/nss/results.
15 CEMA Progress Report, 1940.
16 John Maynard Keynes, 'Art and the State', *The Listener*, 26 August 1936, pp. 344–5.

At first The Pilgrim Trust funded these tours with £25,000, but the Treasury added £50,000 from April 1940. This was the first Government award given to visual arts outside those annual amounts required by the eighteen national galleries. The sum increased annually thereafter.

CEMA's exhibitions were circulated to public buildings according to a philosophy similar to that already established by a series of displays inaugurated in 1934 called 'Art for the People' — the original idea for which came from the British Institute of Adult Education (BIAE). Their motives were benevolent if patrician: 'Our chief object has been to "expose" people to art, simply to put them in contact with really good pictures and hope that they will catch the infection.'[17] The main purpose was to counteract the centralization of arts provision because in the provinces there existed negligible art activity and exhibition opportunity, the BIAE considering even major regional galleries to be second rate. Four 'Art for the People' exhibitions toured the country each year, often to places without art galleries. A lecturer who helped visitors understand modern work of a kind they might not have encountered before accompanied these shows. Provision increased to twelve shows a year under CEMA, whose intent was summarized as 'the best for the most'.[18] In its turn, Government believed that if circulating exhibitions bolstered morale, the tiny sums involved were well spent. Surprisingly large numbers attended these shows: half a million alone in 1942 saw thirty travelling displays.

Later in the war, as works from national galleries emerged from secure store, there were historical shows, but the bulk comprised mainly recent work by British artists of a 'modernistic' persuasion whom the art establishment wished to assist and promote. Selection proved a tricky issue. Debates centred on the stylistic balance between the traditional and the experimental. The prevalence in touring exhibitions of the avant-garde was, in 1944, the subject of a correspondence in *The Times*. Conservative artists, including Royal Academicians, accused CEMA organizers of 'subversion'.[19] So, already, even at this infancy of state funding, there was perceived to be an unfair bias towards art that was unfamiliar and even potentially off-putting for most audiences.

It would seem that a pathological condition commonly exists among those wishing to promote recent visual arts to the uninitiated. A

17 William Emrys Williams, 'Art for the People', in R.S. Lambert, *Art in England* (Harmondsworth: Penguin Books, 1938), p. 115.

18 Cited in F.M. Leventhal, '"The Best for the Most", CEMA and state sponsorship for the arts', *Twentieth Century British History*, 1 (3) 1990, pp. 289–317.

19 E.g. *The Times*, 11/03/44 & 14/03/44.

religious devotion to the esoteric and the flagrantly new drives a compulsion to convert others. And nothing can stop them. Like sect leaders, or drug pushers, victims of this mentality want everyone to be infected with their own addiction to the more rarefied reaches of 'the cutting edge', which they are convinced has greater innate validity than any old style. A desire to introduce neophytes to work that will probably mean nothing to them (mainly because, at least more recently, it doesn't mean anything in the first place) is ingrained in these evangelicals. Thus the academic conservatism of the 19th-century Salon has been gradually overturned in the 20th century and replaced with the psychology that only innovation and 'progress' (Fry called it 'vital art')[20] is desirable and worth support. In the 21st century this partisan thinking has become lore and adherence to it is the *sine qua non* of any career in the visual arts.

From Fry to Keynes and Kenneth Clark one senses an urgency among establishment supporters of Modernism to make up for lost time. In their defence they appreciated what others missed, and their insight in supporting experimenters became a template for future art bureaucrats. Early sympathizers with this alternative mindset were described as 'going Fry'.[21] These highly influential individuals shouldn't however be blamed for recent extravagant excesses. They were operating before the arrival of public funding threw its weight behind marginal ideas and turned them into establishment thinking. Fry, Keynes and Clark saw it as their duty to help succour careers that might wither without critical and financial support. Fry and Keynes were, however, defending styles that still operated within roughly conventional limits and both were dead well before their tendencies were used to justify the current anarchy. Clark, on the other hand, survived into more indulgent times in which his form of connoisseurship would play no part and even provoke sneers. There were limits to his tolerance. He might have bought thirty drawings and six sculptures from a young Henry Moore and stood guarantor to Graham Sutherland's overdraft but he dismissed abstraction—as Fry had before him—and other more bizarre areas of Modernism as dead ends, and wasn't afraid to say so.[22]

The flag of novelty for its own sake was carried forward by others. What had begun as the project of assertive lone mavericks would

[20] Roger Fry, *A Roger Fry Reader*, ed. Christopher Read (Chicago: University of Chicago Press. 1996).

[21] Meryle Secrest, *Kenneth Clark: A Biography* (London: Weidenfeld and Nicholson, 1984), p. 103.

[22] E.g. Kenneth Clark, 'The Future of Painting', *The Listener*, 351, 02/10/35, p. 543.

become establishment philosophy. Telling everyone else what to like—this was a common criticism of know-all Clark—is now part of the job description. Art bureaucrats are expected to be progressives, and never conservatives, with the result that a mass audience has been left trailing so far behind it shows not an atom of desire to catch up. As far as the state is concerned a diet of novelty is all there is, and it's all you're going to get whether you like it or not. Despite his antipathies, Clark was sufficiently tolerant of novelties meaningless to him to preside over the Arts Council between 1953 and 1960 when its travelling exhibitions were estimably omnivorous in the stylistic variety of work they circulated. Indeed, one can look back to Clark's period of authority as the last golden age in which all styles were promoted equally.

What happens today is only an extreme version of what has always been an in-born instinct in Modernism's apostles. It was certainly the case with both 'Art for the People' and CEMA's efforts, where illustrating and explaining developments in Modern Art were among the principal motives in the selection of their exhibitions. From the beginning of Government subsidy in the visual arts, therefore, there has been a resistance among art bureaucrats to giving innately conservative audiences what they might feel comfortable looking at. Selectors have always preferred forcing viewers outside their comfort zone. That audiences must be 'challenged' has become a sort of commandment, a battle cry even. Public resistance to specialist enthusiasms in art has remained an enduring subject of bafflement to such believers. In 1934 Fry had expressed his frustration: 'The vast majority of mankind is aesthetically damned, and damned not for want of opportunity or goodwill, but by predestination.'[23] And as long ago as 1930—a Depression year in which UK unemployment increased 10%—the economist Keynes had asked himself: 'Why does the general public find it so extraordinarily difficult to get over its reserves and hesitations towards contemporary art?'[24] The obvious answer to this question would never have occurred to someone living in so rarefied a 'bloomsbery' world as the one Keynes inhabited.

The 1946 charter of the Arts Council includes in its purposes: '...developing a greater knowledge, understanding and practice of the fine arts exclusively, and in particular to increase the accessibility of the fine arts to the public throughout Our Realm, to improve the standard

[23] *Observer*, 22/04/34.
[24] 'The London Artists' Association: Its Origin and Aims', *Studio*, June 1930. Reprinted in *The Collected Writings of J.M. Keynes*, Vol. 28 (London: Macmillan, 1982), p. 307.

of execution of the fine arts …'[25] Lists of the Arts Council's exhibitions during its first thirty years fulfil these aims. They offered a varied menu of classical and nouvelle cuisine courtesy of a steadily increasing annual grant from the Treasury. This had started in 1946 with £235,000 (£6 million in today's money) and rose quickly—recent accounts show £74 million is allocated to the visual arts.

Coincident with the establishment of the Arts Council and the novelty of public funding emerged other transformations. The clean slate of the post-'45 peace encouraged social change. A desire to smash class privileges was everywhere fermenting. In visual art the upheaval was most immediately evident in education, where old teaching priorities were gradually jettisoned in favour of a supposedly liberated outlook. What we now call youth culture soon became institutionalized. 'New' and 'Young' became buzzwords: 'Young Contemporaries' exhibitions were inaugurated at the ICA in 1949 while 'New Generation' shows began at Whitechapel Art Gallery in 1964. Modern abstract styles imported from abroad, mainly from the USA (they were later discovered to have been subsidized by the CIA), were turning student heads with their ambition, scale and effrontery. A sea change was apparent, and art rapidly distanced itself even further from what the majority were comfortable with. Art changed much more quickly than the ability of general audiences to keep up.

Also after the war previously stuffy institutions had awoken to an unfamiliar dawn and were trying to keep abreast of advances in order to appear 'with it'. Driven by guilt and criticism all now embraced 'progress'. During the 1950s the Tate, which had been slated by supporters of the avant-garde for missing opportunities to acquire cheaply important Modernist pictures, began to jettison its behind-the-times image by buying the works of younger experimental artists. The average age of artists from whom pieces were acquired for the national collection dropped dramatically during this period to below 35. In 1963 the Tate bought a Pop Art painting from Anthony Donaldson—the only one they ever purchased by this artist as it turned out—while he was still a student at the Slade. Artists no longer had to wait on fame. It might arrive straight from college, where the degree show became increasingly important for establishing instant reputations. Attending a degree show in 1998, Doris Saatchi would confess to being 'appalled at how careerist the artists had become', which was rich coming from her since it was she and her former husband Charles Saatchi who had

[25] Cited in Robert Hewison, *Culture and Consensus: England, Art and Politics since 1940* (first published 1995, revised edn. London: Routledge, 2015) p. 43.

contributed significantly to encouraging such conceit and calculated ambition in the first place.[26]

As an indication of the opposing traditions in education and thinking from 1950 onwards, the words of two distinguished art teachers working during this critical period give a flavour of the time. Keith Vaughan, a painter and teacher at Camberwell and the Slade, said during an interview with Bryan Robertson in 1961:

> I don't share their [the students'] automatic rejection of the standards of the last 500 years which seems too much like a sort of Dada-classicism. I question what often seems to be an underlying assumption that disturbing or disagreeable looking objects are necessarily more vital and true than pleasant and agreeable ones.

In the other (victorious) corner, Harry Thubron, a trailblazing architect of new thinking in art education since the early '50s and a zealous reformer, wrote in *Studio International* (July/August, 1968) just as the character of education was about to be changed irrevocably by the subsuming of art schools into polytechnics:

> The present state of being has evolved through new ideas being grafted on to the old order, allowing far too many of the outworn attitudes and practices to remain. These static and linear concepts and attitudes are in fact dead but linger on to dog the system, largely from the fear the idea of change engenders. Now is the time for uprooting and planting anew. The idea of Polytechnic allows this, perhaps the last chance for some time ... The central unit should be aimed at establishing a milieu in which students 'learn how to learn for themselves' and at the same time allowing both staff and students to abolish and select their own tradition. We would abolish the Fine Art departments as they exist generally, in both name and aim, replacing them with Environmental-Light-Sound-Movement-Workshops, the motivation of which was the externalization, examination and control of phenomena. The essential essence will be a building of bridges between differing disciplines. This will demand an 'open' system ... it could be that we can establish a milieu that allows a 'culture' to grow and develop.[27]

Around 1990 the disparate threads that would weave together to form State Art began getting closer together. All that was needed was a catalyst. Charles Saatchi had begun to buy in bulk works by the so-called 'young British artists' (YBAs) before they had any reputation. Serota, meanwhile, who had arrived as Tate Director in 1988 having spent all his previous career working either directly or indirectly for the Arts Council, oversaw a revision to the Turner Prize, which returned

[26] 'Pieces from a confessional', *The Independent*, 17/10/88.
[27] Elma and Harry Thubron, 'The Polytechnic, a last chance for new ideas', *Studio International*, 1968.

following a brief hiatus in 1991 with an agenda to promote the avant-garde at all costs. Also in 1991 Serota convened a secret committee, for which no minutes were taken (a discovery made when I asked to see them), whose job was to suggest ways of generating greater coverage in the media for contemporary art. The existence of this was later divulged by Jay Jopling, founder of White Cube gallery,[28] who was invited to attend and who had a similar interest in manufacturing reputations for his artists, nearly always by controversial or sensationalist means. On the grounds that all publicity fuelled the fire, it was decided to lure newspapers, especially the easily provoked tabloids, into covering offensive or otherwise shocking work.

Over the next decade this process became a masterclass in media manipulation. The climax of this *modus operandi* was the tremendous fuss caused by the inclusion of a portrayal of Myra Hindley made using a stencil of a child's handprint by Marcus Harvey (one of Jay Jopling's artists) which featured in *Sensation*, an exhibition at the Royal Academy in 1997 comprising works owned by Charles Saatchi. The ensuing rumpus, which led to the picture being twice vandalized on the first day of public opening, was manufactured by the issuing of a press release in advance of opening stating that this particular picture was to be included. This was a deliberate invitation for all and sundry to be offended. In PR terms it was a brilliant example of 'Light the touch paper and stand back'. (The notoriety generated—four Royal Academicians resigned because of *Myra's* inclusion—no doubt helped when, soon afterwards, Saatchi sold the picture for ten times what he'd paid Jopling for it to an American commodities trader who had, coincidentally, worked for the company who invented 'junk bonds' and, embarrassingly, were the first sponsors of the Turner Prize. It's a small world.)

Thus, three people with overlapping interests fertilized the State Art egg. One had unstoppable authority in the most influential national gallery for recent art; another had cash sufficient to buy market position for what he bought and sold; and the other was a dealer with a need to create reputations for artists whose works alone could never by themselves have justified such pre-eminence. Serota showed work bought and exhibited by Saatchi, who in return donated works to Serota (and also—in the case of some works he had been unable to sell —to the Arts Council), while Saatchi also bought works from Jopling who himself worked with Serota and then afterwards supplied winners for the Turner Prize, the annual stunt chaired by ... Serota. It was beautifully circular. And it ran like the German railways.

[28] *The Observer*, 22/09/02.

On currently available evidence, it would be putting it too strongly to claim that a conspiracy created State Art. The ground had been well prepared before 1990 and the momentum in education, exhibition and collection was already bound in that direction. But the imago of a policy with a distinct personality did suddenly emerge, following which only Conceptual Art would now matter. This marked the final nail in the coffin for traditional methods of art teaching, at least in the public sector where fine art education in any traditional sense has virtually ceased to exist.

It soon seemed to outsiders as though the YBAs were the only artists in existence. No one else got a look in. Newspapers were full of their extra-curricular antics. And Thomas Hoving, former director of the Metropolitan Museum in New York, wasn't wrong when he characterized the new mood: 'Art is money-sexy-social-climbing-fantastic.'[29] So effective was this concerted hungering for novelty that the avant-garde quickly became that contradiction-in-terms, a part of the Establishment; in short, as dull an official academy as any pre-ceding it. The ethos was even celebrated in Downing Street under the rubric 'Cool Britannia'. But this was a new sort of strictly *capitalist* avant-garde, one where artists no longer starved in garrets but marketed branded merchandise, advertised luxury goods and bought massive country estates.

Another new phenomenon was required to explain what was other-wise visually incomprehensible. Unlike previous academies where the quality of work was more or less obvious to anyone looking at it, and to which everyone had access because it was at least figurative imagery, we had now to be told what we were looking at, what it meant and, finally, how very important it was. We were often told there was more there than met the eye. Except there wasn't. What was so often described as 'deceptively simple' in order to disarm cynics was, in fact, just simple. As the American art critic Hilton Kramer put it: 'The more minimum the art the more maximum the explanation.'[30] Hyperbole became the *lingua franca* of explanation.

Without any recognized criteria for judging what was there every-thing we saw became, on the face of it, as important as everything else. If official verdicts concerning quality were accepted it was only because they were *ex cathedra* and originated from those in authority who, it

[29] Quoted in Louisa Buck and Philip Dodd, *Relative Values or What's Art Worth?* (London: BBC, 1991), p. 63.

[30] Widely cited as being said by Kramer in the late 1960s. E.g. Richard Eldridge, *Introduction to the Philosophy of Art* (Cambridge: Cambridge University Press, 2014), p. 271.

could reasonably be assumed, must know what they were talking about if only because of their regulation black uniforms, fancy titles, gift for baffling periphrastics and accumulated medals and titles dispensed by the Queen. In fact, as we have discovered, they were making it up as they went along. Unless the artist had told these 'experts' what was being signified they had no more clue what a work was about than the rest of us. They swallowed artists' statements, which had evolved to become as important as the work itself, like children greedy for sweets. One week a pile of stones could be about mortality, the next a comment on climate change and the spoiling of the environment, and the week after that it might represent the most significant development in landscape art since Constable. It was hard to keep up. Sculptor Eduardo Paolozzi spoke for many when he confessed about one such 'masterpiece', 'It just looked like a pile of stones to me'.[31]

The Turner Prize has now lasted as long as it took Modern Art to exhaust a score of distinctive 'isms' at the beginning of the 20th century. A quarter of a century afterwards and we've not moved on from the YBAs. The system is still unsuccessfully trying to crank out more of the same. This flagship State Art annual prize has become inbred to uselessness. Winners are now so insignificant that no one except those who chose them can remember their names from one year to the next. Can you name who won the Turner Prize the year before last? Well can you? Or indeed anyone who has won in the last five or even ten years?

An on-message Arts Council, which had been hand-in-glove with Serota since the early '70s, was in a perfect position to ensure the success and ubiquity of State Art because over the years they had accumulated an impressive number of their own galleries through which they might promote work they liked. And they provide nothing short of a complete service, for they even fund art magazines with neither circulation nor visibility whose purpose is to review their own exhibitions.

The Institute of Contemporary Arts (ICA), funded from 1968 by the Arts Council, was started in 1947 by Modernist artists specifically to show recent art—unquestionably a much-needed development. However, it was a function which became watered down when the Council began funding other galleries, many of them also in London, which duplicated the ICA's job. What had begun as a peripheral but necessary concern, namely the fostering of the avant-garde, had become mainstream. The Hayward Gallery opened in 1968, the Serpentine in 1970. The Whitechapel, which had existed since 1901, was directed for a

[31] Personal communication.

crucial decade in the '80s by Serota, one of the Council's own placemen. The change in the character of exhibition programmes of these galleries between then and now is significant, and reflects the altered shift in what the Arts Council was prepared to support. At first all except the ICA staged a wide range of exhibitions, often selected by distinguished art historians and critics. I know from my own experience that these were places which those interested in art history from the Renaissance to the present had to visit. For example, in its first year the Hayward staged exhibitions of Matisse, Nolde and Van Gogh. In the second year it was Caro, Frescoes from Florence, Pop Art, Claude Lorrain and a thematic show including Barry Flanagan and the abstract painter Ian Stephenson. Compare this to the last ten years when the same gallery has shown work only by contemporary artists, usually foreign ones, who hardly anyone can have heard of. The last important historical survey at the Hayward was in 2001, of drawings by Goya, one of the most engrossing exhibitions ever staged there—the unforgettable 1973 show of Cézanne's watercolours (which followed Salvator Rosa!) ran it close. In its early days, the Hayward provided an exemplary service in which 'difficult' contemporaries—Dieter Rot with his putrefying food —rubbed shoulders with, say, the Impressionists in London. Under State Art the Hayward is now no longer a place one feels it necessary to visit.

Those dubbing themselves 'curators', a coinage now utterly debased by overuse, select exhibitions of exclusively new work. To those of my generation, 'curator' meant a serious scholar, a specialist worthy of respect and an author of original contributions to a *recherché* subject. Now everyone calls himself a curator, a title that has become merely a fancy synonym for 'selector'. There is, however, a worthless 'professional' qualification for these 'curators' of the moment. The Arts Council pays the Royal College of Art £200,000 a year towards its 'Curating Contemporary Art' course (which, coincidentally, was headed until recently by Mrs Serota)—and by 'contemporary art' they don't mean *all* contemporary art but only the bits State Art likes.

Apart from the venues mentioned above there are now in London other galleries displaying only the Arts Council's preferred 'Challenging Contemporary Art'. These are Camden Arts Centre, Matt's Gallery, South London Art Gallery, Chisenhale Studios and the non-gallery organization Artangel. Their combined subsidy (from the Arts Council) in 2014 was around £7 million a year. It's hard to give a precise figure because, one suspects, the Council make it deliberately difficult to find these things out by rendering their accounts impenetrable. In 2013 I investigated the recent funding history of the Serpentine Gallery, which frequently and inexplicably shows the

world's wealthiest artists whose own high profile commercial galleries have their more extensive and lavish premises only a couple of miles away in Mayfair. I discovered that on top of its £1.3 million a year grant it has also received £6.8 million in the form of twelve — *twelve!* — Lottery awards given during the National Lottery's 20-year history. We are referring here to a former tearoom in Hyde Park. By the way, the Serpentine is a charity which, at the time of writing, has two directors both of whom earn more than the director of Tate Britain.[32] It was a misguided decision, probably born of ignorance as to their true motives, when the Arts Council were given authority to disperse lottery funds in 1994, because in the visual arts this ensured that their existing favoured clientèle would be well looked after. Yes, even the National Lottery is a reliable backer of State Art, courtesy of its Siamese twinning with the Arts Council.

Conclusion

State Art is an invention of my lifetime. I've watched it evolve. It has successfully infiltrated and now controls every corner of contemporary art, funding only what it deems challenging, conceptual, minimal, etc. It is an outrageous travesty of what public funding for art should be. No artist should be excluded from assistance simply by virtue of a stylistic path, or the use of a medium, which officialdom deems misguided. State Art discriminates against any traditional styles, favours the contemporary over the historical, and colludes in a sleazy manner — ref. the Serpentine Gallery above — with the marketplace. It has contributed to the ruin of the Fine Art college system, which now teaches practically nothing but the transparent pretence of intellectualism, and produces 'artists' fit only for the State Art treadmill. Artists excluded by State Art, a very large majority, must fend for themselves. Some do this successfully against the odds: but they will be denied acclaim, they won't be collected by the state, they won't have books published about them by mainstream publishers and they will be condemned to having their work reviewed only rarely because print and broadcast media are also on message with State Art.

All official institutions are now contributors to this closed shop and their very survival is made contingent on continued adherence to State Art diktats, because in 2016 subsidy is effectively accompanied by blackmail. Apostasy means poverty.

The influence of this monotonous domination on art students cannot be overestimated. If all students see or are encouraged to look at

[32] See *The Jackdaw*, No. 112, Nov/Dec 2013; No. 113, Jan/Feb 2014; No. 114, March/April 2014.

is one approach only, then the results will be as predictably dull as is now everywhere evident—consider the wretched thinness of recent Turner Prizes, British Art Shows and New Contemporaries. And if their tutors have also been reared under this system, the teaching of nothing becomes ancestral, the perpetuation of inadequacy stultifying. The result of this bankrupt process is disastrous for those who don't make it, for they have no saleable craft on which to fall back. A distinguished writer and artist anonymously wrote the following observation in *The Jackdaw*:

> Of the many criticisms I could make of what I have seen of the current state of art education in this country … the first is the lack of instruction in fundamental skills. A talented young man I know recently graduated from Winchester College of Art with a first class degree in 'fine art'. He had specialised in sculpture. He proudly showed me his card, which he had printed with his name and address and the words 'Artist and Sculptor'. He cannot draw, paint, carve or model and he knows practically nothing about the history of art. He now earns his living by washing up surgical instruments at the hospital where his father is a surgeon. He has no prospects, but he is slightly better off than most of his fellow art-students, who are on the dole.[33]

The cause of my personal animosity towards State Art is that I feel cheated. It has censored and manipulated what I have been permitted to see and therefore to know. I've spent most of my adult life not being able to view in public galleries or collections works by artists, old and young, that would have interested me, and many others too, had we all been vouchsafed the opportunity.

All I can do is await the day when a Minister has the guts to tell the Arts Council to close down its visual art department and replace it with something fairer, less discriminatory and with a policy supportive of work by all good artists wherever they inhabit what is a miraculously diverse artistic spectrum. The problem hitherto is that culture ministers are uncritical and subservient. Having invited me to his office, an intelligent arts minister once told me that he sympathized with many of my criticisms but that the Arts Council 'is, you must understand, as untouchable as any sacred cow'. But why?

······

Nothing has changed in 25 years, which, coincidentally, corresponds almost exactly with the autocratic regime of Serota at the Tate and his Age of the Turner Prize.

33 *The Jackdaw*, No. 81, Sept/Oct 2008, p. 11.

Selby Whittingham

Turner in Our Time
La Trahison des Clercs

J.M.W.Turner is fêted as much today as at any time. But his bequest is mistreated as never before. When he died in 1851, he left to the nation thousands of works on paper and some 300 oil paintings, including 98 finished paintings left specifically to the National Gallery, if and only if a new room or rooms were built to display these pictures 'constantly' and together. But the chances of seeing most of these pictures together as Turner wished has diminished in recent decades.[1]

And for all the exegesis that pours out today, Turner's artistic achievement is no better understood. Both 'traditionalists' and 'modernists' lay claim to his artistic legacy, which testifies to its continuing relevance. The trouble is that each 'camp' seeks a validation of its own views and this begets a distorted and partial view of Turner. He wanted his work to be an inspiration for the future; but, merely appropriating his name, the Turner Prize and the Turner Contemporary Gallery do not attest to that, nor do these institutions honour the dwindling number of living painters who acknowledge a debt to Turner.[2]

The result is that it is not fully clear what Turner's achievement was, nor, indeed, what its relevance is today. Given his supreme importance in our visual culture, the treatment of Turner is a particularly telling (and poignant) example of how we allow our culture to decay, failing to cultivate awareness and understanding of its greatest achievements by treating them with the admiration and respect that they merit. This

[1] For full details of Turner's complex will and codicils, and subsequent events, see Selby Whittingham, *An Historical Account of the Will of J.M.W. Turner, R.A.* (London: Independent Turner Society, 2nd edition, 1993–6).

[2] The Turner Prize was instituted in 1984 by Tate to celebrate new developments in contemporary art. It is awarded annually to a British artist aged under fifty for 'an outstanding exhibition or other presentation of their work in the twelve months preceding': http://www.tate.org.uk/visit/tate-britain/turner-prize. The Turner Contemporary Gallery opened in 2011, in Margate, the seaside town which Turner visited regularly.

failure is a failure to sustain the continuity without which a culture must perish. In this respect, the treatment of Turner epitomizes a threat not only to our visual culture but to our culture generally, a threat posed, in part, by '*la trahison des clercs*'.[3]

The curators and scholars offer us partial views of Turner. For example, Andrew Wilton has led the reaction to the idea, fostered, amongst others, by Lawrence Gowing, of Turner as a precursor of developments in modern art, developments of which Wilton disapproved. (Later, Gowing did not so much withdraw as modify and refine that view.) Wilton argued that Turner should be seen 'in his time'.[4] Whatever seeing a painter 'in his time' might mean, it clearly suggests that there should be opportunities to see Turner's work as a whole, as the artist intended by his bequest. Recent major exhibitions have, however, concentrated on the late works, geared to the contemporary love of all that is bright. For example, the Preface to the catalogue for the Tate-organized touring (2014–16) exhibition, *Late Turner – Painting Set Free*, declared that the exhibition had two aims — 'one is to argue against the idea that Turner was the first modern artist, and the other is to argue that he was a very modern artist.'[5] Quite apart from the dubious presumption that an exhibition can or should 'argue' for (or against) any view of a painter's work, this was a recipe for confusion, not wholly resolved in the leading essay in the catalogue, 'Turner In and Out of Time', by Professor Sam Smiles. The exhibition was a futile attempt to accommodate the opposing views of 'Tate' (primarily now, as always, a gallery of modern art), as represented by its numerous directors, with the views of the historical curators. Predictably the reviewers took the Tate directors' view, as has the Caumont Centre d'Art at Aix-en-Provence, which heralds Turner in its exhibition in Summer 2016 as a 'précurseur de l'impressionisme'.[6]

3 The phrase comes from Julien Benda, *La trahison des clercs* (first published 1928). Translated by Richard Aldington as *The Treason of the Intellectuals* with new introduction by Roger Kimball (New Brunswick, NJ: Transaction, 2007).

4 Andrew Wilton, *Turner in his Time* (London: Thames & Hudson, 1987, revised 2006); Lawrence Gowing, *Turner: Imagination and Reality*, exh. cat. (New York: Museum of Modern Art, 1966).

5 David Blayney Brown, Amy Concannon and Sam Smiles, eds., *Late Turner: Painting Set Free*, exh. cat. (London: Tate, 2014), p. 8.

6 The website for the Caumont exhibition, titled 'Turner et la couleur', claims 'L'impact de son œuvre est en effet incontestable sur les générations d'artistes qui ont donné vie, quelques décennies plus tard, à l'impressionnisme', http://www.caumont-centredart.com/fr/turner-et-couleur (last accessed 17/03/16).

While Turner long had little influence in Britain, he was undoubt-edly admired, to their profit, by some Impressionists, Symbolists, Fauves, Abstract painters and others. He has as much claim to be 'the first modern artist', as Sickert and Victor Pasmore thought, as has Manet or Cézanne, as the French and Francophiles have claimed. But, arguably, such claims are often misconceived because lurking behind them is an assumption that the importance of artists is to be judged by their supposed roles in hastening the pace of history, as if the history of art were like the history of science, a matter of more or less rapid progress.

Turner did not seek imitators, but sought to inspire later artists by his example, principally through his planned Turner's Gallery, but also through other bequests keeping his name alive, such as the Turner Medal, which have also now been dishonoured by neglect. He has been criticized for this apparent vain-gloriousness. But he was proudly ambitious not only for his own success and fame, but also for advancing art and not, like many others, remaining stuck in a success-ful formula. Politicians today talk of the importance of people's aspira-tions being met, by which they principally mean having successful careers. To Turner success meant more than just that. It involved thinking big. By that is not meant that he created huge works, as did some of his contemporaries (and some today), which he generally did not. Indeed some of his finest works are on a miniature scale. But they exhibit what Constable referred to as his 'wonderful range of mind'. He combined a bent for inquiry with visions of a better world (his 'golden visions') set against the perils and tragedies of the existing one.[7]

It has been suggested that the apparent formlessness, esotericism and self-indulgent expressionism of some of Turner's late work have given licence to later artists to think that anything goes. These traits were of course criticized by many in his lifetime. Indeed, already in 1806, one of his works was described as 'the scribbling of painting'.[8] That Turner's late works were dismissed by contemporaries, but are now among his most appreciated, has also been used by apologists for today's art as reason to believe that, if that art is criticized today, it will

7 Charles R. Leslie, *Memoirs of the Life of John Constable Composed Chiefly of His Letters* (London: Phaidon Press, 1951), pp. 44 & 166.

8 Kathryn Cave, Kenneth Garlick and Angus Macintyre, eds., *The Diary of Joseph Farington: Volume VII* (New Haven, CT: Yale University Press, 1982) p. 2748. Farington quotes the critic James Boaden at the 1806 Royal Academy Exhibition as describing a landscape by John Crome and Turner's *Waterfall at Schaffhausen* as both being 'in the new manner, — it is the scribbling of painting — so much of the trowel, — so mortary, — surely a little more finishing might be borne?'

win general recognition in the future.[9] But this emphasis on Turner's late works and his role as a 'precursor' is to overlook the foundation of his work. The late work was only possible because of the completeness with which he had internalized, *had made his own*, the tradition which he inherited. Originality, as distinct from novelty, always evolves within a tradition.

If Turner was a great artist, it was not simply because he lived in an age of great artists who acted as a spur. Indeed most of his British contemporaries were pleasant plodders. The call to see Turner 'in his time' is indeed timely, but his context was provided less by minor British painters than by the intellectual ferment of the time, one of general cultural, political and religious regeneration. He undoubtedly belonged to the Golden Age of Romanticism (albeit that that included much dross). Romanticism in England flowered with a burst of optimistic youthful vigour akin to other such golden ages at birth—5th-century Athens, the Gothic and Renaissance. Like those it grew old (it was growing old by Ruskin's generation), as have the innovations made at the beginning of the 20th century which are the foundation of 'avant-garde' art today.

The idea that civilizations decline was familiar to Turner. Gibbon was Professor of Ancient History at the Royal Academy when Turner was a student there.[10] And the idea was represented by Turner in his Rise and Decline of Carthage pictures. Luxury, which also features in Turner's *Fountain of Fallacy/Indolence*, has long been thought to lead to moral and political decay. A century ago Paul Signac painted a picture subtitled *The golden age is not in the past, it is in the future*. It seems inconceivable that any Brit Artists today would choose to embody such an idea in their work. Their impulses are derivative from the last golden age of art a century ago, but have lost the excitement and vitality that had—and we might reasonably doubt that the present age of art is golden. Some critics of contemporary art call for a return to the disciplines of the past, echoing the dictum of Ingres that drawing is the probity of art. Those who wish to regenerate painting or sculpture today need to think about the wider context rather than only about what goes on in art schools or who is director of the Tate. The attention to craftsmanship, as advocated by Ruskin, Prince Charles and many others, is not sufficient, and would only follow from a revolution in

9 Not everyone today shares the enthusiastic assessment of Turner's mature style, though they may keep their opinions quiet. For example, the modernist Reyner Banham told me that he disliked Turner's watercolours as the colouring was unnatural.

10 Gibbon's six-volume *The Decline and Fall of the Roman Empire* was originally published between 1776 and 1788.

ideas and society. It might be added that increased formal education at a 'higher' level, another fashionable nostrum, is not, merely in itself, necessarily the solution either. Learning may narrow the learned's outlook and generally constrains those employed in the realms of academe and museums to conform. Aspiration in their case is for career advancement and advancement of ideas that will not interfere with that.

Today's Brit Artists are not only disengaged from the great questions which concerned the Romantics, but they are also less ambitious. They and their admirers concede that their art is ephemeral. Its impact today is everything and, unlike for Turner, the past and future are of little consequence. With this comes the 'democratic' idea (not one held by the Athenian inventors of democracy) that all types of art are equal and that the hierarchy which reigned in Turner's day is outdated. Turner and his age accepted that such great exemplars as Raphael, the subject of one of his biggest and most programmatic paintings, set a standard, if not a stylistic pattern.[11]

Ruskin had argued in 1843, when Turner was at the height of his powers, that there is 'a poetry in painting, to meet which, some preparation of sympathy, some harmony of circumstance, is required'.[12] To agree with this and to suppose that this preparation might now be lacking is not simply to say that the subjects of many of Turner's works, drawn from Antiquity and Scripture, are foreign to people today, but that their frame of mind is quite unprepared for the Romantic. Ruskin was arguing that Turner's work was alien also from that of most of his contemporaries and that it should therefore be shown apart from them. The validity of Ruskin's opinion was well illustrated when, in the 1960s, the National Gallery had a room of alternating Turners and Constables, the latter making the former look meretricious and the former making the latter look plodding. The historian had supplanted the connoisseur. The two artists may have been twin pillars of Romantic landscape, but were chalk and cheese. A trait of Romanticism was that its artists were individualists and not classifiable in the way that those of the Renaissance had been.

Ruskin was the first to moot the idea of a separate Turner gallery, and was enjoined by Turner to ensure that his bequeathed collection would be kept and shown together. And it is this idea that has come to

11 *Rome from the Vatican. Raffaelle, accompanied by La Fornarina, preparing his pictures for the decoration of the loggia,* Tate (first exhibited in 1820 and included in the Turner Bequest).

12 John Ruskin, *Modern Painters*, Vol. I, Appendix (first published 1843, reprinted in *Collected Works of John Ruskin* (London: George Allen, 1903), p. 651).

be opposed by the gallery and museum establishment, for reasons that go well beyond the barriers of practicality and expense, which could surely have been overcome had Turner's achievement and wishes been accorded the honour that they deserve.

To honour Turner's stated wishes it would clearly be desirable not only to obey the primary one—for a gallery of his finished pictures '*constantly*' on display—but to relate it to the National Gallery. Although, for a time, he had planned for his gallery to be at Twickenham (as part of Turner's Gift, his projected almshouse for needy artists), the National Gallery was, in the end, his choice. This was probably partly from pragmatism—it would last for ever and cover the running costs—but also probably partly because, for Turner, it was imbued with associations with art and place. Influenced by the theory of Associationism popularized by the Revd Archibald Alison in 1790, Turner associated places with people, and so with emotions (condemned as sentimentalism by the modernists), events and culture.[13] When Turner made his bequest in 1848, William Wilkins' building in Trafalgar Square housed both the National Gallery and the Royal Academy. Trafalgar Square, viewed from his club and dealer's gallery, and its environs held vital associations, artistic and historical, for Turner.

It is clear, however, that Turner did not give his 'gallery' to benefit the National Gallery but to preserve a permanent display of his works: hence the provision that the bequeathed paintings should be sold if his precise wishes were not followed within ten years of his death in 1851, as they have not been. The National Gallery accepted the paintings for Turner's Gallery (and more of Turner's bequeathed works). But it has not met the terms of the gallery bequest; any steps to do so having been temporary or partial.[14]

When a House of Lords committee considered in 1861 what should be done with the Turner Bequest, the issue was as much what should be done about the National Gallery, with its limited space. Should it remain at Trafalgar Square or move to Burlington House? In favour of the latter (and of honouring Turner's conditions) was Lord Overstone,

[13] The situation of art appropriately conducive to a state of mind receptive of it was prized by contemporaries such as Quatremère de Quincy, royalist perpetual Secretary of the Académie des Beaux-Arts in the years when Turner frequently visited Paris. It has prompted the Romantic ideas of the return of Napoleon's looted art to its countries of origin and, from the time of Byron, of the Elgin Marbles to Athens.

[14] For a more detailed account, see Selby Whittingham, *The Fallacy of Mediocrity: The Need for a Proper Turner Gallery* (London: J.M.W. Turner R.A. Publications, 1992).

a Trustee of the Gallery, who suggested that 'many moral influences are exerted by architectural effects upon the public mind' and that the quiet of the Burlington courtyard was conducive to appreciating the art. The Director, Sir Charles Eastlake, concurred.[15] (Amusingly his successors today continue to complain about the noise in Trafalgar Square.)

It was by the 1883 National Gallery Loan Act that the British state first overtly betrayed Turner's principal artistic aim, unchanging throughout the successive codicils to his will, to preserve a permanent display of his finished paintings.[16] That aim has subsequently been further sabotaged. First, in 1910 the collection was split between the National Gallery and the Tate, with the larger share going to the then new Duveen Galleries at the latter. Secondly, although the Tate's Clore Gallery, which opened in 1987, was officially designed to show the Turner bequest, its scale was inadequate for that purpose from the outset, and its rooms are quite unsuitable for displaying Turner's work.[17] Thirdly, the display of Turner's paintings in the Clore Gallery has been far from permanent. Since 2000, many of the paintings have been repeatedly sent out on loan and paintings by other artists have been frequently inserted into the rooms supposedly dedicated to Turner.

Even those not under the Turner spell accept that he represented a remarkable phenomenon. But those visiting the Clore Gallery 'for Turner' are more likely to be bemused than amazed. Kenneth Hudson, begetter of the European Museum of the Year Award, found that, while his students who visited the David d'Angers museum came away with an understanding of that artist, the opposite was true when they visited the Clore Gallery.[18] That was not just because Turner was a more complex artist, but was also due to the depredations which his bequest has suffered and the inadequacy of the Clore building to show meaningfully what remains.

The National Gallery's former Director, Neil Macgregor, justifying the split of the bequest between National Gallery and Tate Britain,

[15] *Minutes of Evidence taken before the Select Committee on the Turner and Vernon Pictures*, 18 & 19 July 1861, *House of Lords Sessional Papers*, Vol. XXIV, 1861, pp. 8 & 20.

[16] This Act extended the National Gallery's authority to loan pictures without recourse to the Treasury: a work of art could now be lent to any public gallery in the United Kingdom, provided it had been in the Gallery for fifteen years, or twenty-five years in the case of gifts or bequests subject to special conditions (such as Turner's).

[17] A selection of criticisms of the Clore Gallery can be found at www.jmwturner.org/critique.htm.

[18] Ibid., and personal communication.

complacently said that, at the first, Turner is seen amid the old masters and, at the latter, among his English contemporaries.[19] To show Turner as part of the legacy of the old masters or as part of the progress of British painting requires only a handful of works. Either of these partial aims would be defeated by a display of hundreds. Moreover, the once conventional approach of the art historian, heir to Vasari, of treating art by century and school, is not as popular as it was a generation ago. It is especially unsatisfactory when dealing with an artist such as Turner, who had, in any case, already subverted it by his separate bequest of two of his paintings to hang with two by Claude at the National Gallery.

Moreover, the supposed basis for the split between the Tate and the National is not actually borne out in practice, The National Gallery has clung on to key late works, such as *The Fighting Temeraire* and *Rain Steam and Speed*, which owe relatively little directly or obviously to the old masters, while casting off to the Tate many of the works that relate more closely to the old masters in subject and style (though not all, most obviously not the two hung with the Claudes). A sense of practicality, if none of honour, would lead the thoughtful person to the conclusion that Ruskin first adumbrated, of a separate Turner Gallery.

Macgregor's glib statement could only be made by someone not really interested in the matter and certainly not interested in the claims of donors. It is as if he is akin to a communist when it comes to art, disbelieving in private property. The Universal Museum, espoused by Macgregor, is the supermarket version of museums, which made the late Sir David Piper, a more sensitive museum director, feel overwhelmed by choice when entering the British Museum.[20] The curator views museums as wholes, but the visitor only bit by bit. Some find smaller museums, of more limited scope, more rewarding, just as they like small specialist shops. In them, visitors are less inclined to drift past their walls like shoppers in Oxford Street. The Artist's Museum was a product of the Romantic Age and such museums have since sometimes been more popular than the universal ones.

When, beginning in 1975, Sir John Betjeman led a campaign to locate the Turner Gallery in the Fine Rooms in Somerset House, the mother of our present arts minister, The Hon. Ed Vaizey, objected that the Fine

[19] Neil Macgregor, 'Preface' to Judy Egerton, *Turner: The Fighting Temeraire; Making and Meaning* (London: National Gallery Publications, 1995), p. 9.

[20] David Piper, *The Companion Guide to London* (first published 1964, London: Fontana, 1970), p. 226. Neil Macgregor became Director of the British Museum following his term at the National Gallery. Sir David Piper was Director of the National Portrait Gallery, the Fitzwilliam Museum, Cambridge, and the Ashmolean, Oxford.

Rooms belonged to the 18th century while Turner was of the 19th century, an opinion ridiculed by the campaign's chief supporter, Henry Moore.[21] Andrew Wilton favoured a modern purpose-built gallery, partly out of a rejection of the 'sentimentality' of going back to the old rooms of the Royal Academy.[22] Turner, however, had regretted the move from those.[23] Perhaps that was because of the entailed loss of independence for the Royal Academy, but surely also on sentimental grounds. This illustrates the gulf between the modern academic and the Romantic artist, however pragmatic, as Turner undoubtedly was.

Turner's injunction to Ruskin to keep all his works together was plausibly interpreted by Evelyn Joll of Agnew's, long the chief dealers in Turners, to mean to keep 'a sufficient cross-section of pictures to demonstrate to posterity his range and development'.[24] This interpretation is indicated by the pictures which Turner either refused to sell or bought back. That showed a further aim: to include in the collection many of his greatest works, so that quality as well as range was a prime consideration, an aim which was defeated by the National Gallery's creaming off some of the best when the bulk of the bequest went to the Tate.

There was nothing remarkable in Turner's wishes, which are shared by organizers of any retrospective of an artist's work, but only in this: making the retrospective permanent rather than temporary. In that idea, Turner had been preceded by Canova and Thorvaldsen. What has changed is that permanent collections have also become temporary exhibition venues, the deleterious consequences of which are not fully appreciated, involving the bartering of works in the permanent collection in exchange for loans from other museums. The curatorial profession's orthodoxy that museums either expand or die is patently false and self-serving.

Francis Haskell advanced various reasons for regretting that 'exhibitions flourish at the expense of museums' in *The Ephemeral Museum*. 'This admirable book,' wrote Evelyn Joll in his review of it, raised 'a subject which needs addressing', the vogue for lending creating 'the fear that one day a plane full of great pictures may

21 *The Times*, 11/01/75; 28/01/75.
22 Personal communication.
23 Anthony Bailey, *Standing in the Sun: A Life of J.M.W. Turner* (London: Sinclair-Stevenson, 1997), p. 286.
24 Martin Butlin and Evelyn Joll, *The Paintings of J.M.W. Turner*, revised edn. (New Haven, CT: Yale University Press, 1984), p. xv.

crash'.[25] If that has not yet happened, damage and losses have occurred. But the Turner Society, of which Joll became chairman, has remained silent on this subject. For it was long ago taken over by scholars for whom exhibition catalogues provide the prime forum for their researches and ideas. These range from factual discoveries on the one hand to theories on the other. The first — establishing the correct dates and topographies — are proper concerns of curators, but have much less interest for the general art public (and, one suspects, also for Turner, who was heedless about such matters). The second can be an important contribution to cultural debate if expressed in the right places — the lecture theatre or the book.

Academic and curatorial speculations can, however, also be examples of intellectual silliness, such as those amusingly dissected by Roger Kimball in *The Rape of the Masters*.[26] Kimball adduces *The Treason of the Intellectuals* by Julien Benda as applicable to these historians of art, although what Kimball and Benda conceive to be betrayal by art historians is perhaps less specifically of artists themselves than of the Enlightenment values to which art historians and others should adhere.[27] Kimball takes as his epigraph the well-known saying of Bishop Butler, from 1726, that 'Everything is what it is and not another thing'.[28] This can be applied, as it is by Kimball, against fanciful academic speculation and arbitrary over-interpretation of works of art. But at the same time, the saying should not be misinterpreted to exclude the exercise of imagination in discussing art, since the meaning of a work of art may be multi-layered or even ambiguous. Benda's denunciation of the hermetic and esoteric expresses more his views than those of artists in general, especially when it comes to the Symbolists, some of whom admired Turner. The boundary between suggestive mysticism and empty and befuddling pretension is not always clear, it seems, to the critics. Art is not the reproduction of nature, but its interpretation and transfiguration, and is sometimes, in Turner's case, metaphysical or metaphorical. Mallarmé talked of the

25 Francis Haskell, *The Ephemeral Museum: Old Master Paintings and the Rise of the Exhibition* (New Haven, CT; Yale University Press, 2000); Evelyn Joll, 'Exhibitionism a bad habit', *Spectator*, 27/10/00, p. 61.

26 Roger Kimball, *The Rape of the Masters: How Political Correctness Sabotages Art* (New York: Encounter Books, 2004).

27 Kimball, 'Introduction' to Benda, *Treason*, p. xxvii.

28 Kimball, *Rape*, P. 3.

pleasure of guessing little by little what the artist meant;[29] Turner similarly liked to make Ruskin guess his meaning.[30]

But instead of presenting Turner whole for us to appreciate, the curators, academics (and artists) are more interested in presenting their own viewpoint. The hero of Somerset Maugham's *Of Human Bondage* says that he has the right to take from another artist only what is of use to himself.[31] That is legitimate for the artist but not for the historian or curator claiming to be objective and comprehensive. A shift is needed from the museum as teacher to the museum as responsive to the requirements of the visitor. The visitor first needs to be engaged by the art, and only then will ask the questions which the historian tries to answer. A grand Turner Gallery, showing Turner in all his aspects and at his greatest, could also help answer those questions, as well as acting as a cultural beacon.

If the failure to provide a proper Turner Gallery more than one hundred and sixty years after Turner died is an indictment of the feebleness and self-interest of his admirers and of the philistinism of the nation, there may be a lesson to be learnt from the history of the call for a national Shakespeare theatre in London, which morphed into that for a National Theatre. The call was first made in 1848, that is, more than two hundred years after Shakespeare's death (and, coincidentally, the year Turner added the main operative codicil relating to his gallery to his will). When, ninety years later in 1938, the foundation stone was laid for what was to prove its abortive building for the theatre, near where I write in Cromwell Road, the symbolic twig and sod were handed to Bernard Shaw, who began, 'I suppose I am here today as the next best thing to Shakespeare'. He went on:

> The way the National Gallery, the British Museum and all those places begin is always by a small group of people who understand the national importance, the cultural importance, of these institutions. They make a beginning, and after a time the beginning they make becomes an institution. Then the Government comes along, or rather the Government does not come along, but the created institution stands in the way of the Government, and the Government, which never wanted it, says, 'Here is something which for some reason or other, we have got to keep going.'

[29] Jean Gimpel, *Against Art and Artists* (Edinburgh: Polygon, 1991), p. 136 (citing John Rewald, *Le Post-Impressionisme de Van Gogh à Gauguin* (Paris: 1961), p. 90).

[30] Eric Shanes, *Turner's Human Landscape* (London: Heinemann, 1990), p. 23. Turner's love of appearing mysterious is attested to by others, e.g. David Roberts. See Helen Guiterman, '"The Great Painter": Roberts on Turner', *Turner Studies*, vol. 9, no. 1, Summer 1989, p. 6.

[31] W. Somerset Maugham, *Of Human Bondage* (London: George H Doran, 1915).

... People sometimes ask me, 'Do the English people want a national theatre?' Of course they do not. They have got a British Museum, a National Gallery, a Westminster Abbey, and they never wanted any of them. But once these things stand, as mysterious phenomena that have come to them, they are quite proud of them, and feel that the place would be incomplete without them.[32]

As well as the Government's reluctance to give support, concern about competition was raised by London commercial theatres and by another initiative specifically to honour Shakespeare—from what is now the Royal Shakespeare Theatre Company, which began as a local venture in Stratford upon Avon in the late 19th century. But the National Theatre was eventually built a generation later on a different site and designed, not by Lutyens, as had been envisaged in 1938, but by Lasdun. It was to Lasdun that Henry Moore initially turned when seeking advice on the adaptation of Somerset House for the Turners. If that campaign failed, it was largely because Turnerians were befuddled by false accounts of Turner's wishes and by the entrenched museum interests in Britain. The artist and set designer Robert Medley, another supporter of Somerset House as the home for the 'gallery', asked why, if Amsterdam could afford a gallery devoted to Van Gogh, couldn't London afford a gallery for Turner? His own answer, that it hindered the momentum of curatorial careers and 'conflicted with the entrenched forces of the Museum establishment' evidently hit home.[33]

Of course, there are limits to any drawing of parallels between a campaign for a national theatre to honour Shakespeare and one to recognize Turner's achievements (and fulfil the terms of his bequest), limits posed in part by the intrinsic differences between painting and literature. Appreciation of Shakespeare's plays does not depend on the public's having access to unique physical originals. Shakespeare's works cannot be irrevocably destroyed by conservators' neglect or by careless freight handlers when a theatre company goes on tour. Appreciating the development of Shakespeare's works over time is not enhanced by the simultaneous presence of large numbers of plays in the same space. In short, the case for a dedicated Turner Gallery is, in many ways, much stronger than that for a specific fixed building as a national tribute to Shakespeare. And the nation has owned the pictures to be hung in a dedicated Turner Gallery for more than one hundred and fifty years.

[32] John Elsom and Nicholas Tomalin, *The History of the National Theatre* (London: Jonathan Cape, 1978), p. 80.

[33] Robert Medley, 'Masters and Museums', *The Spectator*, 19/06/76; *Drawn from the Life: A Memoir* (London: Faber & Faber, 1983), p. 235.

Turner's admirers need, like the advocates of a National Theatre, to unite (Turner's most memorable speech to the Royal Academy called on his fellow artists to stand shoulder to shoulder as the Roman hoplites had done)[34] and to see his oeuvre as an organic whole, instead of crying up the watercolours and disdaining the oils, favouring one interpretation rather than another and indulging in other partialities.

Can the case for a Great Turner Gallery be defeated indefinitely by pessimism, error and self-interest, when the arguments for it are so compelling? Such a gallery could be 'Sublime and Instructive', to borrow the title of a collection of Ruskin's letters; instructive not through labels, but through the images. Sublime, because the work *is* sublime when viewed properly. Instructive because a Turner Gallery that inspires could make a contribution to changing the intellectual climate. Artistic achievement is not validated, Turner maintained, by popularity. He was aspirational not in the way politicians today mean, just for one's own betterment, but in pursuit of higher goals. A gallery that honoured his aspirations could help augur a time when

The world's great age begins anew,
The golden age returns.[35]

[34] William Powell Frith, *My Autobiography and Reminiscences*, Vol. 1 (third edn., London: Richard Bentley, 1887), p. 138.

[35] Percy Bysshe Shelley, *Hellas* (1822) 1.1060.

Laura Gascoigne

Dangerous Nonsense
The Corporate Takeover of the Queen's English and the Cost to Art

During Tony Blair's second term in office, I started collecting examples of contorted speech. At the time, the Iraq War was injecting oil into New Labour's notorious engine of political spin. The 'sexed-up dossier' on Saddam Hussein's alleged WMD was just the half of it. War unleashed an arsenal of military euphemisms, most of them American imports, like Blair's foreign policy. The British public became inured to phrases like 'collateral damage' — meaning killing innocent civilians — 'area targets' — meaning firing into crowds — and the less felicitous coinage 'extraordinary rendition' with its unfortunate connotation of rendering meat. The torture of suspects seemed to go hand-in-hand with the torture of the English language.

The abuse wasn't confined to clumsy phrases, but spread out into convoluted syntax. If Bush was the king of the blooper, Blair was the master of the evasive circumlocution. Here he is responding to the Hutton Inquiry into the death of Dr David Kelly in 2003: 'I mean, all I can say is that there is nothing in the discussion that we had that would have alerted us to him being anything other than someone, you know, of a certain robustness …'[1] In grammatical terms, this statement is as wriggly as a worm on a hook.

I'm not a political journalist, I'm an arts journalist. My interest in New Labour's abuse of English was prompted by what seemed a parallel development in the language of art. In the case of art, the problem predated New Labour. Thomas Patin and Jennifer McLerran, in their preface to *Artwords: A Glossary of Contemporary Art Theory*, trace the trouble back to the 1970s when contemporary art began developing its own vocabulary; subsequent expansion has occurred so fast that 'many teachers, students, artists, and critics have found themselves

[1] Quoted in *The Guardian*, 28/08/03.

drowning in a sea of jargon that seems to have descended from outer space'.[2]

There's something rather peculiar about art jargon. As Albert Carnoy observed in the 1920s in *La Science du Mot*, one of the functions of specialist language is to protect the group. Users of expert jargon 'speak, for non-initiates, a sort of sacred language that acts as a tissue of protection, forming itself spontaneously around the social group'.[3] But in the case of art—as opposed to medicine, say, or football—the sacred language exerts a mesmeric pull on outsiders. This explains the contradiction highlighted by Robert Atkins in the introduction to *Artspeak*, that while 'to the uninitiated, contemporary art can seem as indecipherable as Egyptian hieroglyphics … interest often exceeds comprehension'.[4]

Since Atkins wrote those words in 1997, the gap has widened. *Artspeak* was published in the year Charles Saatchi's Royal Academy exhibition *Sensation* launched the YBAs into popular consciousness, ushering in the age of Cool Britannia under a newly elected Labour government headed by Blair. Collected by an adman, most of the art in *Sensation* had a punchy visual message that didn't require verbal explanation. Love it or hate it, the public understood it. But the media frenzy over the exhibition turned the spotlight on contemporary art, making what had been a self-protective social grouping with its own sacred jargon the focus of mass media attention. How could contemporary art build on this success? *Sensation* was a tough act to follow. Not many post-modern artists made work that was as self-explanatory. Interpreting it required a grasp of artspeak, and translating artspeak into plain English for a mass audience was beyond the capacity of most art critics, let alone gallery PR staff.

'The propriety of using technical terms in speaking or writing depends on a common sense principle', wrote James Bradstreet Greenough and George Lyman Kittredge in *Words and Their Ways in English Speech* back in 1901. 'A remark should be intelligible, not merely to the speaker, who is presumed to know what he wishes to say, but also to the person addressed. Otherwise, it can hardly be called language in any proper sense.'[5] By this definition, it is doubtful

2 Thomas Patin and Jennifer McLerran, *Artwords: A Glossary of Contemporary Art Theory* (London: Fitzroy Dearborn Publishers, 1997), p. vii.

3 Albert Carnoy, *La science du mot: Traité de sémantique* (Louvain: Editions Universitas, 1927).

4 Robert Atkins, *Artspeak: A Guide to Contemporary Ideas, Movements and Buzzwords, 1945 to the Present* (New York: Abbeville Press, 1997).

5 James Bradstreet Greenough and George Lyman Kittredge, *Words and Their Ways in English Speech* (New York: Macmillan, 1901), p. 57.

whether these two eminent Harvard professors would have recognized much of what is written about contemporary art today as language. Yet every profession needs its own terminology, as the 19th-century bibliophile John Camden Hotten, compiler of *A Dictionary of Modern Slang, Cant and Vulgar Words*, recognized. To Hotten, even Victorian artspeak sounded ridiculous. He scoffed at the use of adjectives like 'aesthetic' or 'transcendental' in relation to art, but was forced to admit that it was hard to find alternatives 'so easily understood by educated readers, and so satisfactory to the artists themselves'. He concluded that 'properly used, these technicalities are allowable'.[6]

George Orwell, in his essay 'Politics and the English Language' — published in 1946, three years before he unveiled the concept of 'Newspeak' in *Nineteen Eighty-Four* — made a similar complaint about the art criticism of his day, when it was 'normal to come across long passages which are almost completely lacking in meaning'.[7] Like Hotten's examples, the 'meaningless' terms Orwell picks on — words like 'romantic', 'sentimental', 'natural', 'vitality' — seem harmless to us now. A fog of airy-fairy lingo has, after all, always hung around descriptions of arts that appeal to the emotions. But contemporary art language suffers from the opposite problem: it is its *lack* of appeal to the emotions that makes it meaningless. And in fact, elsewhere in his essay, Orwell directs his criticism at precisely this emptying-out of emotional content. The faults he highlights in political writing — the preference for multisyllabic phrases, words with Latin or Greek derivations, worn-out metaphors, abstractions, the passive voice — are all linguistic devices that distance language from direct experience of concrete reality. They are useful tools, accordingly, for politicians who want to persuade the electorate to discount the evidence of its senses.

At least the privileged politicians of Orwell's day, having benefited from classical educations that taught them the rules of grammar and the Latin and Greek roots of words, could identify nonsense when they heard or spoke it. Now that management and marketing textbooks have replaced Latin and Greek primers in the education of aspiring politicians, this can no longer be taken for granted. Today's professional politicians can hardly open their mouths without a stream of corporate codswallop coming out. One reason, I suspect, why the Labour Leader Jeremy Corbyn is regarded as a traitor by the

6 John Camden Hotten, *A Dictionary of Modern Slang, Cant and Vulgar Words*, second edn. (London: JC Hotten, 1860), p. 71.

7 George Orwell, 'Politics and the English Language', *Horizon*, April 1946. Reprinted in *The Collected Essays of George Orwell, Vol. 4, In Front of Your Nose, 1945–1950* (Harmondsworth: Penguin, 1970), p. 161.

Parliamentary Labour Party is his insistence on communicating in plain English. You never hear him using corporate euphemisms like 'modernization' or 'flexibility', terms that trip off the tongues of other politicians hoping to conceal the pain their policies are going to inflict. He doesn't need to resort to this vocabulary because he is trying — unrealistically perhaps — to avoid causing pain.

Euphemistic usages are just one way in which the McKinsey-schooled generation of political leaders hides the consequences of its neoliberal policies from the public and from itself. Another defensive verbal strategy is depersonalization. Take the now ubiquitous term 'delivery' and its associated pseudo-noun 'deliverable', as in 'interim deliverables'. Its effect is to downplay corporate responsibility. If something goes wrong, it is not the executive's fault — the 'delivery' somehow got lost in the post. Mechanistic metaphors have a similar function. Take the word 'drive', as in the expression 'driving outcomes'. It portrays human agents as cogs in a machine that can function — or malfunction — independently of the person responsible for 'setting the direction of travel'. Here is management-speak supremo Lord Birt talking about the National Health Service in 2005: 'Britain's key problem is shortage of medical system capacity, which drives poorer medical outcomes but also, crucially, waiting times, the most important drivers of patient dissatisfaction.'[8] Birt's statement doesn't even make sense on its own terms. If you accept the clunky driving metaphor, how can a shortage of capacity drive anything? It can only fail to drive it. As for waiting times driving dissatisfaction, the operation is simply unimaginable.

'Such phraseology', says Orwell, 'is needed if one wants to name things without calling up mental pictures of them'.[9] It distances language from reality by deadening imagination. Analyse the utterings of government ministers and you'll find that they're often just strings of words. Take this statement by Home Secretary Charles Clarke in 2005: 'There are many young people, too many, who are engaged in low-level issues. We have to address this.'[10] Taken out of their context — teenage crime — Clarke's words are meaningless. But although we may find such nonsense funny, it can have serious consequences. Under recent changes to the benefits system, for instance, claimants are penalized for 'sub-optimal job-searching', when all job-searching is by definition 'sub-optimal' until it 'delivers' a job. 'The great enemy of clear language is insincerity', says Orwell. 'When there is a gap

8 Quoted in *The Guardian*, 02/07/05.
9 Orwell, 'Politics', p. 165.
10 Quoted in *Evening Standard*, 25/01/05.

between one's real and one's declared aims, one turns as it were instinctively to long words and exhausted idioms, like a cuttlefish squirting out ink.'[11]

Unlike politicians, artists are not prone to insincerity, since there is no gap between their real and their declared aims: the making of art. They have no need to squirt out clouds of verbiage, but those who depend on them for a living feel obliged to do it on their behalf. Dealers, auction houses, curators, gallery PRs and critics have assumed the role of explaining contemporary art to the uninitiated, who include the new breed of rich international collectors. Damien Hirst's *Spot Paintings* and Jeff Koons' *Balloon Dogs* aside, contemporary art can be a hard sell. An army of apologists is needed to justify its prices. Consider that in 2015 a 'word painting' by Christopher Wool featuring the four large letters 'RIOT' stencilled in black on white sold at Sotheby's New York for $29.9 million, while in the same year a Constable painting of *The Lock* sold at Sotheby's London for £9.1 million. In terms of buying power, both sound like staggering sums to spend on a picture, but in the case of the Constable the purchaser could see what he was getting. In the case of the Wool it needed to be spelt out — or to put it another way, the wool had to be pulled.

Here's how Sotheby's went about it the catalogue note for the sale:

> Wool's subversive conceptual project nowhere better echoes the content of his painting than in the immediacy of the word *RIOT*: a rebellious, insurrectionary edict that parallels the insurgency of Wool's own artistic practice. The leviathan *Untitled (Riot)* encapsulates Christopher Wool's anarchic painterly enterprise with complexity, juxtaposing the chaotic entropy of the image with the austere stringency of language. Concurrently outrageously provocative, artistically seductive and conceptually brilliant, Christopher Wool's monolithic *Untitled (Riot)* is the very quintessence of his most immediately recognizable and significant body of work.[12]

What we have here is a piece of sophisticated patter designed to persuade punters that what they see isn't all they get. It's pure salesmanship, couched in the language not of Petticoat Lane Market but of a *Bluff Your Way in Post-modern Philosophy* manual.

In the post-war era, the subjective and vague vocabulary of artistic discourse criticized by Orwell has been replaced by an objective and even vaguer lexicon borrowed from various socio-philosophical disciplines. The glossary compiled by Patin and McLerran in *Artwords*

[11] Orwell, 'Politics', p. 166.

[12] Sotheby's Contemporary Art Evening Auction, 12 May 2015, www.sothebys.com/en/auctions/ecatalogue/2015/contemporary-evening-n09345/lot.7.html

includes terms deriving from 20-odd interrelated fields of critical analysis, from literary theory and post-colonial discourse to Marxist criticism and poststructuralist semiotics.[13] From these hybrid roots springs the bastardized pidgin identified by American researchers David Levine and Alix Rule in an essay published in 2012 as 'International Art English' (IAE). After applying language-analysing software to gallery press releases, Levine and Rule concluded that the language they were written in 'has everything to do with English, but is emphatically not English' and in fact most closely resembles 'inexpertly translated French'.[14]

A curious feature of IAE, as an expert jargon, is that it has become the *lingua franca* of contemporary art despite the fact almost no artists – with the exception of Antony Gormley – are pretentious enough to use it. For dealers and publicists, however, it has the professional advantage of impressing non-experts, who have a natural tendency to assume that if they don't understand something it's above their heads. Conveniently, this is especially true of international art collectors for whom English is not a first language. The consequences for artistic discourse are obvious. Orwell draws a depressing analogy: 'A man may take to drink because he feels himself to be a failure, and then fail all the more completely because he drinks. It is rather the same thing that is happening to the English language. It becomes ugly and inaccurate because our thoughts are foolish, but then the slovenliness of our language makes it easier for us to have foolish thoughts.'[15]

To confuse things further, language has itself become a subject for art. 'Text-based practice' is now a recognized branch of contemporary art, from Christopher Wool's word paintings to Barbara Kruger's advertising slogans, Gilbert & George's graffiti, Bob & Roberta Smith's campaign posters, Jeremy Deller's banners and Martin Creed and Tracey Emin's neon messages. There are even artists who specialize in verbal transcriptions. Emma Kay has rewritten the Bible and Shakespeare from memory and Fiona Banner's entry for the 2002 Turner Prize included a blow-by-blow account of the action in a porn film. The Tate has described Banner's work as 'devoid of image yet dealing entirely with the visual'.

Contemporary artists, it seems, can't leave words alone. It's as if they know where it hurts and don't know to fix it; they just keep

[13] Patin and McLerran, *Artwords*.

[14] David Levine and Alix Rule,'International Art English', *Triple Canopy*, 2012, https://www.canopycanopycanopy.com/contents/international_art_english, n.p. (last accessed 21/03/16).

[15] Orwell, 'Politics', p. 157.

rubbing away at the affected area and inflame it further. At Bury Art Gallery's inaugural Text Festival in 2005, Hester Reeve spent nine weeks writing out Martin Heidegger's *Being and Time* by hand — an artistic exercise that only succeeded in lending confirmation to Heidegger's view that art 'is nothing more than a word to which nothing real any longer corresponds'.[16] In a press release explaining why text art needed a dedicated festival, the organizers wrote: 'The written word or sign consumes and clutters virtually every environment, so Text Festival explores the ways which [sic] poets and text artists work with language.' They also promised: 'Text Festival challenges the boundaries between art and poetry.'[17]

How does one challenge a boundary? Presumably by repeatedly threatening to cross it without doing so, since once a boundary is crossed the challenge is over — unless of course you reissue it from the other side. 'Challenging boundaries' is now such a cliché of artspeak that it passes for English even though it makes no sense. It's in the same class of nonsense as that overused trope of installation art, 'engaging the space'. The words making up these phrases make sense separately but not together, yet they carry associations that the user wishes to promote. 'Engage' sounds passionate and focused; 'challenge' sounds free and defiant, just as 'boundaries' sounds restrictive. The phrase 'challenging boundaries' suggests making a bid for artistic freedom, while meaning nothing of the sort. Its function is similar to that of 'robust' in political usage as an all-purpose stiffener to make a statement of intent sound stronger. 'A robust process for making decisions', 'a robust system for control orders' and 'robust community sentences' were among examples collected by *The Guardian's* Parliamentary Sketch writer Simon Hoggart in 2005. Hoggart concluded that for New Labour ministers — as for Humpty Dumpty in *Through the Looking-Glass* — a word simply meant what they wanted it to mean. 'Does it matter?' he wondered. 'Not a lot, it's just another small example of how language is dragooned and shaped into serving the purposes of politicians.'[18]

It may not seem to matter, but it's through the repetition of just such apparently minor infringements of sense that the meanings of words are gradually eroded to the point at which they lose connection with reality. That connection, Orwell argued, is the lifeblood of language, for without it the human brain ceases to function. Concreteness, for him,

[16] See http://buryartmuseum.co.uk/Text-Art-Archive; Martin Heidegger, 'The Origin of the Work of Art', in *Poetry, Language, Thought*, trans. Albert Hofstadter (first published 1950, New York: Harper & Row, 1971), p. 17.

[17] http://1995-2015.undo.net/it/evento/24404 (last accessed 21/03/16).

[18] *The Guardian*, 12/07/05.

was the foundation of good prose. Even such minor slips as mixed metaphors were warning signs 'that the writer is not seeing a mental image of the objects he is naming. In other words, he is not really thinking.'[19]

The Plain English Campaign, now celebrating its quarter century, has made great strides towards clarifying official language. What we need now is a similar campaign against the swamping of politics and art in gobbledygook. More than a campaign, we need a moral crusade because, as Orwell knew, this sort of nonsense is inherently dangerous. Ready-made phrases, he cautioned, 'will construct your sentences for you — even think your thoughts for you, to a certain extent — and at need … will perform the important service of partially concealing your meaning even from yourself. It is at this point that the special connection between politics and the debasement of language becomes clear.'[20]

Sixty years on, the connection still needs clarifying. There should be a public outcry every time a politician speaks of 'driving outcomes'; every time an art publicist talks of 'challenging boundaries' or 'engaging spaces'. We should impose penalties — make the offenders write out lines of poetry — because every such mindless phrase anaesthetizes a portion of our brains. Abuse of the language is more than a crime against literacy; it's a failure of imagination, a dismantling of the ability think in concrete images that is civilized society's chief safeguard against corruption by mind-numbing terms like 'collateral damage'. Loose talk costs lives. We must put the concrete image back where it belongs, at the heart of language, as our best test of truth and defence against falsehood. Without reconnecting language to reality there can be no return to the golden age of civilization pictured by Thomas Mann in *The Magic Mountain*, when 'writing was almost the same as thinking well, and thinking well was the next thing to acting well'.[21]

Meanwhile the rot continues, as reality is wrapped in a thickening fog of corporate obfuscation. The languages of politics and art are edging closer: the winners of the 2015 Turner Prize, Assemble, were praised by the judges for work on a run-down Liverpool housing estate that showed 'the importance of artistic practice being able to drive and shape urgent issues'.[22] However different their contexts, the languages

19 Orwell, 'Politics', p. 164.
20 Ibid., p. 165.
21 Thomas Mann, *The Magic Mountain*, trans. H.T. Lowe-Porter (first published 1924, Harmondsworth: Penguin Books, 1960), p. 159.
22 http://www.tate.org.uk/about/press-office/press-releases/assemble-wins-turner-prize-2015 (last accessed 21/03/16).

of politics and art are equally open to corruption, since both are now essentially about salesmanship. But art has one big advantage over politics: it can communicate without words. Contemporary artists should give up fretting over the inadequacies of language as a tool of communication. If they want to stop the rot, they should set an example by taking the advice inscribed by Salvator Rosa under his self-portrait: 'Aut tace, aut loquere meliora silentio' — 'Either shut up, or say something better than silence.'[23]

[23] The self-portrait is in the National Gallery, London.

Eric Coombes

Criticism and the
Collapse of Culture[1]

After the recent change of government, this might be a suitable
moment to look back to the year in which the recently ejected gang of
liars, buffoons and crooks first came to office. And, as our misgivings
about their replacements find ready confirmation, we may well
suppose that 1997, with its coincidence of conspicuously symptomatic
events, may come to be seen as the year in which our cultural dis-
integration finally manifested itself as irrevocable. For this was also the
year in which there occurred the most extraordinary eruption of mass
hysteria that any of us had ever witnessed: hysteria in response to the
sudden death of a foolish, ill-advised and unfortunate young woman —
distinguished by no outstanding virtues and with no claim to general
admiration or affection not rooted in fantasy. This fantasy appears to
have obsessed the many enfeebled dupes of the mass media, by which
it was concocted and sustained with ruthlessly exercised power, and
filled the confined space of their imaginative lives with the cheaply
manufactured — and therefore profitable — junk of sentimentality and
factitious passion.

Within three weeks of Princess Diana's death, an exhibition at the
Royal Academy of Arts quickly fulfilled the intentions of its publicity-
orientated organizers by reaching a level of notoriety which was,
perhaps, unprecedented in recent years, for something promoted under
the label of the visual arts. This notoriety derived from the appre-
hension that so much of the exhibition seemed intended to shock, dis-
gust or offend. Consisting of items from the collection (or stockrooms)
of Charles Saatchi, it was suffused by the ethos of the advertising
industry in which Saatchi made his enormous fortune, an ethos which

[1] This essay was first published in *The Jackdaw*, almost a year after the forma-
tion of the coalition government of Conservatives and Liberal Democrats,
following the fall of New Labour from office. Since its observations, if
apposite at all, are no less apposite now than they were then, I have decided
to leave it essentially unchanged for this publication.

also appears to govern his activities as a collector and dealer — the imperatives of advertising and art being, for him, indistinguishable.

The joyous acclamation, as he pranced into office, of a risibly obvious charlatan; the earth-moving torrent of emotional incontinence — which he exploited — flowing from people who never knew the object, or putative object, of their grief, and whose only loss was delusional or phantasmagorical; and, under a transparent pretence of high-principled seriousness, the filling of the best and most prestigious exhibition space in the metropolis, at the centre of the cultural establishment, with the disgusting and offensive: in their different but connected ways, these three occurrences flaunted the triumph of fantasy over reality, and the infantile over the mature.

In the exhibition, named *Sensation* in gloating anticipation of its reception, there was certainly plenty to disgust or offend, as well as the usual large helpings of slightly nauseous tedium, and a certain amount of pitiful incompetence masquerading as sophistication. As was intended, much of this provoked outrage and controversy — if 'controversy' is a term that can properly be applied in the absence of anything amounting to reasoned argument. Obscene items by the Chapman brothers, for instance, attracted, understandably enough, a good deal of opprobrium, as did the moronically blasphemous (and formally feeble) contributions of Chris Ofili. But the main focus of outrage was, of course, an image, more than twelve feet high, reproducing on this enormous scale the police mug-shot of the infamous murderess of children, Myra Hindley, a photograph ubiquitously familiar to the British public through featuring, almost invariably, alongside recurrent press reports and commentary about Hindley herself, and about the stupendously evil actions in which she engaged.

The story of those actions is harrowing; but, since they are familiar, despite occurring more than forty years ago, we need not repeat the appalling details here, but merely remind ourselves, in general terms, of what happened. Hindley and her male accomplice abducted and tortured to death five children, having sexually abused at least four of them. In at least one case, they made a recording, presumably for their later delectation, of the ten-year-old victim's screams and pleading as she died. Her mother later undertook the duty of listening to this recording in order to help the police by identifying the voice as that of her little girl.

For almost all the British, that photograph instantly evokes thoughts of the murderess and the depravity of her barely imaginable crimes. It is clear, therefore, that the exhibit alluded to matters of great public concern and intense moral anxiety. The outraged felt that, given its scale and prominence, the presence of something so disquieting was

such an affront to the bereaved's feelings of distress that its inclusion should not have been contemplated, let alone implemented. Disagreements about the rights or wrongs of showing *Myra* were—however squeamishly the metropolitan chattering classes might cringe with embarrassment or disdain from explicit invocations of morality— disagreements about a moral issue.

Can this moral issue be separated from any serious attempt to assess the exhibit as a work of art? If this was just a cheap publicity stunt, cynically exploiting a merely sensationalist item of negligible artistic merit, then surely the painting's prominent display was indefensible. If not, if it is a serious work of art—the very least required to justify its showing—then must it not engage in some morally responsible way with the deeply disturbing matters which it evokes? Any such engagement could hardly be understood as separate from or additional to its aesthetic character; and to consider this question is to confront a fundamental issue of aesthetic understanding: are aesthetic and moral intuitions and judgements entirely distinct, or do they interpenetrate or illuminate each other? Do they, in the last analysis, come together in our efforts to sustain and vindicate a unified cultural domain of that which we ultimately value? Is this why we find it natural to speak in terms of moral beauty, or moral ugliness, and why the concept of grace, for example, can be exercised with equal appropriateness in our thoughts about the aesthetic and the moral? Is there anything to be said for Keats's famous words: 'Beauty is truth, truth beauty', or is it now impossible to hear them without jeering?

One should not, of course, require the criticism of art to turn itself into extended philosophical discussion, at a high level of abstraction. But is it not reasonable to suggest that, for *serious* and *responsible* criticism, an awareness of these questions must be integral to the context of discourse? So far as art is taken seriously, it finds a place in the wider context of our lives and thoughts, and, in particular, our thoughts about what we value and what concerns us (sometimes by showing us, or even by *being*, what we value). The role of criticism is, in part, to place art in this wider context, in a cultural space which is constituted, furnished and maintained through discussion (of its nature never closed), a space of shared perceptions, in which we hope to realize in imagination that which we seek to comprehend intellectually. If criticism involves 'the common pursuit of true judgement', then it aims at a widely shared understanding of where and in what we should come together in the 'truth' of feeling and imagination. Even the 'challenging', to mention what is usually a weasel usage rightly much mocked in *The Jackdaw*, can ultimately be valued only if it challenges us to extend the scope of shared sensibility.

Any serious discussion of *Myra*'s merits as a work of art, then, would need to consider whether its aesthetic character bears the grave moral weight of its allusions, or in any way illuminates the deeply disturbing matters which it evokes. This would not be to ask what *message* the painting might convey. The crass philistine notion that the significance of art inheres in its 'message' is one that has now invaded art education, where it would once have been treated with the scorn that it deserves. We do not value Dickens, to take an obvious example, because he *told* us about social evils and the depravity which they engendered, matters of which we or his contemporaries might otherwise have been ignorant. Nor would we have looked to him for solutions; and had he suggested any they would have had no more authority than anyone else's. What an artist of Dickens's stature achieves is the means by which what we might or might not otherwise merely know about is made available to the imagination as well as to the intellect, and so unites thought and feeling. Could anything similar be claimed for *Myra*?

The photograph on which the painting is based is merely a typical example of its kind, in not flattering an apparently quite plain and even disagreeable-looking young woman, staring unsmilingly directly at the camera. Its strangeness mostly derives from the wooden and unnatural effect, which, as a glance at a few passports will confirm, tends to characterize such photographs. Such epithets as 'the face of evil' are not a response to any properties intrinsic to the image, or to the face revealed in it, considered in detachment from the highly specific context of its notoriety; and its blood-curdling power of evocation is entirely a matter of association, relentlessly reinforced over a period of many years. This power of evocation was, of course, the sole reason for using that particular photograph. And apart from the overwhelming size of the painting, its only significant difference from the press reproductions of the police mugshot was that, on closer inspection, the granular texture of the image, imitating the coarse effect of the half-tone screen used for newspaper printing, was seen to be composed of a child's hand prints.

Appropriately enough, for an exhibition informed by the ethos and imperatives of the advertising industry, the scale of the image and the familiar device whereby its texture resolves at close quarters into further imagery—indeed, everything about it—suggest that it would have been quite a good idea for a billboard poster. One could imagine it as an advertisement for a horror movie—the face of the villainess on the hoarding commanding, by sheer size, transient attention from across the street, or revealed at close quarters to be dabbed all over by the desperately scrabbling hands of her helpless child victim. But what

was this advertisement an advertisement of? Of Hindley's crimes? Did they *need* to be advertised? The very suggestion is preposterous. Indeed, it could be said that, by this time, their advertisement was actually impossible, in the sense that a fully saturated cloth cannot be wetted. Such was their notoriety that, far from the painting's advertising Hindley and her crimes, it was she and her crimes which were advertising the painting.

With this last point in mind, let us return to the outcry against its exhibition. One of the protesters was reported to have said that she objected strongly to the transformation of the murderer of her child into 'an icon to titillate the public for a moment or two, before it moved on to its next, equally momentary, preoccupation or amusement'.[2] And a spokesman for the children's charity, *Kidscape*, said 'How sad that an artist has to resort to sick exploitation of dead children to get noticed'.[3] These unpretentious statements expressed feelings with which any decent person might at least sympathize. But they were made from positions entirely external to the art world and its preoccupations; and it is not difficult to imagine the sniggering disdain with which their apparent lack of sophistication might have been greeted in some quarters. But there is a paradox here. For while these superficially simple-minded comments did not state, they nevertheless implied, a shrewd and *sophisticated* understanding—showing itself, admittedly, only in a very inchoate form—of what was at stake culturally; an understanding far shrewder, and at a higher level of *genuine* sophistication than was reached by the self-satisfied panjandrums of the contemporary art establishment, for whom shrewdness means cynicism and sophistication frivolity. It takes only a little reflection and imagination to find in these condemnations the seed of a *critical* observation far more penetrating than most of the perfunctory remarks of professional critics. These ladies sensed that the decision to exhibit *Myra* prominently was made in the pursuit of publicity for the sake of publicity, and, in their heart-felt unselfconscious way, made observations which require very little elaboration to arrive at precisely the point reached in the previous paragraph: this is painting as billboard advertisement; but, through exploitation of the notoriety of Hindley's vile crimes, what is advertised is the advertisement itself.

If this account is at all right, then we have an emphatically negative answer to the critical question raised above, as to whether this painting engages in any serious way with the grave and disturbing matters to

2 Conversation reported in 'Trash, Violence, and Versace: But Is It Art?', by Theodore Dalrymple, *City Journal*, Winter 1998.
3 Reported in *The Independent*, 31/08/97.

which it alludes: for it is not even *concerned* with those matters, except to exploit them, since their role in relation to the painting and its projected reception is merely instrumental. In fact, some of the *favourable* commentary implicitly conceded this point.

I have suggested that some of the supposedly naïve observations from outside the contemporary art establishment, observations not ostensibly aimed at aesthetic judgement at all, got closer to *aesthetic* understanding than did the words of many professional critics. What did the latter have to say? Let us take as an example the judgement of Richard Cork—critic at various times for several highly respectable national newspapers and journals; who has been editor of *Studio International*; a Turner Prize judge; Chair of the Visual Arts Panel at the Arts Council; a member of various other high-level committees and panels disbursing taxpayers' money, supposedly in support of the visual arts; Henry Moore Senior Fellow at the Courtauld Institute; and even—God help us—Slade Professor of Fine Art in the University of Cambridge. In a review of *Sensation*, the following was all he had to say by way of direct critical commentary on the painting:

> Far from cynically exploiting her notoriety, Harvey's grave and monumental canvas succeeds in conveying the enormity of the crime she committed. Seen from afar, through several doorways, Hindley's face looms at us like an apparition. By the time we get close enough to realize that it is spattered with children's handprints, the sense of menace becomes overwhelming.[4]

Well, perhaps—for reasons already discussed here—it did have some 'sense of menace'. But why, in the absence of some wider context of elucidation in which it found its significance, that claim would count as attributing artistic merit—or even, still less plausibly, as establishing the status of the painting as an important work of art—this is unexplained. And how could he say that it 'succeeds in conveying the enormity of the crime she committed'—rather than merely reminding us of it—when that enormity was already an established and prominent feature of public consciousness (the 'sense of menace' deriving adventitiously from that very condition); and when the painting itself contains no information whatsoever about the crime? Is this not preposterous nonsense?

If this critic's intellectual distinction reaches the exalted level at which we could legitimately expect to find the thinking of a recipient of the honours he has gathered, and of an occupant of his numerous positions of power and influence, could he not have said something a little more convincing and a little more developed than this? If he could

4 'The Establishment Clubbed', *The Times*, 16/09/97.

not have risen above mere assertion, could he not at least have risen above assertion of the patently absurd? Did he feel no obligation to support his favourable judgement with some more extended account, which, by educating our perception of the work, would vindicate the hysterical hyperbole of his praise, justify its exhibition, and excuse the vulgar puerility of the incontinent abuse with which he denounced those who wanted it excluded?

At the beginning of the article, he had greeted the whole exhibition with glee: 'The rebels have stormed the bastions of conservatism, and howls from outraged academicians are still bouncing around the walls of Burlington House.' Its clownish tone reminiscent of a children's comic, this grotesque rhetoric was either brazenly disingenuous or spectacularly stupid, in so far as it suggested that 'the rebels' consti-tuted an arbitrarily excluded group of the talented, bravely triumphing over an unjust and intransigently reactionary establishment. The truth, of course, as the slightest acquaintance with the facts would reveal, is that these people basked in the favour of the contemporary art estab-lishment; and one might reasonably ask how much audacity and military valour were required to storm the bastions of a fortress which was under the command of the invaders' pugnacious chief ally— namely, the all-powerful exhibitions secretary, Norman Rosenthal. This is, again, preposterous nonsense.

This is what he wrote about the issue of whether *Myra* should have been shown:

> By making an hysterical attempt to ban Marcus Harvey's painting of Myra Hindley, the crustiest academicians have revealed just how ugly their censorious hatred can be. If they do fulfil the threat to resign in protest, their departure will be the Academy's gain. ... So I am delighted that the exhibition will open on Thursday, with the Hindley painting defiantly in place. The show's arrival is a welcome sign that the Academy has belatedly decided to atone for its disgraceful, antiquated intolerance in the past.[5]

In the article from which I am quoting, which itself merits the epithet 'hysterical', this triumphalist gibe is *all* he said about the issue, which is therefore treated as if it were a disagreement entirely confined within the preoccupations of the art world, themselves construed, and almost celebrated, as narcissistic. Again, this is either disingenuous or extra-ordinarily stupid, since it would be hard to imagine any conflict more calculated to burst out of the art world's domain of self-regard, and engage members of the public at large. Those engaged included the protesting mothers of murdered children, and one wonders what they

5 Ibid.

would have made, had it been brought to their attention, not only of Cork's astoundingly narrow view of the nature of the disagreement, but also of his apparent blank unawareness of the connotations which, in this context of use, would naturally attach themselves to his words. Is there nothing more obvious that springs to mind here that might cause one to think of ugliness and of hatred? Whether they were right or not, is it not in the least possible that the 'crustiest academicians' might have been motivated, not by 'censorious hatred', but by its opposite—by compassion and respect for the feelings of the bereaved? (That their artistic judgement might have been sound is, of course, unthinkable.) Did it not occur to Cork that, only through the inadequacy of gross understatement, does 'intolerance' fall short of being an appropriate word to describe the attitude of those so comfortable in the prison of their own narcissistic preoccupations and prejudices that they implicitly dismiss without a second thought— dismiss as less important than the freedom to 'ignite controversy'[6]—the feelings of a parent whose child has been tortured to death?

The perverse narrowness of Cork's view, which we may take as representative of other enthusiasts for the exhibition, seems pathological. How can anyone be so deficient in the capacity for ordinary human sympathy as not even to consider whether, if the bereaved felt as they did, then this might—just *might*—*in itself* be sufficient reason for the painting not to be shown? To entertain this thought is not to favour censorship: it is simply to ask whether the prominent exhibition of this painting could, in the circumstances, be reconciled with common decency, and to question the integrity of the motivation for showing it.

We might notice a contrast between the attitude of the powerful to appeals from the parents of murdered children, and the attitude taken to the hysteria prompted by the death of the Princess of Wales, less than three weeks earlier. Many concessions to what we can only call the mob were made by the establishment—or, more accurately perhaps, by a declining establishment pushed aside by the new anti-traditionalist establishment of shameless ignorance, semi-literacy, contempt for truth, and minimal attention spans. The new establishment exploited the occasion of these concessions for its own advancement, by imposing, for example, with no precedent in customary protocol, the new ham-actor Prime Minister as a reader at the princess's funeral service in Westminster Abbey, and by inserting into the solemn rites a performance by that preposterous figure, Elton John, of a pop song, distinguished by its mawkishness and by the fatuousness of its lyrics. An atmosphere was created in which it seemed almost obligatory, if not

6 Ibid.

to participate in, then at least to respect this orgy of hysteria — although subsequent surveys established that it was, in fact, neither shared in nor respected by most of the population. In this almost totalitarian climate, authority itself was intoxicated by the all-pervasive fumes of hysteria: unsurprisingly, if in the circumstances incautiously, a few people tried to take mementos from the gigantic heap of 'tributes' (so vast as to have become a health and safety hazard), reasoning, no doubt, that one or two teddy bears out of thousands would not be missed, and were, in any case, destined for disposal as refuse, like the contents of skips. But two Slovakian lady tourists were sentenced to twenty-eight days in prison for removing a teddy bear, an offence which, if occurring as ordinary shoplifting — where, at least, a victim of crime could be identified — would scarcely merit a caution, and then only if the police could be bothered to attend. On the other hand, a man who punched someone for the impiety of removing a teddy bear was acquitted of assault. Thus was the impartiality and proportionality of British justice vindicated.

What, one might ask, would the attitude of a court have been if a sympathizer with the protests of bereaved mothers had punched Norman Rosenthal for what they perceived as an insult to their feelings and the memory of their children? Would a magistrate have acquitted such a sympathizer on the grounds that it was the court's function to express public outrage, which was, apparently, the view taken in at least one courtroom during the Diana delirium? The question, as they say, answers itself. But then these were uninfluential, unglamorous, working-class people, from such tedious provincial places as Manchester. What importance did they have compared with the cosmopolitan luminary, Norman Rosenthal? To the mass media, their importance had been exhausted many years earlier, when they played a supporting role in relation to the original horror story. If the renewal of their importance was to be permitted, it could only be as a useful element in the concoction of the latest media frenzy, in which they did, indeed, helplessly play their ordained role of enhancing the exhibition's publicity.[7]

Apart from the huge disparity in numbers, there are two obvious differences between the grieving parents and the 'grieving' mob. One

[7] For the facts related here concerning the princess's death and its public aftermath, I have largely relied on the information included in *The Late Wicked Princess: Reflections on a State Funeral*, an appendix to Ian Robinson's *Untied Kingdom* (Bishopstone: The Brynmill Press, 2008). This is the fourth and concluding volume in his series, *Coming to Judgement*. His work has greatly assisted me in getting my own thoughts into sharper focus. The suggestion that 1997 will come to be seen as a defining moment is his.

difference is that, while in one case the object of grief was a real person known and loved by the grievers, in the other case it was an image endlessly renewed and elaborated by the popular media in a phantasmagoria taken for, and displacing, reality—an image remotely associated with a real woman who happened to die, but who was completely unknown to the mourners. The second difference is that whereas this image had all the glamour that can be sustained only by colossally expensive artifice, the murdered children were just that: unglamorous children mourned by unglamorous, unimportant people. We see here an aspect of the odious hypocrisy festering at the centre of our debased culture: we supposedly live in a democratic and even egalitarian age; and this might be thought to find confirmation in the flattery of the least educated and the indulgence of the lowest taste, implicit in the prevalence of coarse material and demotic usages swamping the media, and in the triumphalist assertion of populist sentiment following the princess's death. But the construction by the media, with her cooperation, of the artifice of her fictional image came about only because she occupied an adventitiously acquired position of hereditary wealth and privilege—the negation of egalitarianism. What, on the other hand, of those examples of ordinary people, entirely untouched by hereditary privilege, the unglamorous parents of the murdered children? Would egalitarianism not wish to promote their right to a hearing, and to a level of public respect and consideration commensurate with the magnitude of their suffering, rather than with the lowliness of their unprivileged circumstances? What was the volume of the popular outcry supporting them, and how much hysterical amplification was applied to it by the media, when their supporters demanded respectful deference to *their* feelings, as the mob demanded deference to their factitious grief for the loss of someone they had never known?

It would not, in fact, be true to say that no such popular feeling was expressed, or even that it was underreported. But what excited the media was the *controversy*, or 'controversy', and it was, of course, 'controversy' that the exhibition's promoters sought. And in this way, the protesters unwittingly served the purposes of those against whom they were protesting. It was not so much that the protests were ignored, as that the reports of protest were absorbed into the media delirium—appropriated by the publicity machine, and rendered into material for the exercise of such infantile posturing as Cork's.

In a book first published in the year after these events, Roger Scruton writes, 'You will not perceive modern high culture correctly, it seems to me, if you do not see that much of it—perhaps the major part

of it—is a pretence'.[8] With the death of Princess Diana, we saw how a
pretence fostered by the mass media at the level of popular culture had
displaced reality from many people's minds, and appropriated their
emotional lives. With *Sensation* we are considering something which
was certainly presented, both physically and institutionally, at a
location in the domain of *high* culture, and with the ceremony of the
corresponding rituals, employing such items of cultural paraphernalia
as an illustrated catalogue, dignified by the inclusion of footnoted
essays.

Is this mode of presentation not a pretence in itself? What—other
than presentation—distinguishes such an exhibition, and in particular
an item such as *Myra*, as a manifestation of high culture, rather than of
the populist culture exemplified by the torrent of images and quasi-
fiction about the princess flooding the market? If we do not accept, as
we surely should not, that mere *presentation* as such is enough to
determine the issue, then the answer can only come in the exercise of
criticism. By this I do not mean anything so crude as the construction of
a ranking order, in which anything placed above a certain level would
qualify as 'high art'. It is rather that assignment to the sphere of high
art presupposes the possibility of a certain kind of serious considera-
tion: it suggests that, being worth seeing, hearing or reading more than
once, the work could become the subject of discussion and judgement,
which would seek to illuminate its character, and, as I put it earlier, to
relate it to the wider context of our lives, thoughts and judgements. In
the case of *Myra*, there can be, surely, no doubt about what aspects of
our lives, thoughts and judgements constitute the relevant wider con-
text. Where did we find, among professional critics, a discussion of
Myra which made a serious attempt to meet this requirement? In the
example I have given, there is what might be considered a gesture
towards these matters, but nothing whatsoever intelligent or illumi-
nating is said.

Cork is not unique in his apparent assumption that if an exhibited
item is 'about' or in some way associated, or even associable, with some
important, interesting or disturbing matter, then, *ipso facto*, that item is
replete with significance about the important, the interesting or the
disturbing. At almost any exhibition at Tate Modern, for example, wall
texts and publicity material are formulated on this principle, evidently

8 Roger Scruton, *Modern Culture* (new edn., London: Continuum, 2006), p. 95.
 My intellectual debt to Scruton is far from being exhausted by the contents
 of this book. In other publications, he has offered a philosophically sophisti-
 cated defence and refinement of intuitions about the nature and value of
 art, which I take to be consistent with the arguments of this essay.

by brainwashed zombies. As I write, a wall text in the museum, repeated on the website (beginning with a moderately strong candidate for inclusion in *The Jackdaw*'s artbollocks column), informs us that 'Ai Weiwei's *Sunflower Seeds* challenges our first impressions: what you see is not what you see, and what you see is not what it means.' Then, a few sentences later: 'The precious nature of the material, the effort of production and the narrative and personal content make this work a powerful commentary on the human condition.' Why do they? How do they? What comments does the commentary include? And in what sense can this 'narrative and personal content' be considered *content*? *Content* is what is *contained* in something, and, in a work of art, *disclosed*. This 'content' is merely the information supplied by curators about the circumstances surrounding, and the activities leading up to, its production, together with some musings prompted by association. One might as well say that the content of a shopping bag includes details of the route to and from the supermarket, and an account of the thoughts going through one's mind as one made the journeys. Because this 'work' is supposed somehow to allude to conditions under the vile despotism of China, a tacit moral blackmail tries to bully us into according it our respectful sympathy, although no one could possibly guess at this alleged allusion without information which is entirely absent from the structureless expanse which confronts us, and remains external to it when imparted.

By what criterion is it determined that the associations which we are *instructed* to contemplate constitute the content of this 'work', rather than any that might occur to us spontaneously? I, for example, find myself brooding on the egregious vanity and arbitrary power of imposters who fraudulently assume the authority of alleged expertise to spend large sums of taxpayers' money on such boring projects as this. Is *that* part of its meaning? And if the 'work seems to pose numerous questions', by what means are they posed? What is the exact status of the three quoted samples of this numerousness, such as 'What does it mean to be an individual in today's society?'? (I shall not attempt the thankless task of considering whether this is a question at all, rather than a sequence of words in the grammatical form of a question. The curators were, presumably, favoured with the editorial advice of E.J. Thribb (17½).) Are the sample questions more legitimate than the following, which (but only with the benefit of the supplementary information) present themselves most spontaneously to me? How, for example, does it come about that a dissident, who has, apparently, suffered serious persecution, including life-threatening police brutality in China, is able to secure the services of a large proportion of the inhabitants of a Chinese city, over a period of two years,

to manufacture 100 million hand-painted porcelain sunflower seeds? What did it all cost, and from whom, other than the sponsor, Unilever, did the money come? And given that, according to the Tate, part of the 'content' is 'personal associations with Mao Zedong's brutal Cultural Revolution (1966–76)', can we refrain from asking whether any of those promoting this stunt are exactly the kind of people — or even some of the actual people — who once looked favourably on Maoism, making absurd excuses for or obstinately denying its unspeakable savagery? Are they, perhaps, still committed to the principles of Mao's ideological cousin in Europe, Gramsci, and especially to his strategy of incremental sedition in a 'long march through the institutions'? This is a pertinent question in view of their privileged positions in the institutional command structures of state art.

One used occasionally to come across undergraduates who seemed to believe that intellectual labour, as in writing an essay, consists merely in mentioning topics subsidiary to the topic of the set question, or matters in some way associable with it, with no attempt to provide an argument which would evaluate their relevance and importance and bring them into some kind of coherent relationship — or, indeed, actually to *say* anything. Such students appear to be those who have subsequently prospered in careers as curators, and sometimes as art journalists (one can hardly say 'critics'); and we might describe their standard procedure as the attribution of meaning by arbitrary or near-arbitrary association, by whim or according to the imperatives of political correctness. Here, 'attribution of meaning' connotes not an attempt to *disclose* or *elucidate* meaning, but the making of vacuous or arbitrary claims, or pseudo-claims, couched in the preposterous vocabulary of artbollocks, and feebly indicating a general area in which meaning is allegedly to be found — an area which may be as illimitably general and as portentously vague as 'commentary on the human condition'.

A good, if primitive, example of this empty blather was reported in the best article by far on *Sensation* that I have come across. Unsur-prisingly, this was written, not by a professional critic or a curator, but by the ex-prison doctor and social commentator, Theodore Dalrymple, who interviewed Norman Rosenthal before writing his piece:

> [Rosenthal] has the charismatic capacity to antagonize at 100 yards; and when he speaks — hundreds of words to the minute — one feels one is listening to Mephistopheles.
> 'All art is moral,' he said. 'Anything that is immoral is not art.'
> There is no such thing, wrote Oscar Wilde, as a moral or an immoral book. Books are well written, or badly written. Presumably, then, *Mein Kampf* would have been all right had it been better written.

'The picture raises interesting questions,' continued Rosenthal.

'What interesting questions does it raise?' I asked. 'Because it must be possible to formulate them in words.'

'It raises a question, for instance, about the exploitation of children in our society,' said Rosenthal.

'Some might say that the use of a child's palm to produce a picture of a child murderer, when the child could not possibly appreciate the significance of the use to which its palm was being put, was itself a form of exploitation,' I replied.

'If so, it is very minor by comparison with what goes on in the rest of society.'[9]

Dalrymple's response here is rhetorically effective: if Rosenthal could defend the work on such preposterously vague and unargued grounds, then Dalrymple could certainly condemn it on grounds much less vague, and with at least the sketch of an argument. But for present purposes, it is more significant that Rosenthal has employed a routine artbollocks tactic of brazen evasiveness: if *Myra* raises a question 'about the exploitation of children in our society', then *what* question does it raise? And why are we not told? Why, in the contemporary-art curators' universe of what we must, I suppose, call 'discourse', are so many questions supposedly 'raised' that are never formulated, let alone answered? And how, in any case, could it be plausibly claimed that this work is even *about* the *exploitation* of children? It is true that the mind might pass, through a chain of associations, from the thought of children's suffering to the thought of their being exploited. But such a chain could be initiated as easily by the mere words 'suffering children', or just the word 'children', or, indeed, by anything at all, since a chain of associations can, without straining any particular link, connect anything with anything. If we try to say what it is about this particular painting which has *exploitation* of children as its content, we are baffled. Certainly it might be allowed, not unreasonably, that it alludes to their murder and suffering. And we could, I suppose, say that the murderers 'exploited' those children to satisfy their evil desires — although this would be an extremely odd and grotesquely bathetic characterization of those monstrous events. But it would be absurd to take 'exploitation of children in our society' as referring to such extremities of abuse as their torture and murder: it must be understood to allude to some pervasive social pathology, or to structural faults in society, conducive to children's being harmed for the gratification of adults.

Now I should be the last to deny that we live in a debased culture which is extremely detrimental to the upbringing of children, and the

9 Dalrymple, 'Trash, Violence, and Versace', (1998).

root of much unhappiness among the young; although I doubt that Rosenthal's views as to the most relevant factors, assuming that he has any, would coincide with mine, in which those factors include, for example, the ubiquity and ready availability to the young of degrading and corrupting material—such as pornography of the type which is presented (with no obvious implication of moral disapprobation) by the author of *Myra* in his other exhibits in *Sensation*. The position of children 'in our society' is, indeed, a deeply disturbing matter, and it is partly because this is so that one objects to Rosenthal's using it in this way—'exploiting' it, as one might say, to give vacuousness a bogus aura of gravity.

Rosenthal, however, does remind us of La Rochefoucauld's famous definition of hypocrisy: 'the homage that vice pays to virtue', which could here be further specified as 'the homage that intemperance, ego-mania and frivolity pay to proportionality, compassion and responsi-bility'. Do we detect, beneath this fountain of bluster, the pressure of a slight sense of uneasiness, adding its force to the flow of incoherent dogmatism, and tingeing it with a defensive sanctimoniousness? To assert as much might be to give Rosenthal more than his due, which, for a man who already has far more than his due, one would wish to avoid. But however that may be, we should notice that, far from rejecting the legitimacy of raising moral questions about the painting, Rosenthal actually asserts, in effect, albeit with characteristic intellectual crudeness, that aesthetic and moral questions are not separable.

Although we should not accept the reduction of this thought to Rosenthal's simplistic formulation, he does remind us inadvertently that—however determinedly unfettered megalomania dismisses any but its own views, and, by the brute force of money and institutional power, imposes its own preferences—in the end and of necessity, art must be sustained by a community in which its meanings are shared and its values endorsed. The meaning of idle references to 'raising interesting questions' about matters of moral concern, or to 'powerful commentary on the human condition', is not to be found *in* them, for they *contain* no meaning at all. But their meaning *to* or *for* us lies in what they betray—that even Rosenthal and the apparatchiks at Tate Modern cannot avoid giving minimal, and perhaps unconscious, recog-nition to the *a priori* truth, that art necessarily seeks intersubjectivity, and cannot be detached from the cultural conditions of shared values in which, and only in which, it can occur, and which it reciprocally sustains.

This being so, a work of art *as such* presents itself as an object of potentially consensual judgement—even if consensus may take some

time to reach and is not monolithic (although this is a point which has, for many years, been absurdly exaggerated). But judgement is not the same as instant and uninformed reaction, and requires an ongoing process, involving revision and renewal in response to the needs of changing perspectives. It involves discussion, description and redescription, and comparison of one person's responses with another's; it involves the readiness to look at things more than once and to consider whether the experience is rewarding; it involves seeking formulations of one's views to make them available to others and thereby topics of discussion rather than occasions of mutual incomprehension. At different levels of sophistication, this activity occurs spontaneously, casually and even tacitly among intelligent people, and constitutes the process whereby art is integrated into, and finds its value in, the wider life of the community. What we call 'criticism', those more formalized activities issuing in journalism, books, lectures or essays, arises, or should arise, from this spontaneous process of collaboration in refining and making sense of our responses to art, and is continuous with it.

If, then, something is placed in the domain of high art, it is necessarily presented as the proper object of aesthetic judgement, and that entails criticism. Nothing could be clearer, as I said above, than that *Myra* and the other contents of *Sensation* were so presented. There was a certain amount of assertion and counter-assertion; but where was the *criticism*—the criticism which, by its very existence, might—if serious—at least have vindicated the presentation of these items in the *domain* of judgement, even if it did not locate *Myra* on the exalted level at which Rosenthal would place it? Where, in particular, was the criticism that, taking seriously the earnest view of *Myra* in which moral significance was intrinsic to the painting's aesthetic character and artistic virtue, attempted to elucidate what this might actually mean, and, through *attention to the work itself,* show how this should inform our perception of it?

Now criticism needs to find a purchase on something which can sustain its attentions. And if there was no such criticism of *Myra*, perhaps this was because the painting would not sustain it—that there was simply not enough to be said. Of course, if this were so, then, one might argue, it was the critic's duty to say something to that effect—and, no doubt, in some instances that duty was discharged, though probably not in quite such explicit terms. It could also be argued that it is part of the critic's role where necessary, to elucidate, possibly employing wider cultural and even quasi-sociological arguments, why a particular item will not sustain serious critical consideration. But this, a kind of second-order activity, is difficult, unrewarding and tiresome,

and especially uncongenial if needing to be undertaken frequently. A bit like trying to prove a negative, it is *entirely* different from expressing reservations about, or finding faults in, something which is, nevertheless, a legitimate object of serious discussion.

It could be wearisome and even daunting to undertake this relentlessly negative task for most of what is promoted under the patronage of state-art apparatchiks and their commercial confederates, whose power is monopolistic, unaccountable and so extensive as to engender hesitancy about crossing them—especially as there has been at least one attempt by the powerful to silence hostile commentary. Moreover, so far as it concerns itself with state art, criticism will tend to become enfeebled and fall sick through lack of healthy exercise; and only the most resolutely independent mind will resist the nagging thought that one cannot dismiss almost *everything* promoted with so much institutional power and unanimity, backed by so much money, and endorsed with such a unified show of certificated expertise. This thought may create a pressure to make discriminations, although the critic may actually be at a loss to make any, or even to know on what basis to do so; for, as Dr Johnson said, 'There is no settling the point of precedency between a louse and a flea.' Whether or not such pressure is felt, and at whatever level of consciousness it is effective, it remains the case that, where motions of discriminating are gone through, their paths often seem arbitrary, random or, indeed, invisible, although followed with a show of factitious conviction—whether in the reasonably mannered but limply unreasoned prose of a Richard Dorment, or with the clownishly splenetic vulgarity of a Waldemar Januszczak.

The corruption of the contemporary art establishment is, in large part, an *intellectual* corruption, albeit one which is both exploited and promoted by the grosser and more obvious corruptions of power and greed. And it has putrefied most art institutions caught up in the lethal embrace, financial and regulative, of the state; so that it is now, for example, impossible—literally impossible—for a young person entering higher education from school to find a reputable place at which to obtain a worthwhile education in the practice of the visual arts. I emphasize *intellectual* corruption, because state art is sustained by a structure of unprecedented nonsense. This structure would collapse if the bonds of demented fantasy holding it together—the absurdly fallacious argumentation, the preposterous *non sequiturs*, the insanely arbitrary and ungrounded claims—were removed or destroyed, as they would be if subjected to effective public scrutiny in an atmosphere where intelligence and rationality prevailed.

It is clear that such scrutiny, which should be part of the wider task of criticism, is not being effectively undertaken—either because it is

hardly being undertaken at all, or because it is marginalized by institutional or financial power. The promotion and reception of *Sensation* constitute an especially convincing demonstration of this critical failure. It was all the more striking because the content of the exhibition, and the extravagantly expressed if vacuous claims about moral significance to be found in that content, brought it, in an unusually insistent way, into the wider domain of public concern, where, if the necessary conditions had prevailed, intelligent criticism could have been effective. But if we consider the prevailing conditions, we are immediately reminded of those other events of 1997, whose proximity seems, in retrospect, so appropriate and significant. What was the condition of public discourse that such creatures as Blair and his coterie of mediocrities and buffoons could so easily avoid the light of effective criticism and the widely visible exposure of their easily disclosed intellectual fraudulence? How could their pretensions have been taken so seriously, sometimes by supposedly educated people writing in respectable journals? (Perhaps through conditions similar to those in which the present gang have acceded to office.) What does it tell us about the power and disposition of the media to promote fantasy that so many people—not all of whom could have been sectionable—'grieving' for the princess, were so entirely removed from reality as to suppose themselves to have suffered a personal loss—a delusion compounded by public endorsement, the 'leaders of opinion' being largely impotent, unwilling or frightened to exercise any moderating critical influence?

This absence of a healthy culture of criticism in the arts is inseparable from the absence of a healthy culture of moral, social and political criticism, and from the degraded state of education. Or perhaps it would be more accurate to say that these are aspects of a single, if complex and multi-rooted, phenomenon. Moreover, the feeble inefficacy of criticism leaves the corruption of the arts unchecked, thereby depleting the cultural resources through which society can examine and evaluate itself. The events of 1997 illustrate this situation not only through their striking if accidental appearance of concatenation, but also because the public discourse surrounding *Sensation* vividly exemplified the continuity of aesthetic with moral judgement and criticism; and, in so doing, demonstrated, by the very crudeness and trivialization with which that continuity was misunderstood, the degraded and enfeebled condition of both.

Like so many of the vapid generalizations that now pass for cultural commentary, it is far from obvious what is meant by the often-repeated claim that we live in a 'post-modern' culture; but if we understand 'post-modernism' to denote the atmosphere of institutionalized and,

indeed, almost *compulsory* frivolity in which we now live, we might allow it some truth. We could regard the events of 1997 as epitomizing that climate. They marked, however, not the *beginning* of the reign of enforced infantilism, but, at the political level, the beginning of an outstandingly shameless and catastrophic episode within it. And it is very far from clear that we can regard that episode as ended, rather than merely entering a new phase, in which there will be no moderation of the malign influence of government and state-funded agencies on our culture, and in which the half-witted and mendacious platitudes of officialdom will change, if at all, only in exhibiting a crassness slightly less brazen, and being uttered in slightly less oafish tones.

Nevertheless, it may not be entirely absurd to regard 2010 as a significant year—if only in an attempt to acquire the virtuous condition of hope. And it so happens that, in 2010, an exhibition was held at the Dulwich Picture Gallery which had a different kind of significance, in offering a particularly strong and poignant reminder of the strengths of our own visual tradition, now the victim, not merely of official neglect but of official malevolence: this was *Paul Nash: The Elements*.

Nash reached early adulthood a few years before the beginning of the First World War, and died in 1946, shortly after the end of the second. His adult life and work, therefore, were dominated by what may well come to be known as the 'thirty-years war'. In the years immediately preceding that prolonged and ramifying calamity—in what we are now inclined to see as the last days of England's serene self-assurance (or complacency)—he made drawings and watercolours that place him firmly in the romantic English tradition of landscape painting. In the best of this work, certain places seem invested with numinous personality, as if the landscape, shaped by centuries of settlement and labour, was saturated and animated by the English people's sense of belonging. It is in this communication of the enchantment of place that he is so close to Samuel Palmer. In the exhibition, this aspect of his early work is represented by a number of images, including *The Orchard*, a preparatory work, and *The Wanderer*, both watercolours. In the latter, a single figure is about to disappear among trees in the middle distance. The landscape has a mysterious quality, which is not easy to describe, and which might have led James King, quoted in the catalogue, to say 'there is an air of menace here'.[10] One wonders whether such remarks are conditioned by our knowledge of what awaited Nash and his contemporaries only a few years later, the 'air of

[10] David Fraser Jenkins, *Paul Nash: The Elements* (London: Scala Publishers Ltd., 2010), p. 76.

menace' being seen as a premonition of the disaster to come. But it seems to me that what we respond to in this image is an undertone of apprehensiveness, even anxiety, towards the unknown, in an exploration impelled by an indeterminate yearning, such that the lone wanderer is drawn on by his desire to enter more deeply into the domain of enchantment, where he is, as it were, in communion with the land itself, as if with those he loves.

This sense of the meaningfulness of place is a constant feature of Nash's work; and even when empty of human figures, as they often are, the landscapes are filled with the resonance of human personality, sometimes concentrated in the character of trees. In 1912, he wrote to a friend, 'I have tried ... to paint trees as tho they were human beings ... because I sincerely love and worship trees and know they are people and wonderfully beautiful people ...'.[11] It therefore seems natural that when, with his world shattered, he came to express his anger and anguish about the slaughter and devastation of the war, he painted landscapes empty, or almost empty, of human figures. His most powerful First World War painting was in this exhibition. Bitterly entitled *We Are Making a New World*, it is a landscape entirely empty of explicitly human figures; and the vast expanse of earth pounded into a brown mash, a waste land of churned-up mud, could be seen, as in a nightmare, as the site of a sinister parody, a hellish graveyard, in which nature herself is among the dead. The broken remnants of trees seem to stand over anonymous and casually undifferentiated graves, like a company of defeated guardians, and anguishedly evoke, as if in bitter mockery, the crosses over decorously ordered graves, in the seemly burial grounds of a peaceful homeland.

If we are moved by the pre-war images, it is because they invoke a capacity to find enchantment in the vision of landscape, which we share with Nash, and therefore with each other. Places are depicted as if the rhythms of their physiognomy moved in harmony with the flow of feeling arising from the sense of belonging in them. This response to nature and to place is in itself an intersubjective experience, and therefore an affirmation of community; and for him, we may surmise, this experience was an intimation of, and, perhaps, in the last analysis inseparable from, being at peace with our fellows. Nothing, therefore, could embody his anguish at the violence and destruction of the war, as a gross violation of *human* life, more than the devastation of the landscape, not merely because it was violently voided of human life, but because the assault on the landscape was also an assault on human life itself, and on the conditions in which peaceful life establishes itself.

[11]　Ibid., p. 109.

We can, then, see this painting as recording a blasphemy against that very vision which the pre-war images so rapturously celebrate, as if, despoiled and derelict, the numinous dwelling-place has been voided and God expelled by the violent usurpation of the devil. If the redness of the clouds, in the unnaturally coloured sky, signifies the redness of blood, then we might well understand it to echo the despairing cry of Marlowe's Faust, 'See see where Christs blood streames in the firmament', and wonder if an entire civilization has sold its soul to the devil.[12]

At the end of the exhibition, we come to a room of landscapes including the Second World War painting, *Totes Meer* (dead sea). This is a painting of a huge dump of wrecked German aircraft, and is based on drawings and photographs which Nash made at the site in Cowley. The scene is depicted as at dusk, lit by the light of a waning moon. Even without the title, this image would insistently suggest a turbulent sea, and at very first glance, there would probably, for most people, be a moment when the sea was taken to be the literal subject matter, although it is quickly obvious that the literal content of the painting is the vast spread of wreckage itself. We know that this effect is based on Nash's visual experience at the site: 'The thing looked to me suddenly like a great inundating sea.'[13] The painting is organized so that the fragments of machines fall into patterns gathering themselves into rhythms which enact and elaborate the visual metaphor of a disturbed sea: the shapes of broken wings sweep up with the impetus of advancing waves, picking up each other's movement in a relay of visual rhymes which runs through the image. The jagged edges of smashed aircraft parts echo the foaming leading edges of breaking waves. The border of sandy ground stretching into the distance at the right suggests a beach onto which the waves are breaking. But the image remains a depiction of the dump, and there is no ambiguity as to its *literal* content.

To compare this painting with *Myra* might seem odd and even perverse. But these works have two features in common, which support comparison (and contrast) relevant to the themes of this essay. First, they both deal with, or at least allude to, very serious matters with obvious moral dimensions. (As a way of distinguishing them from other kinds of art, this is a *very* rough-and-ready characterization, and I would emphasize the word 'obvious'. For it would be quite wrong to say that a Chardin still-life, for example, properly understood, is without potential significance for the moral dimension of life — properly

[12] These familiar words from *Doctor Faustus* are invoked by Anthony Bertram, quoted in the catalogue; ibid., p. 58.

[13] Ibid., p. 160.

understood.) Secondly, they each employ a device whereby images of different things, logically incompatible if taken literally, come together in one configuration: child's handprints and murderess's face; sea and dump of wrecked aircraft. As described earlier, in *Myra* the granules of the image's texture, with its distantly-viewed effect of a coarse half-tone screen, are revealed on close inspection to be the handprints of a child. There are thousands of these little handprints, which, if not perfectly identical, fail to exhibit any meaningful variation, and do not, therefore, emerge from their status as mere texture to disclose any further significance — any more than the dots of the newspaper picture reveal, on closer inspection, more information about anything but the reproduction process. Once the easily grasped point is grasped, there is nothing more to attend to in the painting, since all we have is more handprints, inertly and mechanically repeated across the image, like thousands of instruments playing one note in unison. Far from being drawn in, viewers have nothing to do but move on, unless they are interested in details of technique or qualities of paint, *in a way which is quite unconnected with the painting's alleged significance*. The painting simply throws one very simple thought, bombastically amplified, *at* rather than *to* the viewer, and, like a brash advertisement, repels reflection rather than inviting us into an ordered space in which reflection may occur.

Now it might be asserted that, the subject matter being what it is, the painting *ought* to be repellent, and should *not* be inviting. Would such an assertion be widely accepted today, or even be regarded as self-evidently just? If so, this would be another symptom of the degraded state of our culture, which will collapse if it has entirely lost the understanding of itself as the inheritor (however unworthy) of a great tradition. A moment's reflection should be enough to remind us that that tradition furnishes many examples — canonical examples — of works which powerfully illuminate themes of suffering and evil. And not only do they do so without repelling the attention of the audience, but their capacity to invite and sustain absorbed attention is a necessary condition of their power. There is, perhaps, no more powerful depiction of suffering than the crucifixion panel of Grünewald's Isenheim altarpiece. But we are not repelled from looking at it, any more than we refuse to attend performances of *Othello* because we cannot bear to confront the personification of evil in Iago. On the contrary, it is because evil is presented in the virtual domain of art, and removed, not from the scope of the imagination, but from the immediate urgencies of our own practical lives, that we are enabled to confront it, and reflect on it. (To the minimal extent that Richard Cork says anything coherent at all, in the review quoted earlier, it is vitiated

by neglect of this fundamental and, one would have thought, uncontroversial point.) By evoking our response to its visual rhythms and powerful drawing, Grünewald's painting invites our attention and holds it, as we acquire a more intimate acquaintance with the compellingly realized forms of Christ's tortured body. It is not the *painting* that is horrific, but what it contains. The suffering of Christ and the horror of the crucifixion are held before the mind, precisely because the painting draws us into contemplating its content and meaning, and retains our attention. In this way it fulfilled its original devotional function of assisting the faithful to confront the reality of evil, and to meditate on the sinfulness of human nature in bringing it about.

Totes Meer has the conviction that comes from its origin in direct visual experience, and what is impressive is the way in which the metaphor of wreckage as sea permeates the whole image, without being forced on it—without weakening that conviction—and without the particularities of the literal scene being lost. The metaphor, therefore, is far more than an inert equation, or a visual comparison *pasted on* to the image, as the handprints in *Myra* are merely pasted into the micro-structure of the painting. The detail is fully realized as that of wrecked machinery, with vigorous and decisive drawing, and the image becomes an object of visual absorption, precisely because of this rootedness in the fascinated observation of its literal subject matter. Although composed of many superficially similar elements, there is no application of a repeated formula. For the viewer, as for Nash, the thought of the metaphorical meaning always informs our perception, and guides our visual exploration, as our gaze moves over the wreckage as depicted. The metaphor is thereby held before the mind, and, as it were, sustained as a focus of meditation.

The broken aircraft have, of course, been literally smashed in consequence of the violent and lethal conflict in the skies above England. But in the painting, disintegration seems to continue, in a process which is imaginatively assimilated to the ceaseless motion and endlessly destructive power of the sea, as if the literally static remnants of machinery are moving over and against each other like the pounding and crashing of the waves. This is an image of entropy (to use a term which Nash would, presumably, not have used), in which the products of human ingenuity and skill, devoted to an aggressive and destructive purpose, are themselves destroyed, returned to the unstructured condition of the materials from which they were fashioned, and inexorably reabsorbed into the vast undifferentiated ocean of heedless nature, from which they were briefly lifted. The thought insistently suggests itself that this can be understood as an image of the self-destruction of European civilization, which succumbs, like all the works of man, to

the inevitability of disintegration. What of the white owl, flying low on the right-hand side of the painting? Nash himself made a slightly ambiguous comment about this, saying that 'she isn't there, of course, as a symbol *quite so much* as the form and colour essential just *there* to link up with the cloud fringe overhead' [my italics for 'quite so much'].[14] This comment suggests, not denial of the owl's symbolic importance, but reluctance to open a path to simplistic or one-dimensional interpretation, by allowing it to be overemphasized. I have no reason, grounded in documentary evidence, to believe that Nash had Hegel in mind, although that is not impossible for a well-read man of his generation; but I find it hard to resist the thought that the owl could be the Owl of Minerva (goddess of wisdom), who, in Hegel's famous words, 'takes wing only at the onset of dusk', when 'philosophy paints its grey in grey' and 'a form of life has grown old'.[15]

I could imagine its being asked whether what I have written here is any better grounded or any less pretentious than the Tate curator's words about *Sunflower Seeds*: 'a powerful commentary on the human condition.' Well, it is not for me to say whether there is any critical aptness in my thoughts about Nash's painting, but I *would* claim that they relate clearly and mostly directly to the painting itself, and only presuppose knowledge which is the common possession of those to whom they might be addressed in a shared culture. It is true that my concluding remarks about *Totes Meer* are, in a sense, speculative. But I am not claiming that they give 'the' meaning of *Totes Meer*. These reflections belong to the nimbus of associated thoughts which gather around the image, as such thoughts gather around other images and other works of art that gain our serious attention. *Were* they apt, they would help to shape a frame of reference in which it was appropriate to contemplate the work, and might thereby reflexively inform one's experience of the painting itself. Such musings are part of the process through which a work of art relates itself to our wider interests and concerns, and, to repeat words from earlier in this essay, 'finds a place in the wider context of our lives and thoughts'. However inept they may be, my reflections are prompted by the manifest content of the painting. They are not vacuous references to 'commentary' that is never expounded, or 'questions' that are never formulated; and they are not just loosely tied to the painting with the threads—flimsy, tangled and indefinitely extendable—of contrived associations. The 'thoughts' provided in wall texts or on the website for *Sunflower Seeds* are not the

14 Ibid., p. 60.
15 Georg Hegel, 'Preface' to *The Philosophy of Right*, transl. S.W. Dyde (first published 1821, New York: Dover Philosophical Classics, 2005), p. xxi.

fruit of critical reflection on the 'work' itself: they are arbitrarily projected on to it, by curatorial diktat. Far from being prompted by manifest content, they are a *substitute* for manifest content. They do not gather around the 'work': they are merely tethered to it, since it entirely lacks the power of manifest content to prompt, attract or hold them.

Wall texts of this kind *are* a kind of criticism, however misplaced — in more than one sense — they often are. And worthwhile criticism always returns our attention to the work under discussion, even though returning attention may seek in the work the resonance of thoughts drawn from a wider field of allusion than was initially supposed relevant. The presentation of *Sunflower Seeds* is a clear and topical example of how curatorial practice standardly involves precisely the opposite: it directs our attention *away* from the 'work'. I suppose that it would be whimsical to wonder if this might be an unconscious response to the fact that there is nothing *in* the 'work' to contemplate. However that may be, much of the feebleness of what often now passes for criticism lies in this failure, or refusal, to attend, and help others to attend, to the work of art itself; and in the failure to promote, not inconsequential blather, but the discourse of those committed to 'the common pursuit of true judgement' — perhaps because judgement itself falls under the prohibition of that vindictive tyrant and potent agent of cultural destruction, political correctness.

In this essay, I have compared two paintings which allude to very serious matters of ubiquitously shared moral concern — serious and moral in senses requiring no sophistication to discern, and for that reason accessible to the non-specialist public as manifesting the ultimate inseparability of the aesthetic and the moral. And, in arguing for my highly unfavourable *aesthetic* judgement of *Myra*, I have tried to show how that judgement is fundamentally the same judgement that rejects any claims it may have to moral seriousness. My highly favourable judgement of *Totes Meer* is defended by a converse argument: the aesthetic distinction of this painting shows itself in how it holds our attention as a focus of moral reflection. And I would suggest that to compare these two works is to gain some understanding of the cultural decline we have suffered during the half-century which separates their production.

But it is not just a matter of the paintings themselves — as if we could consider them in isolation. Of equal significance at the present time is the cultural environment in which *Sensation* was presented. In this environment the promoters were not inhibited from allowing the prominence given to *Myra* to function as a publicity stunt, and felt free to ignore the protests of those who found it distressing. Nor were they

concerned that the exhibition might be a *critical* disaster. Is there any longer any such possibility in the visual arts? Is the condition of the arts, as embraced and *circumscribed* by the modern-art establishment, not approximating now to that of celebrity culture, in so far as the very idea of *judgement*, with its implication that it is right to value some things and *wrong* to value — or at least to overvalue — others, is simply incomprehensible, or politically incorrect? It is for this reason that celebrity culture is the epitome of the unchallenged and *institutionalized* frivolity, which pervades all the organs of society — embracing politics, social policy, the arts and, especially, education. Where the concepts of value and of rational discrimination are inapplicable, criticism clearly has no place. But has the corruption of criticism not itself been a factor in allowing the visual arts (as officially recognized) to approach in this respect the condition of celebrity culture, just as a parallel corruption of discourse on social and political matters is destroying the moral health of society — a process of which the dominance of celebrity culture is itself both a symptom and a cause? That these parallel corruptions are, at root, a single corruption becomes a little clearer, when we consider such an example as *Myra*, along with the circumstances of its promotion and its reception. And this thought returns us finally to those spectacular manifestations of grotesque sentimentality, delusion, hysteria and infantilism, almost concurrent with *Myra*'s exhibition in 1997 at Burlington House — manifestations which could have occurred only in a culture from which intelligent critical reflection was absent, or in which it was impotent.

The Exaltation of Trivia and the
Abasement of the Transcendent

Theodore Dalrymple

Celebrity Culture
'... a fantasy and trick of fame' (Hamlet)

Where human conduct is concerned there is no new thing under the sun. That is why it is futile to seek the precise date of origin of any social phenomenon. If I find an instance of it in the 19th century, you will be sure to find one in the 18th;[1] and before long we shall reach back to the Bible, as an Ur-text of all human conduct.

Nevertheless, few would deny that there has been an efflorescence, if that is quite the word, of celebrity culture in the last two or three decades. (I use the word 'culture' in its anthropological sense.) It is easily recognizable: it is that culture which evinces an obsessive interest in the lives and doings of celebrities, almost all of whom come from the worlds of entertainment and sport. Royalty may come within its purview, but royalty these days are few and relatively unimportant; there may also be some celebrities the origin or cause of whose fame is lost in the mist of previous stories, celebrity culture having but a short attention span. In the main, the culture is concerned with the circus division of the modern regime of bread and circuses.

The increased prominence of celebrity culture is obvious to any observer. When I turn on my computer, my server regales me with the latest news about the 'private' lives of world-famous people of whom I have previously not heard: their marriages, divorces, break-ups, reconciliations, children born out of wedlock (known technically as *love-children*, suggesting a dismal view of the possibilities of marriage), self-inflicted illnesses, addictions, overdoses and suicides—the latter being to celebrity what fatal crashes are to Formula 1 races.

So-called serious newspapers devote ever more space, no doubt in the futile effort to maintain their circulation, to celebrities who not so long ago would have been considered unworthy of the notice of their readers. When, for example, the singer and song-writer David Bowie,

1 Immediately after writing this, I happened to read Amin Maalouf's *Un Fauteuil sur la Seine* (Paris: Grasset, 2016) in which he implied that Voltaire's reception in Paris shortly before he died was the harbinger of celebrity culture.

whose main talent was for self-advertisement, died on 10 January 2016, the *Guardian* newspaper, the house journal of the British liberal intelligentsia and higher bureaucracy, devoted at least 27 articles on succeeding days (at which point I gave up counting) to the disappearance of this sublime genius. When Stalin died, 53 years earlier, having been responsible for tens of millions of deaths, the *Times* devoted but a single page, admittedly of smaller and closer print, to his demise.[2]

Much of the print press may be dying, but celebrity magazines flourish, at least in the number of their titles, and in many places where magazines are sold they dominate the racks. It goes without saying that the broadcast media dilate long and frequently, even constantly and obsessively, about celebrities, but even the publicly-funded or state broadcasting services do so, though the only justification for their very existence is that they purvey what commercial broadcasters either cannot or will not purvey. On 22 April 2016, for example, the BBC website (which I viewed from abroad) led with the news that a pop star called Prince had died aged 57, with a subsidiary story whose title was 'World pays tribute to Prince'.[3] Hyperbole is an understatement.

A BBC disc jockey called Craig Charles wrote on the website:

> It's heartbreaking news. Everyone is truly shocked. Bowie, now this. The two most talented adventurous creative talents of their respective generations.[4]

The state-sponsored booster of celebrity also published online the reactions of other celebrities to the news:

> My heart aches at the loss of Prince. He has joined his angels, of which he was one.

This makes the death of Little Nell seem like kitchen-sink drama. Or:

> He showed me early the power of living one's life by one's own rules and no one else's.

It would be interesting to know whether Prince ever signed a legal contract, and whose rules he expected to be enforceable.

> This is the worst day ever.

Try saying that in Hiroshima! One comment seemed to me to be infinitely sad if true:

> Seeing him perform was the highlight of my life.

[2] *The Times*, 06/03/53.

[3] http://www.bbc.co.uk/news/live/entertainment-arts-35962617 (last accessed 05/05/16).

[4] Ibid., as are all the following quotations relating to Prince's death.

What a life his or hers must have been, for this to have been its high point! President Obama felt obliged — or perhaps, what is worse, was genuinely moved — to join in:

Today, the world lost a creative icon.

The BBC website did, however, advertise a programme that might have been of some interest:

There was a surge of people getting famous fifty or sixty years ago — does this explain the wave of celebrity deaths in 2016?

In other words, fame itself changed its nature or intensity with the arrival of television, and more particularly colour television, in every home in the 1960s. Cheap vinyl records and rising disposable incomes, the proliferation of radio stations and the consequent increase in the diffusion of popular music (which became an industry) contributed to the cultivation of celebrity as an end in itself and as a form of mental or emotional sustenance for the masses. Since then, of course, electronic means of communication have grown exponentially, until for some people the virtual, what takes place on a screen, is more real, in the sense of presence in their mind, than what was once considered the real world. There are more ways to become famous than ever before; and where fame is so easily attainable, to remain anonymous feels like failure.

Since one way to achieve fame, or at least to achieve notice for a time, is to behave outrageously, to break not only conventions but taboos, to be *transgressive* (to use a favourite word of approbation in contemporary art criticism), it is hardly surprising that outrageous behaviour should be promoted, requiring an ever greater degree of it to achieve its end. Eccentricity, which is the unselfconscious difference from other men in the way of going about life, as if it were the most natural thing in the world, has given way to exhibitionism, the conscious adoption of a mark of difference merely to stand out from one's peers.

A good place to start in the examination of celebrity culture (that is also the cult of celebrity) is one of the many magazines devoted to it, which differ from one another hardly at all. They cross borders, in style if not in the people deemed celebrities: French celebrities seem a degree less vulgar than those in the Anglo-Saxon countries, which demonstrates France's backwardness.

I happened to be in an Australian airport recently, and for research purposes there bought a magazine called *NW* (or the *New Weekly!* — n.b. the exclamation mark). Belying its title, it was typical of its genre: the cover, in bright near-primary colours, was a collage of photos of

celebrities, half of them happy as only celebrities can be, and half of them wretched as only celebrities can be, their feet of clay displayed to the view of thousands or millions. This is the law of celebrity: he who lives by self-exposure dies by self-exposure.

The first and most important of the stories on the cover was head-lined as follows:

It's twins! Miley and Liam's big shock!
Their cute announcement. Two baby boys—just like his brother Chris![5]

Accompanying these less than crystalline words are four photographs, including an ultrasound of what one assumes are Miley's twins. Since this would have been a gross breach of medical confidence without Miley's express permission, one must also assume that she consented, even suggested, the publication of the photo. One of the first modern celebrities, Greta Garbo, finding public attention irksome, said, 'I just want to be alone'; by contrast, modern celebrities would say 'I always want to be before the public'.

The main photo of Miley (of whose claim to celebrity I had no idea, nor did the magazine enlighten me on this point) shows a dyed blonde young woman with a round face, dark eyebrows, glistening pale pink lips, pearly teeth, with several star-shaped diamond studs in her left ear. Another nearby photo reveals that she has tattoos on her fingers of her right hand, one of them in the shape of a heart. She would once have been called *common*. Her clothes manage to combine cheapness with expense, the secret of modern clothes design and marketing being cheapness in the design, expense in the cost. Her face, that of an Edwardian barmaid in a lower-middle class pub, is fixed in the grin of one who knows there is a camera present—as in her life, it seems, there always is. She faces another picture of herself, this one round and taken with the proud father of the twins, whose source of celebrity was also unknown to me, possibly being only that he is Miley's current *partner*. In this photo, Miley is not blonde: her hair is dark, her eyebrows darker, her eyelashes longer and her lips pouting. Liam, only half of whose face is shown, is a conventionally good-looking young man with fashionable stubble, his eyes clearly turned towards the camera. He is being licked on the face by a dog, not coincidentally a terrier of the Staffordshire type.

5 This cover, and some of the contents for *New Weekly!*, issue 14, 26/04/16, can be seen at http://www.magzter.com/AU/Bauer_Media/NW_ Magazine/Celebrity/160576 (last accessed 05/05/16).

It is worth reflecting a little both on the type of dog and the bright colours in which the cover of the *New Weekly!* is, like all its competitors, printed.

The type of dog tells us at which social class the magazine is directed. (Contrary to its image, and possibly its self-image, Australia is a class society like any other, though it might lack some of the more obvious snobberies of longer-established societies. No one who has been to Sydney could have any difficulty in distinguishing between residents of the North Shore and those of the Western suburbs. And Australia, be it remembered, is the most urbanized society of any size in the world despite, or because of, its vast extent.)

Such dogs as the Staffordshire breeds are the favourites almost if not quite exclusively of the so-called lower social classes, and are particularly popular among those who want to project an image of toughness. I know nothing of Liam's social background, but his adoption of the breed obeys another law of modern celebrity: those who achieve it must not express tastes or attitudes of a higher social class than those who grant them their celebrity. And since imitation is the highest form of flattery—or is often believed to be such—Liam's adoption of the breed of dog demonstrates that, despite his fame and no doubt lavish fairy-tale train of life, he is at heart 'one of us', only one made good.

What is true of breeds of dog is true of tattoos: once the fashion of sailors and the marginal, they are now part of the dialectic between the celebrities and the masses. This explains the seemingly evangelical enthusiasm with which they have been adopted by celebrities: self-mutilation is the price of their fame.

As for the bright colours employed by the celebrity magazines, they bespeak the arrested aesthetic development of those who buy and read them. The colours are such as one would expect to attract untutored small children: but if one examines the colours of the mass-produced cheap plastic toys, and the colours of the apparatus in children's public playgrounds, it is scarcely surprising that, in the absences of countervailing influence, children's taste for bright and crude colouration becomes fixed (rather as does their taste for sweet and fatty prepared foods in households in which no fresh ingredients ever enter). One of the manifestations of this almost programmed arrest of children's aesthetic development is the almost total replacement in the public iconography of Winnie-the-Pooh of Ernest Shepard's illustrations by those of their Disney equivalents or, rather, competitors. The former,

monochrome, invite tenderness and the exercise of the imagination;[6] the latter, crude, simple and brightly-coloured attract as a magpie is attracted to what shines or flashes. The Disney designs anaesthetize rather than activate the mind: they require no effort on the part of the young child, who can be left alone with them. It is their very immediate appeal that is so fatal to aesthetic development — that arrested development one of whose effects later in life is attraction to the bright colours of celebrity magazines.

The other stories on the front cover of this issue of *New Weekly!* likewise give an insight into the mental world — emotional, cultural, social, spiritual and even ethical — of those who consume celebrity culture. Here are the headlines of the stories:

> Rob's shotgun wedding
> So young and addicted to surgery!
> Kylie's new man: what will Tyga think?
> How Brit got those abs. Three experts show us how.
> Drew's tears: pregnant and divorcing

This is a world in which the name 'Leonardo' conjures DiCaprio rather than da Vinci; in which it is unnecessary to give the surnames of Rob, Kylie, Brit or Drew because they are more present in the minds of readers, more real to them, than the old lady who lives down the road from them, as is only to be expected in an environment in which the passage through life is accompanied almost constantly by screens turned to entertainment sites or channels. There is therefore no need to explain who Brit or Kylie or Tyga are, any more than it is necessary to explain to a doctor what the acronym *MCV*[7] stands for. Celebrity culture has its own vocabulary, almost a technical language of its own, in which such names are currently inscribed, though no doubt the names of Brit and Kylie and Tyga and Drew will be forgotten in ten years' time, as entirely as are the names of the inhabitants of Shahr-e-Sukhte, the ancient Persian city founded in about 2000 BC.

Noticeable among the celebrities is the proportion of them who bear non-traditional names (of course, what is non-traditional can become traditional). In this edition of the magazine alone are found such names of celebrities as Blac, Taylor, Hailey, Mila, Miley, Iggy, Kesha, Dixie, Candis, Demi, North, Shailene, Kyle, Brandi, Chyka, Aviva, Puki, Rebel, Amber, Reese, Suki, Taron, Dax, Twigs, Soko and Tori. Whether or not these names were given at birth, or assumed in the search for

6 I am aware that some modern editions of *Winnie-the-Pooh* include subtly coloured versions of some of Shepard's illustrations, but, personally, I am not convinced these are improvements on the original editions.

7 Mean Corpuscular Volume.

celebrity, is beside the point; they set an example that will be (and has been) followed, perhaps as an instance of magical thinking: if celebrities have non-traditional names, then I or my child will become a celebrity by having a non-traditional name, with all that is desirable in that exalted status.

There is more to it than that, however. It was the law in France until the 1970s that every child born in the country had to be given a name from an approved list. To this law libertarians might and did object that it was an unconscionable and unjustified interference of the public power in a purely private matter, that of what to call one's child. But whatever the abstract objections to the law, it had the tendency and no doubt the intention of preserving a minimal degree of cultural and social identity irrespective of political, social or economic opinions and conflict. The list of names was sufficiently long to offer a real and effective choice, but it was a circumscribed choice rather than an infinite one.

No one could deny that the freedom to give a child any name that the parent chooses is a real freedom: and, in some circumstances, it can be exercised in a charming way. In Africa, for example, I was charmed by the giving of such names to children as *Clever*, *Bloke* or *Sixpence*, sometimes simply because the naming parents liked the sound of the words. In Liberia I came across a lawyer called Hitler Colman; no doubt his parents had heard the name frequently mentioned and like the sound of it (in conjunction with Colman, it is euphonious); and the giving of the name had a completely different connotation from that which it would have if, *per impossibile*, it had been given in post-war Germany.

In the West, the giving of non-traditional names to children or their adoption by adults has a different meaning from that in Africa where, among other things, it signifies an attempt at Europeanization. In the West it signifies, in addition to magical thinking, an inflamed egotism and a deeply conventional opposition to tradition as such. By giving or adopting a non-traditional name, the parent or person who adopts it hopes thereby to confer an unusual character on his child or himself, without anything further being necessary. What's in a name? Quite a lot, it seems.[8]

The giving or adoption of non-traditional names is a response (as also, I surmise, is the vogue for tattooing) to an increased need for individuation at a time when it is harder than ever to be an individual.

[8] Curiously, two of the most eminent British neurologists of the first half of the 20th century were Sir Henry Head and Sir Russell Brain. There are many English names that would preclude a person from becoming a poet.

Celebrity culture itself makes individuation more imperative; for minds fixated on fame to melt anonymously into a crowd as a pebble sinks into a pond is felt not as a perfectly honourable fate but as failure in life. Any means to escape anonymity is good, then, even if it means behaving foolishly or in an uncouth fashion. Outlandishness, when consciously sought, soon becomes convention.

The rebellious connotation of such conduct nevertheless remains; and it is the supposed rebellion that is wanted, irrespective of what is rebelled against, because rebelliousness is now felt by many to be the only honourable (and individuating) stance to the world. To accept a convention that one has neither originated oneself or to which one subscribes as a result of one's own ratiocination from self-selected first principles is therefore experienced by the rebellious as a humiliation, as an intolerable limitation of their freedom of action. Since, however, this freedom in large things is usually limited, it becomes all the more important to assert it in small ones. Thus the giving or adoption of non-traditional names has become more the rule than the exception in the lower reaches of society: the sign not so much of freedom as of a petulant reaction to its supposed absence.

Whoever reads the *New Weekly!* (or any other such magazine), not for pleasure or entertainment, but to try to understand the culture of which it is both cause and symptom will be struck at once by the strange dialectic between, on the one hand, a realm that is as inaccessible as one in a fairy-tale and, on the other, the complete banality of those who inhabit it. The clothes that the celebrities wear are merely more expensive versions of what the consumers of celebrity culture wear, of better manufacture perhaps but not stylistically different. In the middle of the magazine was a feature titled *Instaglam: get star looks and style today*.[9] The clothes advertised are not expensive and certainly not elegant; under the rubric *Tip* women readers are told—and it is obvious that the magazine is directed mainly at women—'An unexpected combination always earns extra style points, like Chloe's chevron shorts and masculine brogues.' Chloe's claim to fame is not mentioned but frankly she looks a lumpen mess, without even the attempt at elegance. The very lack of discrimination necessary for 'star looks and style' must reassure the readers greatly: their own lack of discrimination being no obstacle in itself to the achievement of the stardom of their daydreams. Celebrities live the same lives as the readers, but on a gargantuan scale, with luxury brands rather than supermarkets' 'own' brands. The glamour is that of freedom from

[9] http://www.magzter.com/AU/Bauer_Media/NW_Magazine/Celebrity/160576 (last accessed 05/05/16).

financial worries or restraints, so that every day is like the so-called holiday of a lifetime, the ability to buy anything you want without having to resort to credit or worry about where the money is coming from: it is the secular equivalent of the Muslim notion of paradise shorn of its previous religious obligations. It is a world in which choice is limitless but also uninformed.

But since the inhabitants of this world supposedly live enviable lives, they are in fact envied. In the *New Weekly!* there is practically no mention of the celebrities' actual achievements: one might suppose that they were plucked from obscurity by lottery rather than by talent, say, or hard work. Nor are they outstandingly favoured by nature. They are, perhaps, above average in looks, but by no means outstandingly beautiful so that one would stop to stare at them in the street. Miley, for example, is clearly of the plumpish tendency, who would run to fat without close attention to diet or chain-smoking. The glamour of the fairy-tale world of celebrity is aesthetically cheap: it exudes no threatening sophistication of taste, much less any hint of connoisseurship, such as is normally associated with aristocracy.

If these people are exalted by living in a supposedly glamorous world in which they have little to do but go on holidays or parties with others like themselves, and change sexual partners from time to time, if they are flattered by the attention of millions as if they were persons of transcendent importance (though they have done nothing that others, even millions of others, could not have done), they must also accept to be torn down, humiliated by exposure, shown to be no better than their idolaters. The *quid pro quo* for their undeservedly privileged existence is that they must put up with unbridled scurrility; perhaps even furnish the opportunity for it. They must provide personal crises for the delectation of the *hoi polloi*: see, they live in the fairy-tale world of luxury, but *really* they are the same as us.

The crises, moreover, must be of precisely the same kind as those who are interested in celebrity experience in their own lives. The crises related in the *New Weekly!* are not those caused by deep disagreement on matters of principle or even by grand passions such as that of Antony for Cleopatra. They are the result rather of the almost random or casual drunken couplings that occasion fights in night-clubs in Newcastle on a Saturday night.

Here, then, is a typical story from the magazine, the use of the first names of the characters implying that the readers are on intimate terms with them; there is therefore no need to set the scene:

Wilmer warns Nick BACK OFF Demi!

A little inset informs us:

The fear: we're told that Wil's worried Demi—who previously dated Nick's brother Joe—will leave him.

Whose fear does this information refer to? Wil's or the reader's, or both? If the latter, why should the reader care? As Hamlet put it:

> What's Hecuba to him, or he to Hecuba,
> That he should weep for her?

The vicariousness of this no doubt short-lived concern for or about Wil, Nick and Demi's triangle hardly needs emphasis: one of the attractions of vicariousness being that it distracts from the miseries and dissatisfactions of one's own life.

Nick, the article says, is 'the slippery singer' who is 'acting more bae than bestie'.[10] 'Bae' and 'bestie' were for me new words, part of the technical language of celebrity culture, or the culture in which celebrity is important. The online Urban Dictionary says that *bae* is Danish for 'poop' (excrement), which for some reason has been transformed in meaning into 'baby' or 'sweeties', meaning lover; while 'bestie' means 'the person you not only go shopping with on a regular basis but also trust implicitly with anything'.[11]

Could any platonic relationship be stronger or more intimate than that with the person with whom you go shopping 'on a regular basis'? But slippery Nick has taken advantage of being a mere bestie maybe to become a bae:

> Joined at the hip as they rehearse for their Future Now Tour, Nick Jonas and Demi Lovato are having a riot! But not everyone is impressed by their cosy carrying-on, with Demi's boyfriend Wilmer Valderama [pictured with a frown on his face] said to be seriously pissed about their nonstop flirting.

> We learn that 'lady-lovin' Nick—who's recently been linked to both Kate Hudson and Lovato—has always been vocal about how much he adores Demi, 23. "We have a really strong bond and a really good relationship. We've seen a lot of life together at this point", he reportedly said in 2012, adding that their connection goes "beyond words". Wilmer, however, has confronted Nick a few times but nothing has changed, he still feels like Nick is super disrespectful.

As any doctor working in any casualty department in any British hospital will recognize, Nick and Wilmer have precisely the 'relationship' that might end in Wilmer *glassing* Nick, that is to say breaking a glass and pushing its broken end into Nick's lady-lovin' face. This Wilmer and Nick, though they inhabit the fairy-tale world of celebrity,

[10] *New Weekly!*, issue 14, 2016 (print copy). Unless otherwise indicated, all subsequent quotations are from the same source.

[11] www.urbandictionary.com/ (last accessed 05/05/16).

are really just the same, at base, as the average young drunken reveller in any British town or city, of violent but shallow emotions and an ego easily bruised by the 'super disrespectful'.

The travails of celebrities are precisely those of those interested in celebrities, namely fleeting-lover affairs dressed up as passionate and the unpleasant consequences of unrestrained bad behaviour or habits. Thus an article enquires: 'How wasted [drunken] can Kerry get in four hours?' Kerry is pictured first at Gatwick Airport at seven in the morning with a glass of champagne in her hand, having tweeted '"Woohoo! Where goes, no one knows"'. This is described in the magazine as her 'pre-bender'.

> Kerry Katona, 35, recently went from daintily sipping champers in the departure lounge at London's Gatwick Airport to rolling around with her pants around her ankles [several pictures shown] in the car park of the Canary Islands' Gran Canaria Airport—all in the space of four hours![12]

Strangely, there were photographers on hand to record Kerry's descent into drunkenness. There were also photographers on hand to record another celebrity young woman's drunken state:

> Hailey boozed and broken over Biebs! Poor Hails is hammered!

> Hailey Baldwin isn't usually one for stumbling out of clubs like a red-hot mess. But after a fortnight from hell—during which her ex Justin Bieber got cosy again with Selena Gomez before creeping on Kendall Jenner—it's no surprise she's on a mission to drown her sorrows.

This is not the end of the tragedy:

> Making matters worse, Biebs, 22, has been putting the moves on Hailey's BFF Kendall, 20, instagramming a shot of her *Vogue* mini-mag cover captioned "Ken you look beautiful". But Hailey's love-rat ex isn't her only worry …

But now I was sufficiently attuned to celebrity culture vocabulary to guess (correctly) that BFF stood for *Best Friend Forever*, forever being a period of at least a month, and best friend being the person upon whom one's ex puts the moves, during or after one's relationship with that ex.

The lives of celebrities are lived or exhibited as an open book—as, thanks to the 'social' media, are the lives of increasingly many people. Thus we learn that Drew Barrymore and Will Kopelman—according to *Us Weekly*, and repeated in the *New Weekly!* – have not had sex in more

12 Much the same report as in *NW!* can be found in *The Daily Mirror*, 03/04/16, at http://www.mirror.co.uk/3am/celebrity-news/kerry-katona-pictured-after-airport-7681551 (last accessed 05/05/16).

than a year. How could *Us Weekly* have known this, assuming it not to
be made of whole cloth, unless one of the two, possibly both, informed
it. The unhappy couple are getting divorced:

> Drew Barrymore left us all with the sad feels when she announced her
> split from husband Will Kopelman last week. After all, we thought the
> former wild child had finally found her happily-ever-after. And despite
> her insistence that the break-up is amicable, things could be about to get
> majorly messy, with Drew sporting what looked to be a baby bump
> during an LA shopping trip on April 4! "The big question is what's
> going to on with that bump," a pal tells *NW*. "It's true she's been
> comfort eating, but people have been asking if there could be another
> baby on the way."

Drew's pal doesn't seem all that loyal, although he refrains from
speculating on who the source of the baby-bump might be. Drew, who
has idiotic tattoos on both forearms, her right ankle and possibly else-
where, speaks of her predicament with all the profundity and precision
of a magazine astrologer, mixed with a little psychobabble:

> I had a really hard time a couple of months ago and kind of knew that
> life was heading in a new direction. I called someone that I really trust
> … I said "What's your advice?" And he said, "You put one foot in front
> of the other."[13]

It is difficult not to read *Schadenfreude* or worse—outright sadism—in
celebrity culture's emphasis on the miseries of those whom it has raised
up for admiration, adulation or emulation. The consumers of celebrity
culture are like those tribes of primitives who beat their fetish-gods
when they fail to procure for them the prayed-for rain or success in
hunting, and that it is the duty of the fetish-gods to provide.

Celebrity culture is a contract between persons of modest attain-
ments on the one hand and masses of frustrated people on the other:
we give you money and fame on condition that you exhibit yourselves
like circus animals, abjure privacy, allow us to humiliate you by our
salaciousness, and accuse you of all our own sordid vices. You live a
fantasy life on condition that we may say anything we choose about
you.

This culture is the *Prolefeed* of *Nineteen Eighty-Four*, that is to say
'rubbishy entertainment and spurious news': but it is not provided by
the Party of the State, as in the book in a centralized and concerted

[13] Other coverage of this important story includes the *Daily Mail's Mail Online*,
09/04/16: http://www.dailymail.co.uk/tvshowbiz/article-3531947/Drew-
Barrymore-strolls-producing-partner-Chris-Miller-recovers-shock-Kopelman-
divorce.html (last accessed 05/05/16).

conspiracy to stupefy the potentially rebellious masses.[14] Rather it is a commercial product for the benefit of the less intelligent or uncultivated members of a consumer society who have time and a little money on their hands, but few other interests. It serves more than one purpose, or at least has more than one effect, and satisfied more than one desire.

It satisfies the human desire for a fairy-tale world, a desire all the stronger in those who are able to compare their mediocre situation with an imagined life of Shangri-La. It peoples the world with unthreatening mediocrities who have achieved that imagined life, thus suggesting that it is not completely out of reach and therefore offering hope, however illusory. It satisfies the thirst for revenge on those more fortunate than themselves, surreptitiously suggesting that those who achieve the imagined life do not really deserve it since they are in fact no better than those who do not achieve it. It validates crude, degraded and undiscriminating tastes by holding up those who share them as successes. It simultaneously raises up and pulls down, both activities being necessary to the human mental economy. It is to those who interest themselves in it what Marx said religion was to the masses of his own time:

Celebrity culture is the sigh of the frustrated, 'the heart of a heartless world, the soul of soulless conditions. It is the opium of the people.'[15]

[14] George Orwell, *Nineteen Eighty-Four* (first published 1949, London: Penguin Books, 2013).

[15] Introduction to *A Contribution to the Critique of Hegel's Philosophy of Right* (first published 1844, reprinted in *Collected Works of Karl Marx*, Vol. 3 (New York: International Publishers, 1987)).

Mark Dooley

Conserving the Sacred in a Virtual Kingdom[1]

On the surface, we have never been more connected. We are plugged in to a global network powered by a constant craving to communicate. Electronic engagement has made it possible to defy natural boundaries in a way inconceivable to our forebears. Traditional allegiances and loyalties no longer matter to a generation that belongs to a nowhere which is everywhere. Family, home, society and State are meaningless concepts to people divided solely by a power switch. In such a 'world', individuals are not defined by language, religion or place. Identities are established on Facebook and across 'chat rooms', virtual congregations where countless communicants are bound by a common Host.

In many ways, the information age is a spirit-world where we trade in the immaterial. Relationships are formed and information shared with 'people' we almost never meet. We call this 'social networking', and yet it bears little resemblance to what we once termed 'social life'. To have a social life meant leaving the isolation or privacy of one's own space to be with others in a public context. It meant interacting with others in communion and conversation. It meant taking time to share a meal, to celebrate, worship or mourn. It involved making lifelong friends.

Virtual reality has radically transformed our concepts of space, time and being with others. We constantly communicate without ever really conversing. We belong to countless chat rooms and social media sites, yet we do not really belong anywhere. When we communicate it is through instant messaging, for the very idea of 'taking time', or of moving beyond the moment, is alien in such a domain. It is a culture of immediacy in which only the present moment matters. There is no past or future in cyber space, only a perpetual 'now' in which all desires must be instantaneously gratified. It is a no man's land devoid of the

[1] An earlier version of this chapter appeared as 'Saving the Sacred', Ch. 9 of Mark Dooley, *Moral Matters: A Philosophy of Homecoming* (London & New York: Bloomsbury, 2015), pp. 171–94.

public–private distinction; a spectral sphere where no one can hide; a 'domain' where no one ever sleeps. I call it *Cyberia*.[2]

We are fully charged and connected, and yet, at another level, we have never been so detached or disconnected. Isolated, we sit before screens and gadgets divorced from the real world and from real people. The great paradox is that by seeking to connect socially, we become ever more solipsistic and secluded. We become ever more alienated and estranged from reality, from human beings and their moral and emotional requirements. We become 'strangers to ourselves', to others and to the world. To put it simply, the so-called 'information age' has altered the very concept of human identity beyond recognition. We exist in the world and yet we do not fully belong to it. In the 'virtual kingdom' of Cyberia, the human person belongs nowhere and to no one, is attached to nothing.

Moreover, in a world where the tablet has replaced the Tabernacle, there is nowhere for the Creator to take up residence. The 'real presence' becomes a perpetual absence, an open void from which all life has withdrawn. This is reflected in abandoned churches and diminishing congregations across the Christian world. It is reflected in our refusal to sacrifice for absent generations by sustaining the legacy of the dead so that it will one day become a gift to their descendants. Nevertheless, in detaching from our sacred origins, we have not ceased to worship. What we worship now is, however, something which serves only to tear us apart.

By contrast, the Latin translation of the word 'religion' is *religare*, meaning to tie or to bind. To be religious means to be bound to something greater than the self, something which involves sacrifice, surrender and, in the case of Islam, *submission*. It is to acknowledge one's complete dependence on the Creator and all His creation. It is to adopt a posture of thanksgiving towards others and the world, one that rejects rights (at least as they have come to be defined) in favour of reverence, responsibility and respect. Religion also involves belonging to a community of believers united together through a shared faith in the sacred source of all things. It is consequently no great surprise that,

2 Philosopher Hubert Dreyfus uses the same concept in his book *On the Internet* (London: Routledge, 2001). Dreyfus has also written a groundbreaking critique of artificial reason in *What Computers Still Can't Do* (Cambridge: MIT Press, 1992). As I develop it in this context, however, Cyberia is not exclusively a term referring to internet alienation, but also to that isolation and estrangement which secularism and post-modernism, in all their manifestations, promote. My view is that we are not perpetually condemned to Cyberia, but that there are many concrete ways to become reattached to reality.

in our contemporary culture of disobedience, religion has become such an object of suspicion and ridicule. From the high priests of scientism to the prophets of post-modernism, the principal aim is to undermine the sense of the sacred and the form of community which it fosters.

For those like evolutionary scientist Richard Dawkins, religion is nothing but a virulent virus which must be eradicated if human beings are to flourish. Like Friedrich Nietzsche, who first announced the 'death of God' in 1882, Dawkins believes we are simply 'clever animals' governed by our genes, and that those who believe in God are deluded.[3] For many post-modernists, on the other hand, God is not so much dead as a shadow of His former self. They are not prepared to go the distance with Nietzsche and Dawkins, simply because they consider the declaration of God's death to be yet another absolutist position. To proclaim, in other words, that there is no God, is to be no less authoritarian than those who maintain they have definitive proof of His existence. As such, they reject both militant atheism and traditional theism in favour of what American post-modernist John D. Caputo describes as the 'weakness of God' or 'weak theology'.[4]

Caputo follows the late founder of deconstruction Jacques Derrida in seeking to give meaning to what both thinkers call 'religion without religion'. This is 'religion' which binds its practitioners to nothing more robust than 'a ghostly quasi-being', to a Messiah that is always to come.[5] Weak theology is one of absence: it rejects the strong 'messianisms' of Judaism, Christianity and Islam, in favour of something which cannot be housed or contained in any temple or tabernacle. On this reading, 'strong theology', the theology of orthodox churches and tenured theologians, endeavours to *domesticate* or put God in his place. It is the theology of pastors and popes, but not that of prophets or the powerless. For the prophet is not one who seeks to make God fully present, but one who reminds us that He is still to come.

That is why, according to Caputo, there is no room for true prophets in the Church, an institution which, he believes, has lost sight of its anarchic 'origins'. In proclaiming a kingdom of 'nuisances and nobodies',[6] Christ came not to endorse but to defy the established order. He came not to settle but to unsettle, not to seek out the familiar

3 See Richard Dawkins, *The God Delusion* (New York: Mariner Books, 2008).
4 The phrase 'weak theology' is a play on Italian philosopher Gianni Vattimo's expression 'weak thought'. See Vattimo, *Belief* (Cambridge: Polity Press, 1999), pp. 34–5.
5 John D. Caputo, *The Weakness of God: A Theology of the Event* (Bloomington, IN: Indiana University Press, 2006), p. 9.
6 This phrase belongs to John Dominic Crossan. See his *Jesus: A Revolutionary Biography* (San Francisco, CA: Harper, 1995), p. 54.

but to dwell among those who were radically different and other. Strong theology endeavours to obscure its own radical origins so as to emphasize that, in the beginning, 'the Word was made Flesh'. This, according to Derrida, is a misguided attempt to conserve what simply cannot be conserved. It is a refusal to acknowledge that at the core of Christianity is a 'Book', in this case Holy Scripture, which cannot fully reveal the true foundations of the Faith. For the deconstructionist, all books — even those which are assumed to be divinely inspired — are predicated on exclusion. There is always some degree of loss in the process of trying to preserve the past, or the spoken word, *in writing*. To proclaim, therefore, that the Word has been made Flesh, is to proclaim the impossible. It is to say that God has been made present in that which, of its very nature, is indicative of loss and absence. It is to insist that we can recollect our sacred origins through that which, of its nature, denies us access to them.

According to Caputo, religion without religion 'does not subsume or enclose particulars within or under it, does not precontain them, but simply points an indicative finger at "singularities" that are beyond its ken, kind, genus, and generic appetite'.[7] It affirms what churches and scripture cannot control or subdue — the 'radical other' which they try but fail to forget or deny. It is a religion rooted in faith alone — faith in the 'wholly Other' which can never be made present. This is faith drained of all doctrine and dogma, one that refuses to be bound by the strictures of any particular creed. It is an affirmation of 'God' as absence, an openness to that which cannot be confined within the present order. Hence it is a form of belief directed towards an open-ended future, or what Caputo describes as the 'unforeseeable and incalculable'.

If, as Caputo suggests, traditional religion is in the business of excluding and excommunicating, this quasi-religion of pure faith unreservedly welcomes that which is different and deviant. It is unconditionally hospitable to the 'just one who shatters the stable horizons of expectation, transgressing the possible and conceivable, beyond the seeable and foreseeable, and who is therefore not the private property of some chosen people'.[8] Having dispensed with all rites, rituals and sacrifice, it is a 'religion' of mercy which says 'yes' to the outcast, the marginalized, the unknown and the forgotten. If it distinguishes itself from the old 'religions of the Book', it is because they all have the 'makings of a catastrophe, that is, of war'. This they unfailingly

[7] John D. Caputo, ed., *Deconstruction in a Nutshell: A Conversation with Jacques Derrida* (New York: Fordham University Press, 1997), p. 177.

[8] Ibid., p. 164.

provoke, Caputo argues, 'with merciless regularity, under one of the most grotesque and terrifying names we know, that of a "holy war", which means, alas, killing the children of God in the name of God'.[9] Weak theology forms the basis of a religion of resistance to all who would make God their own, to all that proclaim to know what or who God *is*, and to those who think they have a divine mandate to do God's bidding here on earth.

It is certainly true that all religions have had a bloody history. It is also the case that they have regularly sought to exclude those who have challenged their creeds. However, if this were the only legacy of the old 'messianisms', they would have few remaining adherents. Take away the sacred sense sustained through the millennia by established religion, and you certainly would not be left with an earthly utopia. Indeed, as the cruel history of the 20th century so vividly shows, whenever a sacred settlement is swept away by secular ideology, the result is neither peace nor harmony, but tyranny, holocaust and enslavement. This is not to say that religion is now immune to fanaticism and fundamentalism. The horrors perpetrated around the globe by radical Islamists clearly demonstrate what can always happen when religion is distorted, when people believe they have a direct line to God. Yet, for the majority of ordinary believers, religion is neither a call to arms nor a blueprint for extremism. It is that which, by uniting them with their sacred lineage, and with absent generations, gives shape, meaning and moral purpose to their lives.

According to its practitioners, weak theology is not in the business of binding or domesticating. It rejects what Derrida calls the 'family scene', in which identity is privileged above difference. That is why it is a theology which emphasizes *blindness*, one which affirms what it cannot see and thus what it cannot contain. It seeks to restore 'invisibility to memory',[10] to show that in relation to the origin we are always in the dark. It is, thus, a 'theology' which limits the sense of sight and, consequently, which shields and disconnects believers from the Divine. This is faith in *nothing* — in something so irreconcilably different and 'wholly Other' that it impossible to know what you are meant to be affirming. If, as I believe, this cannot serve as a proper object of faith, it is because faith invites us to unite to something more than 'what is always to come'. As I once asked Caputo in the course of a public debate on this subject: 'What's the point of having a god ... if it's [such]

9 Ibid., p. 161.
10 Jacques Derrida, *Memoirs of the Blind: The Self-Portrait and Other Ruins*, trans. Pascale-Anne Brault and Michael Naas (Chicago, IL: The University of Chicago Press, 1993), p. 47.

a weak force?' He replied by inquiring, 'would it be possible to think about what's going on "in the name of God" if we could dissociate God from force and power, while retaining the notion of an unconditional claim, something that claims us unconditionally and demands that justice flow like water across the land?'[11] Unless we can *identify* the source of that claim, unless it has a certain *power* to elicit a response, then I do not believe it is possible.

Most Christians, for example, are not well versed in theology or even in the basic catechism of their faith. Yet, they live in accordance with Christian principles because they identify with the *person* of Christ. In responding to His claims, they respond to something con-crete, to the source of their salvation. In the absence of this personal relationship with the Divine, it is not at all obvious that they would consider the mandate to love unconditionally as anything more than an empty precept. This explains why I define weak theology as a *religion of detachment* — an opening to something with which you can never recon-cile or identify, being as it is so remote and unrecognizable. It is why I think it could never evoke the same passion for justice, mercy or love that established religion has throughout its long history. In the words of American theologian Mark C. Taylor, 'sojourners can feel at home only in a world in which the divine itself is at home'.[12] Only when the 'wholly Other' becomes one of us, when it becomes somewhat the same (and thus ceases to be *wholly* other), can it have true force in the lives of believers.

The underlying assumption of weak theology is that traditional religion is predicated on knowledge rather than faith. Having domesti-cated God, we can now claim *to know* His intentions, *know* with certainty what He wants of us. Faith, on the other hand, does not claim a special relationship with the Divine. With genuine faith, there is always a degree of not knowing and uncertainty. It requires a 'leap' into the unknown, a movement of trust and hope rather than certainty and clarity. Such is the great lesson of Kierkegaard's long meditation on Abraham in *Fear and Trembling*, a dramatic text which seeks to illustrate that 'faith is the highest passion in a person'.[13] In knowledge,

11 'From Radical Hermeneutics to the Weakness of God: John D. Caputo in Dialogue with Mark Dooley', in *Cross and Khôra: Deconstruction and Christianity in the Work of John D. Caputo*, eds. Marko Zlomislić and Neal DeRoo (Eugene, OR: Pickwick Publications, 2010), pp. 327–47.

12 Mark C. Taylor, *Journeys to Selfhood: Hegel and Kierkegaard* (New York: Fordham, 2000), p. 122.

13 Søren Kierkegaard, *Fear and Trembling*, trans. Howard & Edna Hong (Princeton, NJ: Princeton University Press, 1983), p. 122. See also Mark

all is made abundantly clear and visible. In faith, we can only see through a glass, darkly. However, it is only those on the fiery fringes of religion that claim to have 'absolute knowledge' of God. If ordinary religious believers make no such claims, it is because theirs is a religion which involves a great deal of trust and hope.

Every time believers enter a church, they make an act of faith in that which is unseen. Nevertheless, it is faith in *something* tangible, something to which they can direct their praise and worship. It is to trust that God has entered time and is now really present in our lives. This is not an expression of fundamentalism, not an attempt to contain or subdue the sacred, but simply a humble effort to connect or commune with their Creator. In the case of Christianity in general, and Catholicism in particular, this faith-filled communion does not direct the eyes of the believer elsewhere or, indeed, to *nowhere*. It is not an attempt to escape the slings and arrows of time and chance. Rather, it is a way of uniting more concretely with creation.

What I want to say is that, by and large, so-called 'strong' religion is neither escapism nor a recipe for fanaticism, but a *rooted* form of faith that inspires love, charity and noble sacrifice. The repudiation of religion is nothing less than the rejection of all those things which serve to connect us to the sacred, the community (both living and dead) and to our common past. For what is religion if not memory, memorialization and a work of mourning in which the dead are never forgotten? What is it except an offering of thanksgiving for all that we have received and, indeed, for the very fact of existence itself? What is it except an acknowledgement of our dependency on that which is far greater than the solitary self? That is why Edmund Burke spoke so potently of the Church as 'the first of our prejudices, not a prejudice destitute of reason, but involving in it profound and extensive wisdom'. It is that which, by rescuing us from the 'paltry pelf of the moment', offers a 'solid, permanent existence'.[14] For through it, we are given a sense that life is rooted in much more than the passing pleasures of secular society.

In seeking to make a home for the sacred, the Church serves as a repository of memory. It endeavours to reconcile believers, not only to their divine origin, but to a tradition which memorializes all those who personified the best of Christian virtue. In worshipping at their memorials and shrines, the community invokes the spirit of the saints

Dooley, *The Politics of Exodus: Kierkegaard's Ethics of Responsibility* (New York: Fordham University Press, 2001), Chs. 4 & 5.

[14] Edmund Burke, *Reflections on the Revolution in France* (New Haven, CT: Yale University Press, 2003), p. 78.

and attempts to live in their light. It is this which keeps us mindful of their sacrifices, mindful of the fact that without their willingness to preserve and transmit what we now possess, our children would be disinherited from their sacred bequest. In the absence of religion, in the absence of those rites and rituals which connect the living to the dead and the unborn, society loses its memory and fractures at the seams. If this has now become commonplace across the secular world, it is because without religion and the institutions which sustain it, identity loses its underlying cohesion. That is because there is no context in which communities can celebrate or commemorate their common origins, nowhere to give praise for all they possess, and nowhere to sanctify their hopes and longings. Where the sense of the sacred is weak or nonexistent, so also will be the sense of belonging which all societies require in order to endure.

A church consecrates not only the community, but also the land upon which it settles. It serves to bind people to God and to absent generations through acts of faithful adoration. Derrida is correct: in as much as it offers sanctuary to the sacred and the dead, the Church does indeed *domesticate*. However, it does not seek to 'shut down the very structure of time and history, to close off the structure of hope, desire, expectation, promise, in short of the future'.[15] If anything, it is domestication rooted in the richest form of hospitality or 'openness to the other'. Indeed, at the core of the Catholic religion is the sacred 'Host' — the God Who sacrifices everything for those who come to worship at His table, or for those who are made one through Holy *Communion*. In accepting the hospitality of the Host, worshippers are, in turn, commanded to welcome the unborn, the living and the dead. For, that is the true nature of the sacramental experience, an experience that binds us unconditionally to the requirements of others.

In kneeling before the Tabernacle, believers are, *in faith*, acknowledging their dependence on the hidden Host and, in turn, vowing to offer hospitality to their dependents and neighbours. The sacramental experience roots them, not only to the source of creation, but to creation itself. They are united to the earth, its fruits, and to its stewards, both past, present and to come. The seven sacraments of Baptism, Holy Communion, Confirmation, Confession, Matrimony, Holy Orders and the Last Rites provide an experience of the sacred in and through the gifts of creation. Through water, bread, wine, fire and oil, the believer is incorporated into the 'great eternal society' of fellow believers. We are reconciled to God and to one another through eating and drinking, through the consumption and use of substances which feed the body

15 Caputo, *Deconstruction in a Nutshell*, p. 163.

and sustain the spirit. In each case, the purpose is to savour the sacred, to experience God as something real, present and true. Naturally, this demands much faith, but it is something which nonetheless enables us to experience God, not as remote, unrecognizable or indifferent to our needs, but as something with which we can tangibly identify. What is more, in uniting with God in this way, we are simultaneously reminded that we belong to a place shaped and moulded in the image of our canonized forefathers. Through the consecration of bread and wine, Christian believers are brought into the 'real presence' of their God. However, they are also reminded, as fellow communicants, that they share a common home, a common past and a joint destiny. For bread is the food of belonging and wine a symbol of our rootedness to time, place and history.

Contrary to Richard Dawkins's assertion that religion is the stuff of fantasy and fairytales, the sacramental experience convincingly demonstrates that, if anything, *religion roots us to reality*. It sensitizes us not only to the requirements of absent generations, but to creation and its manifold gifts. It is an experience of the Eternal which does not result in division, detachment or denial, but in communion, benediction and belonging. Take away the Church as that which sustains the sacramental experience, and you disconnect from that which unites and binds. You rob religion, not, as Caputo maintains, of its extremist element, but of its matchless power to convey an enduring sense of community, identity and settlement.

Of course, this is not to suggest that the question of God's existence is secondary to the social and moral function of ecclesial institutions. The primary role of the Church is to preserve and transmit those theological truths which are the bedrock of the faith. This it does, not in ignorance of the so-called 'catastrophe of memory', for the Church has always been sensitive to the need for theological interpretation. However, as Benedict XVI writes, unless 'there had been something extraordinary in what happened, unless the person and the words of Jesus radically surpassed the hopes and expectations of the time, there is no way to explain why he was crucified or why he made such an impact'.[16] In other words, we can take for granted everything modern exegesis, and indeed deconstruction, tells us 'about literary genres, about authorial intention, and about the fact that the Gospels were written in the context, and speak within the living milieu, of communities', while still believing that 'Jesus really did explode all existing categories and could only be understood in the light of the mystery of God'.[17]

[16] Benedict XVI, *Jesus of Nazareth* (London: Bloomsbury, 2007), p. xxii.
[17] Ibid., pp. xxii–xxiii.

Through its sacred liturgy, the Church seeks to conserve that defining truth. In word, ceremony and song, it recollects and rehearses its founding moments. This ancient rite attempts to transmit to the living that sense of awe and wonder experienced by the first apostles in the presence of Christ. By participating in the ceremony, the community or congregation connects to a living tradition. That it does so through a ritual steeped in culture is because it is through art that we have always attempted to express our sacred longings. It is through painting, sculpture, music and sacred architecture that we have sought to express the inexpressible, to identify with the supreme object of our adoration.

The great tradition of sacred art, which in essence constitutes the Western artistic tradition, can be seen as an attempt to put a face on God, to let His light pierce the fabric of time. Art is that through which the finite mediates with the infinite, that through which we acquire a sense that there is more to this world than mere matter. If Hegel placed art next to religion and philosophy as that through which we acquire full self-recognition, it is because it was, for him, a manifestation of spirit shining through the veil of sense-experience. It is through art in general, and religious art in particular, that we overcome the alienation of finitude. Through it, we are given a presentiment of our eternal home and our sacred settlement.[18]

At its best, religion is *homecoming*. It enables us to surmount earthly estrangement—but not, as Kierkegaard says, by escaping to eternity through the back door. Rather, it roots us to where we are, inviting us to see intimations of infinity in the concrete circumstances of everyday existence. The sacramental rites bind us to the great eternal society by rooting us to the world. As I have already suggested, they do so through the symbolic use of material substances such as water, wine, food and fire. In the case of marriage, however, we are, quite literally, invited to put down roots, to build a home for absent generations. We are asked to live sacramentally by sacrificing the ego and its immediate desires, so that the requirements of others might be fulfilled. In this way, the commonplace world is sacramentalized and sanctified.

This is what it means to live in the light of eternity: it is a way of existing that does not seek to contain or control the Divine, but one that allows the sacred to shape the manner in which we dwell. It involves responding to the sacred through building, dwelling, settling, cultivating and nurturing. That is why, traditionally, the family paused before and after meals to offer grace. It was their way of giving

18 For an expanded discussion of the role of aesthetics in sacred worship see Mark Dooley, *Why Be A Catholic?* (London & New York: Bloomsbury, 2011).

gratitude, not only for the food before them, but also for their settle-
ment, sanctified as it was through countless sacrifices down the
generations.

I do not say that *only* religious people care for creation or conserve
culture. However, in living sacramentally, you are more likely to do
both. That is because religious people ponder the earth, not simply as a
playground for their own private possibilities, but as a sacred bequest
to be sustained for those yet to come. They look at the world as though
through stained-glass windows, seeing in it the spirit of absent others
and traces of the infinite. The religious are more likely, therefore, to
adopt the *pastoral perspective*.[19] They are more likely to conserve and
sacrifice for those they cannot see or may never know. They are also
more likely to undertake the work of culture which, from their per-
spective, testifies to humanity's irrepressible urge to connect with the
sacred in time. It is this which explains why religious people are
natural conservationists. For when the world and our representations
of it are no longer perceived as revelations of truth, beauty or the
sacred, they are much easier to squander, misuse and neglect. Take
away the sacramental, in other words, and there is little to stand in the
way of desecration. As expressed by Benedict XVI, 'the new ideologies
have led to a sort of cruelty and contempt for mankind that was
hitherto unthinkable, because there was still respect for God's image,
whereas without this respect man makes himself absolute and is
allowed to do anything—and then really becomes a destroyer'.[20]

To reiterate: the loss of religion is a loss of home, a loss of all that
binds us to the earth, to its sacred source and to each other. To drain
religion of that essential experience, to make it one of pure faith with-
out any concrete content, is to trade identity for estrangement. It is to
experience the homesickness of Hegel's 'unhappy consciousness', to be
a 'stranger on earth, a stranger to the soil and to men alike'.[21] That is
why I disagreed with the late American pragmatist philosopher
Richard Rorty when he wrote that religion is what we do 'with our
solitude', or when he argued that 'talk about God should be dropped
because it impedes the search for human happiness'.[22] It is, of course,
true that much religious observance is conducted in private, such as

[19] See Dooley, *Moral Matters*, Ch. 7, 'Caring for Creation', pp. 125–46.

[20] Benedict XVI, *Light of the World: A Conversation with Peter Seewald* (San
 Francisco, CA: Ignatius Press, 2010), p. 54.

[21] Hegel, 'The Spirit of Christianity and its Fate', in *On Christianity: Early
 Theological Writings*, trans. T.M. Knox (Gloucester, MA: Peter Smith, 1970),
 p. 186.

[22] Richard Rorty, *Philosophy as Cultural Politics: Philosophical Papers, Volume 4*
 (Cambridge: Cambridge University Press), p. 4.

personal prayer and acts of penitence. Still, as I have been suggesting, the root of religion is that it binds the individual to something greater than himself. In so far as it shapes the way he engages with others and the world, religion is essentially *public*, and cannot be divorced from its communal context without losing its power to convey theological truth and conserve identity. Neither is it possible simply to drop the name of 'God' as though it were similar to objectionable words like 'outcast' or 'untouchable'.[23] In all contexts and circumstances, those words have caused suffering, exclusion and offence. However, despite the fact that the name of 'God' has often been used to justify violence, oppression and even murder, it has more often been a principal source of comfort, consolation, charity and mercy. Through the saints, martyrs and in the very ordinary, but no less noble, sacrifices of ordinary believers, we see how this name has unrivalled power to serve the cause of human happiness. Hence, to blame it, or religion, for the atrocities perpetrated in its name is, as Roger Scruton remarks, 'like blaming love for the Trojan War'.[24]

Giving up on God-talk is to fundamentally change the way you relate to reality. It is not just a matter of altering one's vocabulary, or of modifying certain habits of behaviour, but of radically transforming the way *life itself* is experienced and lived. That a person so intellectually sophisticated as Richard Rorty failed to recognize this is perhaps best explained by the fact that he was born into a socialist household and was a lifelong atheist. The truth is, however, that the quest to jettison the word 'God' has not resulted, as Rorty hoped, 'in a global civilisation in which love is pretty much the only law'.[25] If anything, the effect has been to divide and distance people from each other, to undermine communities which were once bound together through their common allegiance to the Church. It has resulted in a loss of that spirit of sacrifice upon which absent generations depend, and without which nothing can be conserved. When religion declines, as it now has, people cease to make public professions of faith. They cease to make solemn vows before God and the community that they shall build a home and live lives worthy of both. They cease to factor the unborn and the dead into their actions, plans and projects. In favouring the secular above the

[23] Ibid., p. 3, and Mark Dooley, 'The Plagues of Desecration: Roger Scruton and Richard Rorty on Life After Religion', in *Human Destinies: Philosophical Essays in Memory of Gerald Hanratty*, ed. Fran O'Rourke (Indiana: University of Notre Dame Press, 2013), pp. 312–36.

[24] *The Spectator*, 14/01/06.

[25] Richard Rorty 'Anticlericalism and Atheism', in *The Future of Religion*, ed. Santiago Zabala (New York: Columbia University Press, 2005), p. 40.

sacred, they no longer know what it means to live sacramentally or to dwell at the intersection of time and eternity.

To stand at that intersection is not, as I have been suggesting, a flight from reality. It is to be rooted in a way which radically contrasts with the secular lifestyle. This is real and tangible communion or communication. It engages and stimulates the mind and the senses, thus enabling us to experience the sacred as something present, lovable and praiseworthy. As such, it radically contrasts with the virtual existence of Cyberia that is characterized by ceaseless communication but no real communion. More than any other modern thinker, Hegel perceived most clearly the fact that without religion we are destined for unhappiness, for a life of disharmony and alienation. Contrary to Nietzsche and Marx, both of whom believed that religion causes alienation in its adherents, Hegel perceived it not only as a source of reconciliation and redemption, but as that which 'unifies social and personal existence and counterbalances centrifugal forces that constantly threaten disintegration'.[26] However, in rejecting the concrete messianisms for the wholly Other—what Derrida calls the *tout autre*—not only 'is the individual set in opposition to the natural and social world, but he also suffers inner fragmentation that alienates him from God'. As such, he is condemned to 'labour under the "infinite sorrow" of separation and loss, and can only "yearn" for the everlasting peace of reconciliation'.[27]

Those, once again, are the words of Mark C. Taylor, an American theologian who first rose to prominence through his writings on Hegel and Kierkegaard in the 1970s. In the decades that followed, he would become a pioneer of theological post-modernism in which God would be 'discredited' and 'disfigured'. Moving from Hegel through Kierkegaard and Derrida to virtual culture, Taylor sought to marry theology and technology, to demonstrate the underlying 'religious' nature of Cyberia. As he wrote in 1999:

> When viewed in the context of the displacement of religion onto art and the eventual transformation of the world into a work of art, which occurs in contemporary media culture, it appears that Las Vegas is, in effect, the realization of the Kingdom of God on earth. As the real becomes image and the image becomes real, the world becomes a work of art and our condition becomes transparently virtual. In the realized eschatology of the virtual kingdom, nothing lies beyond.[28]

[26] Taylor, *Journeys to Selfhood*, p. 35.

[27] Ibid., p. 41.

[28] Mark C. Taylor, *About Religion: Economies of Faith in Virtual Culture* (Chicago, IL: The University of Chicago Press, 1999), p. 5.

Lately, however, Taylor has come to recognize that dwelling in this virtual kingdom is, in fact, an experience of destitution. This once great prophet of post-modernism now believes that the prevailing 'obsession with difference tends to leave us with nothing in common'.[29] Hence he writes that while 'new information, networking and media technologies have undeniable benefits, they also bring losses that should not be overlooked. It is time, indeed, past time, to slow down and ponder what is slipping away before it is too late'.[30]

In a virtual kingdom where nothing is for certain, where speed is valued for its own sake and nothing is embedded, religion reminds us of what it is that we stand to lose should we refuse to slow down. It binds us to place, time and history, to friends, neighbours and community. The sacramental experience of religion goes well beyond belief, ritual and devotion, however vital and integral they are to the religious way of life. It is, in essence, an experience of *reconciliation* and *atonement*, an experience of being at-one with God, of belonging to a place that has been sanctified in His image and to a people whose common destiny you share. It is an experience of home in a world that is homeless.

If secular post-modernism emphasizes rupture and amnesia, religion generates a culture of remembrance, responsibility and reparation. For most people, living a religious form of life does not involve excluding the stranger or condemning those of other confessions as infidels or apostates. It does not involve seeing God as someone 'who's going to come in here and slay his enemies and do all the heavy lifting for us'.[31] If anything, it is a way of existence which prioritizes *hospitality* and *forgiveness*, which makes holy the hours in service and humble solicitude. Far from being an example of theological totalitarianism, this is a work of love motivated and nourished by that sense of mutual dependency sustained and transmitted through religious traditions.[32]

Caputo writes movingly and convincingly of the 'claustrophobic catastrophe' which would occur if there were nothing to 'check the free reign of the "profane", the unbroken rule of the "world", the harsh economy where there are no gifts, where everything has a price'. For the profane is nothing less than 'the degradation of the sacred into acquisitiveness, the truncating of human experience into consumption, leaving us to wander the shopping malls in search of what we desire

29 Ibid., p. 2.
30 Mark C. Taylor, *Recovering Place: Reflections on Stone Hill* (New York: Columbia University Press, 2014), p. 2.
31 Caputo, 'From Radical Hermeneutics to the Weakness of God', p. 331.
32 See Dooley, *Moral Matters*, Ch. 4, 'A Work of Love', pp. 59–78.

and relegating us to reality TV to search for what is real'. If the profane life 'is flat and thoughtless', the sacred interrupts the 'closure of secularism … by means of the event which stirs within the name of God'. Secularism means the 'rule of the world, the regime of the pro-fane'. It attempts to 'disenchant the world in virtue of which everything we mean by God is reduced to the economy of the *saeculum,* where everything has a market price'.[33] Hence, if theology is to counter the profane, it must re-sacralize 'the settled secular order, disturbing and disordering the disenchanted "world"'.

There is nothing in that with which I disagree. However, I am not convinced that the re-sacralization of the secular order, of this our profane paradise, can happen in the absence of the concrete confessions which terrify weak theology. When, however, the sacred has a home, when it dwells amongst us in a form to which people can relate and with which they can easily identify, it is possible to resist the regime of the profane. Even now, when people are so disconnected, there is a still an immense hunger for identity and belonging. There is widespread desperation for that sense of rootedness which I have sought to defend here. We see this in the way they seek to connect through sport and through social media sites like Facebook and Twitter. That, however, is an ephemeral form of identity which cannot satisfy beyond the moment, and certainly can never fulfil our deepest yearnings.

The presence of the churches in the midst of the profane kingdom offers a powerful experience of home to the spiritually destitute and dispossessed. They remind us that we are not condemned to perpetual isolation, to a life devoid of love, attachment and belonging. At any time, we can unplug from the virtual kingdom and return to reality. We can cease to live a life of opposition and rejection, opting instead for one of affirmation—affirmation of all those things which secularism denies, but which, in truth, are the foundations of true happiness and real freedom. So long as the churches prevail, therefore, the closure of secularism will not be complete. So long as they, and the people shaped by them, continue to give witness, the rule of the world will be unsettled by the sacred. That is why the work of saving the sacred should not be a matter of undermining religious institutions, but of conserving and caring for them.

Naturally, I recognize that, in Europe at least, the churches are almost empty. I recognize that the old rites of passage, sanctified and conserved by religion, are in decline, and that the sacred has almost vanished from the public square. To many it seems that the regime of profanation has finally triumphed, and that where signs of the sacred

[33] Caputo, *The Weakness of God,* p. 290.

survive they too must be banished. Still, those who celebrate this seeming victory of the profane over the sacred ought to be mindful that *all* societies, including secular ones, depend on sacrifice, commitment and devotion for their survival. It is doubtful, in other words, that where the churches have finally shut their doors, the habit of sacrifice will continue to shape people's lives. It is doubtful they will be bound by anything more than virtual relations, or that they will be attached to anything greater than the passing fancies of the present age.

In short, when the churches decline, so too does everything they actively conserve and transmit by way of sacred ceremony, moral teaching and theological truth which takes concrete form in a life of faith. All of which leads me to conclude that if the Church is 'the first of our prejudices', it is because without it the work of conservation does not stand a chance. And if that is so, then, sadly, neither do we.

Index